Giotto and Florentine Painting

Giotto
and
Florentine Painting

1280–1375

BRUCE COLE

ICON EDITIONS
HARPER & ROW, PUBLISHERS
NEW YORK, EVANSTON, SAN FRANCISCO, LONDON

FIRST EDITION

Designed by C. Linda Dingler

Library of Congress Cataloging in Publication Data

Cole, Bruce, 1938–
 Giotto and Florentine painting, 1280–1375.
 (Icon editions)
 Bibliography: p.
 Includes index.
 1. Giotto di Bondone, 1266?–1337. 2. Painting,
Florentine. 3. Painting, Gothic—Florence.
I.Title.
ND623.G6C57 759.5 75–7632
ISBN 0–06–430900–2

76 77 78 79 10 9 8 7 6 5 4 3 2 1

For Doreen, Stephanie and Ryan

Contents

Preface

There are many marvelous pages on Giotto. From Boccaccio to Berenson many scholars have discussed the artist, while numerous critics have devoted learned articles and books to him. There remains, however, a gap in the Giotto literature. For the general reader there is in English no comprehensive introduction to Giotto's art and to Florentine art of his century. It is hoped that this book will serve as such an introduction. In it I have tried to discuss the form and meaning of Giotto's paintings, trace his pictorial development and relate his works to his artistic ancestors and heirs. I have mainly been concerned with those paintings clearly ascribed to him in the belief that these are the key documents for our understanding of the artist. Consequently, discussion of a number of questionable works has been relegated to the Notes or referred to only in bibliographical citation. Investigation of the difficult question (still under debate) of whether Giotto worked at Assisi has been placed in the penultimate chapter with the hope that the issues raised by the Assisi problem would be set in better perspective after a survey of Giotto's more secure paintings. The last chapter seeks to survey the history of Giotto criticism.

The footnotes and bibliography have been designed to provide an up-to-date survey of the many specific problems of Florentine Trecento art. It is also hoped that they will serve to introduce readers to some of the broader questions still posed by Italian painting of the fourteenth century.

Many people have been extremely helpful to me in the preparation of this book, and it is a pleasure to thank them here. Nancy Lambert, Professor Ulrich Middeldorf and Professor David Wilkins all provided great assistance. I am also indebted to the following: Mr. Cass Canfield, Jr., Professor Marvin Becker, Professor Marvin Eisenberg, Dr. Irene

Hueck, Professor Charles Mitchell and Mr. Scott Walker. I wish to express my gratitude to the National Endowment for the Humanities and to Miss Mary Davis and the Samuel H. Kress Foundation for the support that allowed me to revisit the works illustrated in the book and to write the text in Florence.

BRUCE COLE

Bloomington, Indiana

Giotto and Florentine Painting

I

Giotto di Bondone

As the visitor to the Uffizi Gallery in Florence turns from the long, statue-lined corridor into the first room of the museum, he sees three enormous, softly glowing paintings —one each by Cimabue, Duccio and Giotto. Whether he knows it or not, he is standing before some of the most important works of art in the entire history of Western painting: the pictorial images and ideals of a quarter of a century that was, in its fundamental significance, unique.

Straight ahead is Giotto's *Ognissanti Madonna* (painted around 1305), as arresting an image as any in the entire museum (Plate 1). In the center of the picture sits the Madonna holding the Christ Child on her lap. Both are enclosed in a large throne whose gable rises toward the top of the painting and is mirrored by the triangular shape of the picture's frame. But the visitor does not stand alone in the presence of the Madonna, for she is flanked by the saints and angels surrounding the throne. They, like the kneeling angels in front of the steps below, stare fixedly at the Virgin; she and her son are the single object of their gaze and the sole reason for their being. Onlookers, angels and saints alike, are held by the great presence of the central figures who occupy space in the most convincing manner, their existence seeming to fill the large room. But the visitor does not feel in the company of some great and fearful image. These figures of the Madonna and Child and the heavenly group that accompany them are not exclusive. Their most believable, solid bodies, the foreshortened turn of their heads and the mixture of awe and compassion expressed on their faces make this a welcome and inviting picture. Its author's humanity is expressed through a wonderful combination of the grandiose and the detailed, the abstracted and the particular—a combination that rather accurately reflects the human condition. The holy figures are brought close to

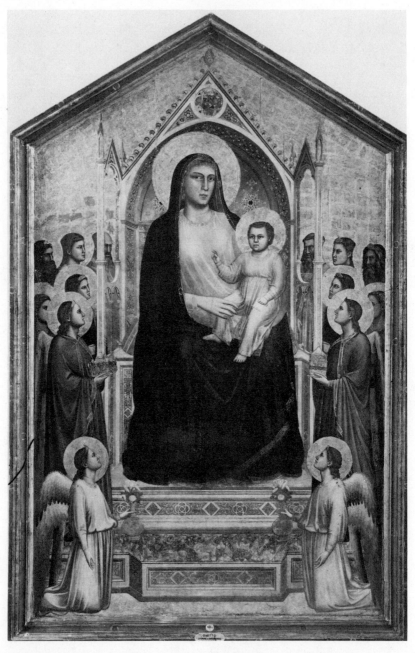

Plate 1. Giotto: *Ognissanti Madonna*. Florence, Uffizi Gallery

the visitor by their likeness to him but removed from too near a kinship by their monumentality and gravity. Here is an image that is in perfect balance and harmony.

When the visitor is finally able to leave Giotto's picture it is more than likely that his attention will be taken up by an equally large painting placed to its right. This *Santa Trinita Madonna* (or *Maestà*, as such works are sometimes called) of c. 1285 is by the hand of Cimabue, the most famous forerunnner of Giotto in Florence (Plate 2). To turn to this panel from Giotto's is to leave one world for another. Perhaps the greatest difference comes first to the mind rather than to the eye. In the *Santa Trinita Madonna*—it was originally in the Florentine church of the same name—the onlooker observes not a presence but a vision. Here is a heavenly host that seems to appear, dreamlike, suspended in time and space. It is hierarchical and graceful in a way the *Ognissanti Madonna* is not. In front of us are the Queen of Heaven and her divine son, not the grave but human images that sat before the visitor in Giotto's painting. We are at a loss to determine exactly where things are in Cimabue's panel, and this helps give it that quality of mystery that strikes us every time we look at it. Where exactly is the Madonna? Is she standing or sitting? How is the child placed on her lap? Where are the angels standing, and what are those prophets below doing? The ambiguous pictorial quality of the picture is a perfect complement to its elaborate surface. The intricate carving on the huge wooden throne, the hundreds of gold striations on the Madonna's robe and the multicolored rainbow wings of the angels add a complexity that keeps the viewer's eye moving from one part of the picture to another. It is as symmetrical and harmonious as the *Ognissanti Madonna*, but Cimabue has taken great pains to vary the position of the angels, creating a balanced but active play up and down the flat surface of the panel. This is not disturbing, for here we do not feel in the actual physical or psychological ambiance of something very holy, as we did while looking at the *Ognissanti Madonna*. Rather we now observe a gorgeous vision of a most elegant and beautiful idea. Perfection has been substituted for presence.

As the visitor turns from Cimabue's panel and looks across the room his eyes focus on the third of the three pictures that make this room in the Uffizi a special place for all those who love painting (Plate 3). It is about as large as the *Ognissanti* and *Santa Trinita* Madonnas and, like them, is a gabled rectangle. It is also nearly contemporary with them (c. 1285), although not Florentine but Sienese, and by the hand of one of the supreme painters of Siena, Duccio. From this painting the

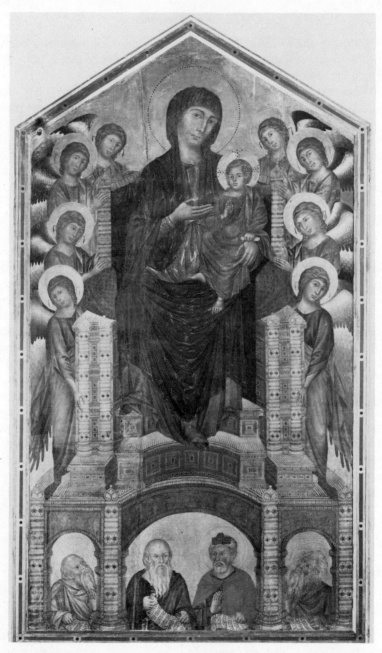

Plate 2. Cimabue: *Santa Trinita Madonna*. Florence, Uffizi Gallery

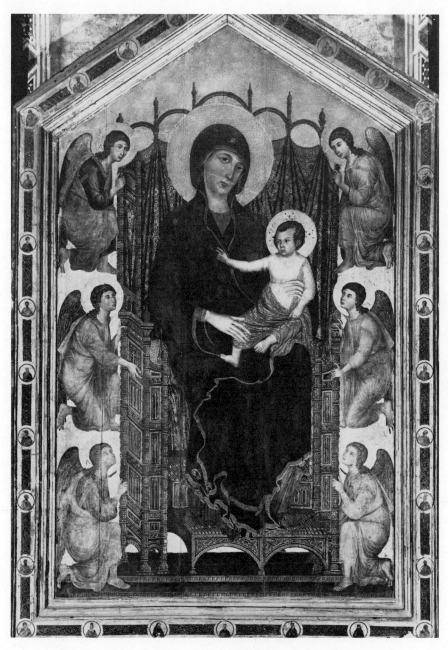

Plate 3. Duccio: *Rucellai Madonna*. Florence, Uffizi Gallery

onlooker receives yet another set of visual experiences, perhaps the strongest of which is a pronounced sense of fantasy. While the throne of the Virgin appears to recede into space diagonally, it seems tipped up and devoid of support, like the two upper angels to either side of it who rest their knees on thin air. The specific and convincing placement of figures and their volume which carved out and occupied space in Giotto's painting is here absent. Duccio, like Cimabue, is not interested in defining his figures in relationship to the spectator; they exist in a world of their own—a world that is not part of the human experience, as it is in all Giotto's pictures. If Cimabue's Madonna was a queen, here we have a divine empress whose beautiful face contemplates us with a regal, wistful glance, while her stern son earnestly blesses someone off to our left. This is a fantastic world where the basic elements of style —void, solid, shape and color—have a wonderful life of their own. The exquisite color harmonies of pale green and light purple, pink and blue and pink and deep green make strong contrast with the earthier, denser grays, greens and reds of Giotto's more restricted palette. And nowhere in Giotto's painting is there anything like the sinuous, decorative, moving line of the gold hem of the Virgin's mantle that plays so tellingly against the dark blue of the material. The lovely pattern of the costly brocade behind her and the elaborate carpentry of her throne add to this feeling of disjointed fantasy and grace. Here we are not confronted by the vision of a majestic court that has appeared before our eyes—as in the *Santa Trinita Madonna*—but rather by a lovely and melodic image, such as we might imagine in a happy daydream.

How different the paintings by Cimabue and Duccio are from Giotto's *Ognissanti Madonna*! Both are basically removed from the onlooker. Neither has a compelling central focus. We see, respect and worship them but do not participate in their worlds. They make few concessions to those who stand before them. They exist outside our experience, serving as strong reminders of a higher but inaccessible sphere. They are icons. But when the visitor turns once more to Giotto's *Ognissanti Madonna* he is now even more aware of the fundamental affinity he has with the picture. He sees the palpable, fully frontal Virgin looking out at him from a definable position in space. The step of her throne and the adoring angels to their sides help create a spatial movement that the viewer seems to complete with his own body. He, like the saints and angels, is a participant at this most holy and believable scene.

This new visual relationship between spectator and picture, between the divine and human realms, is the creation of Giotto; the *Ognissanti*

Madonna is one of its first and greatest manifestations. This picture, and others like it from Giotto's hand, decisively broke the iconic bonds of Italian art, making a return to such mentally and physically removed works as those by Cimabue and Duccio in the same room impossible. But Giotto did more. By creating such convincing illusionism and by humanizing his monumental figures, he set the stage for much of the subsequent development of European art. For hundreds of years artists were to follow along the road he first charted.

Who, the visitor might well ask, was this genius and how did he come to paint such a picture? What do we know about his life? Where was he trained and with whom? What are the rest of his works like? The answers to these important questions, as we shall see, are not always clear. However, the best way to begin to answer them is to start with the man.

It is surprising how little we know about the lives of many great artists—Masaccio or Donatello or Piero della Francesca, for example. Giotto is no exception; even the artist's birth date is unknown, although there is good reason for supposing that it occurred in 1267.[1] His birthplace was Colle di Vespignano in the Mugello, a region not far from Florence. He seems to have come from a family of shepherds and was a son of a certain Bondone, about whom we know absolutely nothing. It is certain, however, that the artist's origins were humble and rural.

The first documentary record of Giotto di Bondone does not appear until 1301, when he is mentioned as the owner of a house in the quarter of Santa Maria Novella in Florence.[2] Four years later we learn, again from documents, that he leased another house in the same city. These two notices seem clearly to indicate that he was a permanent resident of Florence by the first few years of the Trecento. How he got there from Colle di Vespignano is a mystery. If we believe the sixteenth-century biographer of artists, Giorgio Vasari, it was Cimabue who brought him. Vasari tells the reader of his *Vita* of Giotto that Cimabue saw the young Giotto drawing a sheep on a rock.[3] Impressed by the work, so the story goes, Cimabue asked Giotto's father's permission to take the boy back to Florence to serve as an apprentice in his shop. This is one of those tales that sounds too fantastic to be true, and it seems much more likely that Giotto's father took the boy to Florence to apprentice him to a painter. We do not know if this was Cimabue, but it might have been, for he was, during the last two decades of the Duecento, the most famous and busiest painter in the city.[4]

Boys often began their apprenticeship in the shop (*bottega*) of

a master while still in their early teens. Thus, if Giotto was apprenticed at thirteen or so, his entry into a shop must have been around 1280. Such apprenticeships were often long (Taddeo Gaddi spent twenty-four years in Giotto's shop, but surely this is more protracted than the average time), and Giotto might not have emerged as an independent artist until the last decade of the century.

We know a fair amount about what apprentices did in the shops, thanks to a treatise called *Il Libro dell'Arte*, which was written about 1390 by the minor Florentine artist Cennino Cennini.[5] This is not a philosophical or aesthetical tract but, rather, a pragmatic manual composed for use in the painter's *bottega*. Cennini was a pupil of Agnolo Gaddi, who, in turn, was the pupil of his father, Taddeo Gaddi, who, Cennini proudly tells us, studied with Giotto. Thus the methods that are preserved in Cennini's book are most likely those of Giotto and may be those which Giotto himself learned as an apprentice. The practice and customs of early Italian artists tended to change very slowly.

Most of Cennini's book is highly practical (except for an occasional aside to the young artist, such as telling him to stay away from too much food and too many women, who, he says, make the hand shake) and is devoted to the day-to-day skills and attitudes needed in the *bottega*. Thus, it tells us a good deal about what it must have been like in the shops of the thirteenth and fourteenth centuries.

Cennini says a number of interesting things about what was expected of the apprentice:

You, therefore, who with lofty spirit are fired with this ambition, and are about to enter the profession, begin by decking yourselves with this attire: Enthusiasm, Reverence, Obedience, and Constancy. And begin to submit yourself to the direction of a master for instruction as early as you can; and do not leave the master until you have to. . . .[6]

take care to select the best one [master] every time, and the one who has the greatest reputation. And, as you go on from day to day, it will be against nature if you do not get some grasp of his style and of his spirit. For if you undertake to copy after one master today and after another one tomorrow, you will not acquire the style of either one or the other, and you will inevitably, through enthusiasm, become capricious, because each style will be distracting your mind. . . .[7]

you will find, if nature has granted you any imagination at all, that you will eventually acquire a style individual to yourself, and it cannot help being

good; because your hand and your mind, being always accustomed to gather flowers, would ill know how to pluck thorns. . . .[8]

Cennini's theory of intellectual and stylistic submission is foreign to our present conception of a young artist's training; today we consider it the painter's job to forge his own style at once. That he should submerge his personal idiom into that of another is unthinkable. He is a free and, above all, original spirit. In the fourteenth century it was just the opposite. It was necessary for the beginning painter to copy his master's work faithfully. He, as Cennini tells us, was not to leave the artist till he had fully learned his style.

One of the reasons for this great difference is to be found in the concept of the artist in the Duecento and Trecento. During this period the painter was viewed as a tradesman doing a skilled job; in fact, it was such a complex technical task that a long apprenticeship was necessary for practical reasons alone. Young artists had to learn how to grind pigments, make brushes, gild, prepare panels, put plaster on a wall and hundreds of other tasks, all before they even began to draw or paint. Of course there were a few cases—such as Giotto's—where the brilliance of his artistic talents elevated him above this tradesman status and he was proclaimed a genius. These were, however, the exceptions, not the rule.

There was another more important reason for the submersion of the individual style of the helper-artist. Often the master was given large fresco cycles or big altarpieces to paint. Since he could not possibly do all these commissions himself, it was necessary for the apprentices to work on them as well.[9] The master would conceive the design, and the shop would help him carry it out on the wall or panel.[10] In order to keep the finished painting from looking like a patchwork of various styles, the helpers had to learn to paint like their master and to suppress, at least for the moment, whatever stylistic independence they had. Later, as Cennini says, when they were working independently they could show their own idiom and employ other young artists to aid them. Understanding this theory is important for any discussion of Giotto and his contemporaries, for it helps to explain the nature of the gradual stylistic shifts of early Florentine painting, while emphasizing how really dramatic are the major breaks that Giotto made with his past.

The head of the shop was the master of whom works were commissioned. It was he who was paid by the patrons. He was the principal artist and he directed the work.[11] Under his sole guidance were the

young men who had entered the shop to learn the craft of painting. They would stay with him till they were ready to accept their own commissions and start their own shops. There were also part-time members of the shop who were called in to help the master and his assistants when there was a lot to be done. For instance, when there was little work the shop would consist of the master and several of his student-apprentices. But when there were numerous commissions or a single commission for a big fresco cycle, a larger shop would be needed.[12] These frescoes involved the most work; it was necessary for scaffolds to be erected, ladders made, walls plastered and many other such hard and time-consuming tasks. When we look at a sizable fresco cycle such as Giotto's in the Arena Chapel (Plates 23 and 24), it is hard to imagine that its walls were once covered with scaffolds on which stood numerous men, all engaged in the feverish activity of fresco painting. Thus the shop was not a rigid system of only master and pupil but rather a more fluid entity that expanded or shrank to fit the needs of its work.

The typical commission on which the shop labored was not the altarpiece or fresco. The scanty amount of remaining documentation suggests quite the opposite. It appears that a considerable amount of the artists' time was spent on painting chests, shields and banners.[13] Often famous painters would decorate the walls of palaces and villas, and they were not above doing purely geometric decoration on timbered ceilings.[14] Although the Trecento writer Francesco Sachetti tells us that Giotto painted a shield for a Florentine parvenu, it seems quite improbable that, like the typical shop, Giotto had much of this work.[15] Most of his life he was flooded with important commissions.

So by the first recorded presence of Giotto in Florence in 1301, the artist's training (with whom we are not certain) must have been behind him by at least a decade. He had already finished the stunning *Crucifix* in Santa Maria Novella (Plate 13), one of his most important early works, and was about to begin the famous cycle in the Arena Chapel (Plates 23 and 24).

We hear of Giotto again in 1311 when he acted as guarantor for a loan. During the next year he is documented renting out a loom in Florence. Throughout his life there are several documents that record Giotto's non-artistic activity. He acts as a guarantor, rents out looms or houses or buys and sells land. And although there is not a great deal of proof, it appears as though he was a man very much interested in making money, aside from his painting.

Around 1310 Giotto was already famous. He is accorded the singular

honor of being the only contemporary artist mentioned by Dante in the *Divine Comedy*. In several fascinating lines the poet says:

> O thou vain glory of the human powers,
> How little green upon thy summit lingers,
> If't be not followed by an age of grossness!
> In painting Cimabue thought that he
> Should hold the field, now Giotto has the cry,
> So that the other's fame is growing dim.[16]

These words affirm that Giotto was a renowned artist and that he had already eclipsed Cimabue, his most famous predecessor.

He had also traveled. We learn from a document of 1313 that Giotto nominated an agent to recover from the house of Filippa di Rieti in Rome certain household goods he had left there. This is important, for it clearly demonstrates that Giotto had been in Rome sometime before 1313. Unfortunately no work by his hand survives intact in the city, although there is a heavily restored mosaic originally by him in the portico of St. Peter's, and several early writers claim that he painted frescoes inside the old basilica.[17] It is fascinating to speculate on what Giotto might have looked at in that ancient city or whom he might have met. Could he have seen and admired the work of Pietro Cavallini (whom we shall discuss in a later chapter), the rather progressive Roman who had executed a series of frescoes and mosaics during the last years of the Duecento? One wonders what he thought of the ancient art he saw about him. But while the document allows us to speculate, it does not permit us to state with certainty anything else but the few facts it contains—namely, that Giotto had visited Rome before 1313.

By the date of this document the artist had finished a number of his most important and well-known extant paintings. The Arena Chapel had been completed for several years, and the great Madonna was in place in the church of Ognissanti. The painter was probably in his mid-forties and far and away the most famous artist ever to work in Florence.

A document dated 1318 tells us something about Giotto's family. In that year he legally emancipated his son Francesco and gave some land to a daughter named Bice. All during his later life Giotto appears to have been involved in a number of business transactions dealing with property. His practice of buying or leasing land is interesting; it may be that he never really severed his ties with the rural countryside in which he was born and reared. Perhaps he was also anxious to insure

that his children retained some real property as well. Such documents seem to suggest that the artist was a practical and practiced business-man.[18]

The date of Giotto's entry into the Florentine painters' guild—the *Arte dei Medici e Speziali* (the painters were in this guild because they bought pigments ground by the druggists—*speziali*)—is unknown, but there is some evidence to suggest it took place before the third decade of the Trecento.[19] He was, in any case, one of the first painters admitted to this prestigious organization; it was a sign of the growing recognition of the position and power of artists that they were allowed to enter the major guild. We know nothing about Giotto's activities in the guild, but it would be surprising if a man with as much practical sense as the documents seem to suggest he had did not play an important role in its affairs.

Records mention Giotto renting or buying farms in the years 1321 and 1322. In 1325 he is once again documented as a guarantor for a loan, and in the same year he makes payment on some land at Colle di Vespignano; in the next he allows his daughter Chiara—she was one of eight children—to marry. It is pleasing to picture the middle-aged Giotto—he was in his fifties—as the comfortable father of a large and thriving family, but the legal records that give us these tiny insights into his life say nothing to confirm or deny this happy thought. We do know, however, that around this last date (1325) Giotto set to work on the Bardi and Peruzzi Chapels in the church of Santa Croce in Florence (Plate 35). These two fresco cycles, although not documented, appear surely to be among his last works. As we will see, they show no signs of a diminution of the power of the artist's thought or style.

From 1328 till 1334 a number of documents suggest that Giotto spent a good deal of time in Naples. Between 1328 and 1333 there are records of payments to the artist in that city. In 1330 King Robert of Naples styled the artist *familiaris et fidelis noster* (our faithful and familiar friend) and in 1332 he assigned him an annual pension. It seems apparent that Robert was the painter's patron in Naples, and there are records of work in the city by Giotto, but nothing remains today.[20] These Naples documents, however, have an importance beyond the few simple notices they contain, for by their very nature they tell us something about the artist's reputation. The fact that he was commissioned by a famous king—who could have undoubtedly employed any artist—gives us an indication of the renown his name must have acquired. That Robert knew Giotto well is clear from the words he uses to describe him (*familiaris et fidelis noster*); that he was pleased with the

work is evident from the pension he gave.[21] This is the first case, in Italy at least, where a royal patron and his artist seem to have known each other in any other than the most official way.

By 1334 Giotto was back in Florence, for in that year he was given a high honor: He was made *Capomaestro* (superintendent) of the works of the Commune of Florence and of Santa Reparata, the city's Cathedral. The document of April 12 that appoints him to this post is fascinating, and parts of it are well worth reproducing here.

The Lord Priors of the Arts and the Standardbearer of Justice, together with the commission of the Twelve Good Men, wishing that the public works which are being and ought to be executed in the city of Florence for the Commune of Florence should proceed honorably and decorously, inasmuch as they cannot be properly and perfectly performed unless some expert and famous man be placed at the head and put in charge of such works, and it is said that there is no one in the whole world more qualified in these and many other matters than Giotto di Bondone of Florence, painter, who should be welcomed as a great master in his native land and should be held dear in the said city; and so that he might have the wherewithal there to accomplish a long sojourn, from which sojourn many people will profit from his learning and instruction, and a noteworthy honor will result in the aforesaid city: a careful deliberation having first been held concerning these matters, and at length, among the Priors themselves and the Standardbearer and the said commission of the Twelve Good Men, according to the form of the Statutes, permission having been obtained and a division and secret vote with black and white beans having been held, by the authority and power of their office, and by every means and right at their command, they have provided, ordained, and established: That the Lord Priors of the Arts and the Standardbearer of Justice, together with the commission of the Twelve Good Men, be enabled and allowed in the name of the Commune of Florence to elect and appoint the said Master Giotto as master and director of the labor and the work of the Church of Santa Reparata, and of the construction and completion of the walls of the city of Florence, and of the fortification of the same city, and of other works of the said Commune. . . .[22]

At first it may seem surprising that Giotto was given the responsibility for the Cathedral, the city's walls, fortifications and other communal projects. There is, after all, no documentation that even suggests that Giotto was an architect. But in the Trecento not only architects planned buildings. There are, in fact, numerous instances when a man trained in another art is documented designing a building or supervising its construction. Arnolfo di Cambio, the first architect and *Capomaestro* of the new Florentine Cathedral, was a sculptor, and it was the con-

struction for that very church that Giotto was to oversee. So the act of giving a painter the title of *Capomaestro* is not unusual. What is strange, however, is the language in which the document is couched. The great praise of Giotto found in this legal record is surprising. We see that the Commune not only wished to honor the famous master by giving him an important position but that it felt that the presence of the artist would also honor the city as well. It is as though the text speaks of some great statesman or general, and all this in the most legalistic of documents! Never before in Florence had an artist been so described.

Giotto's tenure as *Capomaestro* was not to be long, and the question of exactly what he designed has never been fully answered. There seems to be little doubt that he was responsible for the plan of the campanile of the Duomo (Cathedral), which is, even today, known as Giotto's tower. Villani, the Florentine chronicler, states that its foundation dates from 1334—the year of Giotto's nomination as head of the works, and if this is true it was most likely he who supervised the initial building of the campanile.[23]

During the next year (1335) there is a notice of a legal action in which the artist was involved, and that is the last we hear of Giotto before his death in 1337. Giovanni Villani writes that he died after a trip to Milan and that he was buried with great honors in the cathedral of which he was *Capomaestro*, a great tribute, for it was rare for an artist to be buried in the Duomo, a location usually reserved for important prelates or famous military men.[24]

The documents which mention Giotto tell us relatively little about the man or his work. True, the few hundred words of the Naples and Duomo documents reveal that he was an artist with a considerable reputation, while the other Florentine records imply that he was not adverse to making money on non-artistic ventures. Documentation also suggests that he still had roots in the land. But these records say almost nothing about his personality or art. Throughout the fourteenth century there are many paintings that cannot be dated on the basis of documents, so it is common not to know when an artist painted or carved a particular work. But Giotto is an extreme case, for none of the records mention an extant work by him except, of course, the Duomo projects. The great and important paintings like the *Ognissanti Madonna* and the frescoes of the Arena, Bardi and Peruzzi Chapels remain undocumented. I do not think there is another major artist whose work is so poorly documented.

As we have seen from the records, for most of his life Giotto was

associated with Florence, even though he was born outside of its walls. The dank, narrow streets and sunlit *piazze* of that stony city were home to him. He was the foremost artist of a town that was near its intellectual, spiritual and fiscal peak. The conditions of any city influence those who live within it, so, before turning to Giotto's stylistic heritage, it may be well to say a few words about the Florence of his youth.[25]

After the dissolution of the Roman Empire, Europe withdrew into itself. Town life and the intellectual stimulus associated with it slackened. There was a marked decline in the number of artists and commissions. Painting and sculpture were of little importance for civic decoration. Much manuscript illumination was produced, but this was done mainly by monks attached to monasteries and churches.

About a hundred years before Giotto's birth Italy began to change; in Tuscany there was a new beginning of town life. Florence started to grow in population; before long it was necessary to enlarge its walls for the first time since the Romans built them centuries before. Commerce and banking flourished; contact both within and without Italy began to develop.

There were other Tuscan cities that began to awaken and prosper during the twelfth century; Pisa, Lucca and Siena were among the most important.[26] They, like Florence, formed complicated and efficient modes of governing themselves. They were independent nation-states, each controlled by its own sovereign government, each minting its own money and each fighting (all too often) its own wars. People began to flock into the city from the countryside; life took on a less rural, less hostile, more civilized character. These towns offered, for the first time in hundreds of years, the advantages of an urban culture. There was the security of living in a somewhat stable community that provided protection for its citizens and commerce (banking, trade and textile manufacture) that brought work and money. Florence, for example, soon became one of Europe's most prosperous centers.

Many of the most important cities developed individual identities that were reflected in the style of their trade, government, foreign policy and art. Men forged allegiances with their towns and viewed them in nationalistic terms. One of the most striking aspects of the rise of Tuscan cities is how individual and local they were and remain even today. Their citizens spoke in different accents, dressed in different fashions, conducted much of their business in a special manner and were, above all, highly individualistic in their art. Such localism is a key factor in the civilization of the Tuscan Duecento and Trecento.

The towns' new wealth made it possible to erect many buildings and to pay for their decoration. In fact, shortly before the first record of Giotto in Florence, the city had begun its greatest period of building.[27] The foundations for the vast fabrics of Santa Croce, the Duomo and the Palazzo della Signoria (the Town Hall) were all laid in the last decade of the Duecento. There were many men, some from old noble families and others who had just acquired wealth and status through commerce, who were now ready to pay for expensive works of art to ornament their community and to commemorate themselves. The expiation of the sin of usury also acted as a powerful spur. Money acquired through the sinful practice of usury weighed heavily on the consciousness of many bankers and merchants. Some consolation—and perhaps a better prospect of salvation—could be had by spending part of such monies on the erection and decoration of churches. This helped the wealthy city of Florence become one of the artistic treasure houses of Europe.[28]

A very significant event in the towns' spiritual and intellectual life was the rise of a religious order founded and inspired by St. Francis of Assisi (c. 1181–1226). But the great influence of the Franciscans did not occur in an intellectual vacuum. There were other important and influential orders, like the Dominicans, which paralleled and vied with the Franciscans, but none had such a profound influence on the religious life of the towns and on their art.[29] Giotto was to work for both orders.

While a young man Francis had experienced a fervent spiritual conversion. A vision, in which a painting of the crucified Christ bade him rebuild the church, inspired the saint to devote the rest of his life to the service of Christianity.[30] By his zealous adherence to the rule of absolute poverty, combined with the most simple and direct religious experience, he set an example that was to be imitated by an ever-growing number of followers, both religious and lay.[31]

But Francis' message was filled with tension, for it asked the true Christian to shun worldly things and to spend his life in the service of Christ. This meant giving up both wealth and family, the two most valued possessions of Francis' contemporaries. In spite of the sacrifices involved in following the saint's tenets, the order soon found itself gathering many novices and even more lay followers. Because of its most accessible principles of humanity, humility and simplicity, it quickly assumed an enormous popularity. After the saint's death in 1226 great Franciscan churches were quickly built and lavishly decorated, an occurrence the simple Francis had wished to prevent. His teachings of kindness to all and respect for the most humble of things

was a civilizing doctrine that helped men to live with one another. It tended to direct the individual ego away from isolation and toward a more collective behavior needed for life in urban centers. It taught men to appreciate the beauty of this world, while preparing for the next, and it tended to make religious experience more personal, less doctrinal. Surely it is one of the guiding spirits behind an image such as the *Ognissanti Madonna* (Plate 1).

The teachings of Francis had an impact on all of Florence and its arts. The change in painting from an iconic, hierarchical, isolated treatment of religious drama toward a more accessible, humane representation of the sacred stories and images must have been aided by both the Franciscans and the life of the new urban centers where men had to live together with at least a semblance of humanity, order and harmony. The change in imagery wrought—in part—by these spiritual and social events can be observed by comparing the removed, iconic *Crucifix* (Plate 6) by Coppo di Marcovaldo (c. 1260) with Giotto's much more human, humane and immediate *Crucifix* in Santa Maria Novella, Florence, of c. 1290 (Plate 13). It is as though the profound human aspect of Francis' teaching was first fully realized by Giotto only about seventy years after the saint's death.

Both of these crucifixes were made for churches, and it was the new urban church that provided much patronage for the artist. Since the church was the original home for all the paintings discussed in this book, it is necessary to discuss briefly some of its decorations, their use and meaning.

For the most part the city churches of the late Duecento and the early Trecento were stony and dark, with narrow lancet windows often glazed with stained glass providing the only illumination. Several types of art were to be found in the churches. There were, of course, tombs, some of which were large and elaborate. These tombs, the free-standing figures of Madonnas and the carved pulpits were the work of the sculptors.[32] The painted decoration consisted of frescoes and panels. In many churches the wide, uninterrupted expanse of the walls was covered with frescoes representing the lives of the saints and Christ and the Virgin. Fresco decoration was also found in the private chapels. Here the iconography of the paintings might have some specific reference to the donor; perhaps a painted life of St. John would be commissioned by someone named Giovanni, or a cycle devoted to St. Anthony would be paid for by a patron who had a special veneration for that saint.

There were also several types of wooden painted panels, and

representatives of each category would usually be found in most churches.[33] The central painting was the main altarpiece. This was placed at the end of the church above the high altar. It was the largest and most important picture in the church, for it stood above the most sacred spot. In Tuscany these were often Maestàs (the Madonna surrounded by prophets or saints and angels) or Madonnas with Children and Angels. The Santa Trinita altarpiece by Cimabue (Plate 2) is a good example of the first type, while Giotto's *San Giorgio Madonna* (Plate 17) is characteristic of the latter. Those done for the major churches in the late Duecento were enormous, and their huge, looming shapes must have been always associated with the high altars.

Above these usually was painted a crucifix (as distinct from the carved wooden crucifixes that stood on altars), such as the two by Coppo and Giotto just mentioned (Plates 6 and 13). Often such a crucifix was suspended from the vaults or ceiling above the high altar or from the choir screen. This accounts for the large size of many of these which date from the thirteenth or early fourteenth centuries; it was necessary for the onlooker to make out the subject from far below. It appears that the cross antedates the high altarpiece of the Madonna and Child with Angels or *Maestà* type, for there are early examples of the crucifix that date back to the twelfth century.[34] The crucifix suspended above the worshipers' heads was a key image. Its presence reminded the faithful, in graphic terms, of Christ's sacrifice, of His central role in the entire Christian drama.

Smaller panels of varied imagery were placed in the private chapels. They might depict Christ or the Virgin in half-length surrounded by other half-length saints, or a saint flanked by scenes from his life and legend, such as the thirteenth-century St. Francis panel in Santa Croce (Plate 5). There are numerous examples of both these types.

It is important to realize that throughout much of the period with which we are concerned people regarded these images differently than we do today and that they saw in them something more than the simple depiction of the holy figures. In their minds these panels contained images that somehow partook of the sacred and mysterious qualities of the figures they portrayed. Thus, the huge suspended Christ on the cross was an awesome object that embodied some of the supernatural power which Christ Himself had demonstrated. They were icons to be worshiped and, I suspect, feared. It was believed that on occasion they had the power to come to life. St. Francis himself had seen a crucifix (of the type we have described) talk, and his is only one of a number of such occurrences.[35]

One of Giotto's greatest accomplishments, as we have observed in the first room of the Uffizi, was the modification of this rapport between object and worshiper. We shall see that he decisively broke the bounds of this highly iconic art and turned Italian and European painting toward a more human, accessible treatment of religious images. He was the first artist to make paintings something more than icons. It seems to be no accident that much of Giotto's work was done for Franciscan churches.

Of course Giotto was a man of his era. Like every great artist his career must be seen against the background of his age even if, at times, his work soars above it. There can be little doubt that the newly invigorated life of Florence and the intellectual and spiritual stimulation of Franciscan thought had a subtle but strong influence on him. However, another equally strong pull on the young Giotto came from the art that surrounded his youth. To comprehend how really monumental was the change his painting made we must first see what this stylistic world was like.

II

Giotto's Heritage

Cimabue's *Santa Trinita Madonna* (Plate 2) stands at the end of a development that began several hundred years earlier when Tuscany started to emerge from the stylistic depression into which it had fallen after the decline of its Roman civilization and style. Soon there were small but flourishing new schools of local painting in the urban centers of Lucca, Pisa, Pistoia and Siena.[1] The names of recorded artists and the number of their paintings increased. In Florence, however, there is almost nothing until the Duecento, and even those pictures painted in the city before the middle of the thirteenth century are rather provincial when compared with the work of Pisa or Lucca, the first two most progressive artistic locations. The Florentine works seem hesitatingly to imitate both of these centers, though they already contain the seeds of the direct, monumental style that will characterize the city's art for the rest of its history.

During the second half of the Duecento, art in Florence began to bloom. The most important of the many mosaics of the Baptistry (which were begun about 1230 and not finished for almost a hundred years) date around the middle of the century or slightly later.[2] The great mosaic *Christ in Judgment* from the ceiling is a good example of this impressive Florentine work (Plate 4). The huge, starkly frontal figure (several times life size) sits on a multicolored rainbow, while his outstretched arms alternately bless and damn the tiny figures to his side. The isolated, iconic Christ well fulfills his role as the supreme judge of humanity. In its scale and slow, grave movements this is a stunning image.

The composition of the figure is simple and abstract. All the basic parts of the body, the robes and the hair are rendered in a magnificent shorthand. Things are both representation—drapery folds, shadows, hair, hems—and decorative patterns with a life and force of their own. The

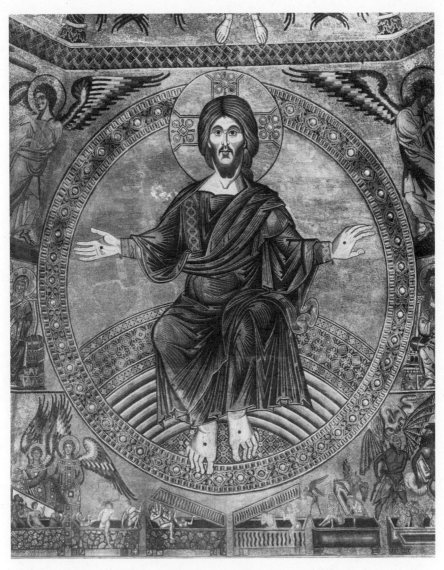

Plate 4. Florentine, thirteenth century: *Christ in Judgment*.
Florence, Baptistry

drapery folds that swirl over the left knee, for example, are so abstracted that they can be read either as cloth or as highly pleasing, exciting decorative patterns. Such subtle tension between representation and decoration will be an essential element of Florentine painting for the rest of the century.

The roots of this art are still not fully clear. During the thirteenth century the Byzantine style, which originated in Constantinople after the establishment of the Eastern Empire, influenced a number of Italian artists. It seems that in the examples of Byzantine painting and manuscript illumination (many of which were imported through the maritime republics of Italy) artists found a style that could help them attain certain pictorial goals toward which they were then striving.[3] Byzantine art preserved, in a most graceful and elegant manner, some of the old illusionistic (or realistic) concepts that were common to the art of Greece and Rome. It was thus quite different from the much cruder and even more abstract art of pre-thirteenth-century Italy onto which it was grafted to form a hybrid style, often called Italo-Byzantine. Although we cannot state with certitude exactly why Italian artists borrowed from the Byzantine objects, it does not seem impossible that they wished to forge a figurative style that more closely corresponded to their human visual experience. If this was indeed the case, then such a motivation must be seen as the earliest step toward something that would find its eventual fruition in Giotto.

Close in time to the Baptistry Christ mosaic, an anonymous Florentine artist painted—for the church of Santa Croce—a picture representing St. Francis standing, flanked by scenes from his life (Plate 5). This is a very early and moving image of Francis, painted only about thirty years after his death. The shape of the altarpiece seems to be taken from a Byzantine model, but its formal qualities are certainly Florentine and Tuscan.[4] Behind the frontal saint is a gold ground bordered by a decorative strip. The gold between the figure and the border plays a very significant role, for Francis' body molds it into a shape that, like the patterns of the robe or hair, acts as a decorative element imposing its rhythm on our eyes. This love of such pure abstracted form, always present in the work of the talented painters of the Duecento, is also seen in the Baptistry Christ.

The scenes from the saint's life—placed at the sides—are set down in a measured, straightforward fashion characteristic of mid-Duecento Florence. Their particular fineness is partially due to the tempera medium employed by the artist. This method uses egg for the vehicle in which the pigment is suspended and then applied to the hard plaster-

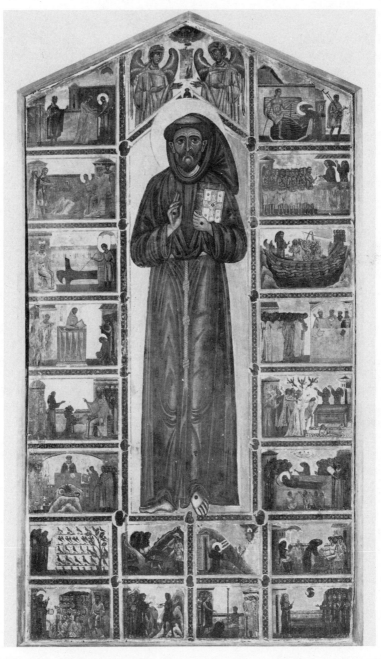

Plate 5. Florentine, thirteenth century: *St. Francis and Scenes from His Legend*. Florence, Santa Croce, Bardi Chapel

like coating of the wood panel called gesso. When the egg dries, it fixes
the pigment to the gesso in a hard, enduring bond. The tempera method
was almost universally used for the painting of altarpieces in Tuscany,
from the earliest known examples well into the fifteenth century. This
method is a tedious one that demands the use of a small brush and a
great deal of time and patience. Its very slowness must have caused the
artist continually to examine his picture and to consider the qualities
inherent in it.[5]

The tiny, animated figures in the scenes around Francis are often
set against a backdrop of pink stage architecture. The cities in which
the actors move or the countryside before which they stand are as
marvelously abstracted as the figures themselves. The swirling blue
brush strokes that form a hill or the smooth pink surface of a wall are
formally exciting and fantastic. The basic compositional rhythms of
the narration are those of Florentine painting up to the time. The
Santa Croce St. Francis and the Christ of the Baptistry are alike in their
frontality, directness and in their stern, powerful images, attributes
that are characteristically Florentine.

Coppo di Marcovaldo, who seems to have been slightly younger
than the master of the St. Francis panel, is one of the most important
figures in the history of Florentine art, for he is the first artist of the
city to be known by name.[6]

His moving *Crucifix* (Plate 6) in the Pinacoteca Civica in San
Gimignano, which may have been done while he was a prisoner of war
in Siena (c. 1260), is a key work of early Florentine art and a painting
of enormous power and pathos. The great Christ is the stylistic brother
of the Florentine mosaic (Plate 4).[7] His entire body is developed not
into space but across it. The sinuous, sensitive line of the body moving
from the chest, down the torso, across the bulging hip and down once
more toward the legs is a *tour de force* of controlled power. Christ's
form echoes the cross while, at the same time, playing a gentle variation
on it. The arms are outstretched along the crossbar, but they dip slightly
from the hand down to the elbow and then rise up again to meet the
shoulder. The head rests on the chest, not quite aligning itself with
the vertical extension of the cross above it. The body sways gently,
masking the cross, except for the area next to the left hip and below
the knees. This subtle opposition of the cross to the body, of the rig-
idity of geometric shape contrasted to but also echoed by the organic
form of the dead Christ, is one of the most powerful aspects of the
work. The iconic, decorative but pathetic body involved in a contra-

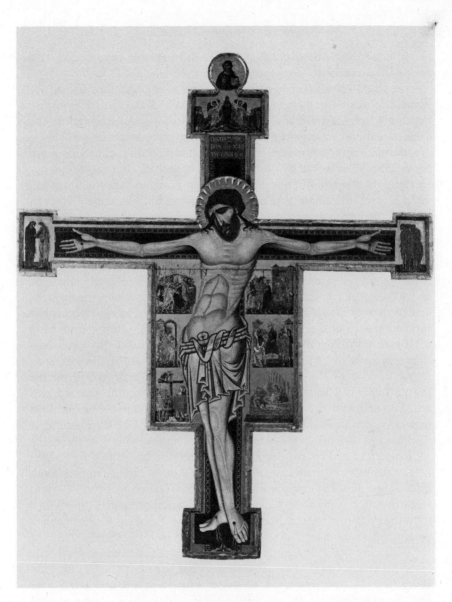

Plate 6. Coppo di Marcovaldo: *Crucifix*. San Gimignano, Pinacoteca Civica

puntal design with the rigid horizontals and verticals of the cross is a very impressive visual concept.

The highly schematic construction of anatomy and drapery so noticeable in both the Santa Croce St. Francis and the Christ from the Baptistry has been somewhat modified. Although still stylized, the chest and abdomen have begun, ever so slightly, to look realistic. Their modeling is more naturalistic, the underlying structure of muscle more convincing than anything done before. The old concept of highly formal depiction of the body and drapery remains basically in force, yet one sees the artist skillfully utilizing the formal conventions to make Christ more human, to invest him with some of the life he once had. A pathetic human dimension is added by the black-brown, pain-filled flowing eyes and the spiky, threatening halo.

The apron (the area containing the small scenes of Christ's Passion) is traditional for crosses of this type.[8] Its six stories are lively, animated and wonderfully colored. Bright blues and pinks are seen throughout, and there is a pleasing dispersal of light-colored hues over the entire surface of each of the small narratives. The vigorous, clear-cut gestures of the tiny protagonists and the beautiful interval with which the figures are spaced form a narrative quickly understood by the spectator.

At the top of the *Crucifix*, the *Ascension of Christ* completes the great scheme of Christ's Passion, Crucifixion and Death in one work of art. The concepts are simple, the narration clear. But the single most impressive feature remains the towering figure of Christ, whose spiritual force overwhelms the entire iconographic machinery of the cross.

Bencivieni di Pepo, called Cimabue, was one of Coppo's worthiest heirs. Like most Florentine artists of the time, very little is known about him; only a few facts concerning his life have come to light. A document proves that he must have been in Rome by at least 1272. This is significant, for it places him near several interesting Roman artists (including Pietro Cavallini) at an early stage in his career.[9]

Whatever the influence Rome had on Cimabue—and we can only assume that such a sensitive painter could not have left the city without being in some way impressed by its art, either ancient or modern—his first known work is an innovative masterpiece. This is the mighty *Crucifix* that hangs like an enormous jewel above the high altar of the church of San Domenico in the town of Arezzo, not far from Florence (Plate 7). Stylistic evidence suggests a dating around 1275, or just about fifteen years after the cross by Coppo in San Gimignano.

There are many differences between the two crucifixes. The most striking is the elimination of the apron scenes, which are now replaced

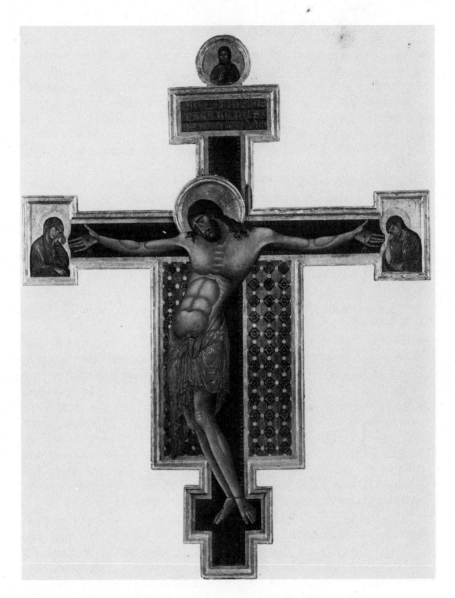

Plate 7. Cimabue: *Crucifix*. Arezzo, San Domenico

by a beautifully patterned red field. It appears that this suppression of the small-scale narrative was a compositional necessity, for the slow, controlled movement of Coppo's Christ has given way to a faster tempo; now the body curves far out to the left, almost to the edge of the painted field. The S-shaped undulation of the entire figure has increased, as has the decorative rhythm throughout the wider fabric of the work. But if the tendency to decorate has been strengthened, so has the ability to represent Christ more as an heroic human being who has suffered on the cross. The painful twisting of the hips is now more evident, the straining of the chest and neck starkly clear. The body has been made more realistic by subtle patterns of highlight and shadow that play across it; undulating surfaces resemble flesh much more than did the same areas in the Coppo cross. The entire body has been monumentalized. The face appears wider, the neck thicker, the chest broader, the torso more powerful. There is a majesty in the figure only seldom equaled in Duecento painting.

The treatment of the loincloth of Coppo's Christ is simple. There are a few wide, clearly defined, abstracted creases, most obviously seen in the hem folds at the bottom of the garment, which appear as a series of bold zigzags. In Cimabue's painting the loincloth has been changed. Fine gold striations have replaced the bold dark lines, and the outline of the folds has been softened and refined. The gold lines, although highly pleasing as patterns, have begun to take on the effects of highlight on cloth. Cimabue brings this almost magical state between pattern and image to a very high tension in this crucifix; he achieves a delicate balance between two ways of seeing. One is an abstracted, highly iconic notion of style that presents formal but distant images. The other is more realistic, compassionate and ultimately more human, the portrayal of things as they appear to the eye.

The standing terminal figures (in the panels at the end of the crossbar) of Coppo's crucifix have given way to two bust-length portrayals of Mary and St. John. These are not in the scale with Christ and are meant to be symbolic of his two principal mourners. Each looks inward, directing attention toward Christ, their ritualized gestures complementing the pathos on their faces. Over Christ's head the *Ascension* has been replaced by the inscription proclaiming Christ King of the Jews, and above this is a roundel of the Blessing Christ, the sole remnant of the once traditional *Ascension*. The entire mechanism of Cimabue's cross is less complicated and more direct than Coppo's. By taking away the apron scenes, the Marys and the *Ascension*, attention has been sharply focused on Christ, who seems more isolated than before and,

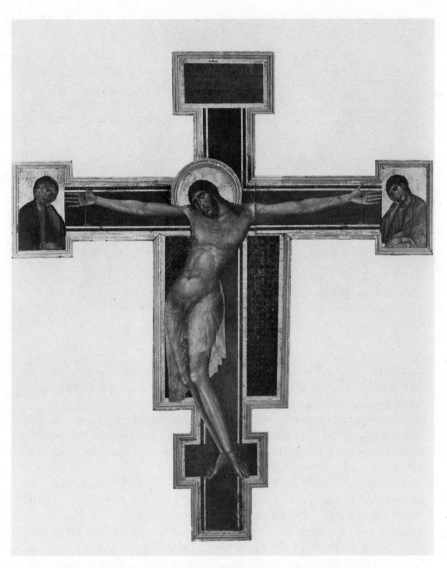

Plate 8. Cimabue: *Crucifix*. Florence, formerly Santa Croce

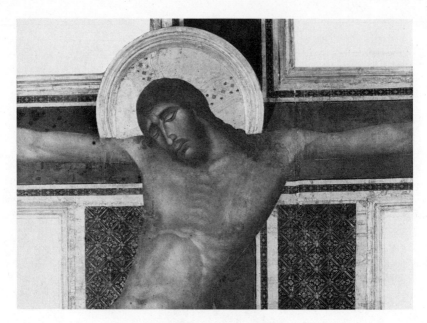

Plate 9. Cimabue. Detail of Plate 8

therefore, more pathetic. Now we look upon him as a lonely, majestic figure rather than as the symbolic center of a complicated iconographic structure.

Cimabue is last documented in 1301, but before that year he certainly completed (c. 1285) his acknowledged masterpiece—the gigantic *Crucifix* (destroyed in the flood waters of 1966) for the Franciscan church of Santa Croce in Florence (Plate 8).

Superficially the two Cimabue crosses look very much alike; the swaying of the body in the Santa Croce painting is perhaps slightly more exaggerated, the figure a bit more elongated. But the subtle, graceful play between the organic figure of Christ and the rigid horizontals and verticals of the Santa Croce cross has never been matched. If one isolates almost any area and studies it from a formal viewpoint, this is apparent. The relation of the head and torso to the cross is a good case in point (Plate 9).

However, what is most surprising about the Santa Croce *Crucifix* is not its overall form but its relative sophistication in the depiction of the human body. There can be no doubt that the great wasplike body of Christ is very close in its general shape to the Arezzo figure, but the basic parts of the figure have undergone considerable change.

The delicate balance between pattern and representation has begun to shift toward the latter.

Now no one would claim that in the Santa Croce *Crucifix* we find a real, convincing portrayal of anatomy. Yet we sense the great strain undergone by the crucified body and thus feel a kinship with the figure. Skin begins to appear more like flesh; we begin to see the traces of the skeletal structure that it covers. When this body is compared with that of Coppo's cross done only about forty years earlier, it is apparent that a rapid and significant change had come over Florentine painting.

One of the most striking features of Cimabue's visual observation in the Santa Croce painting is the loincloth. We saw that in Arezzo he began to break away from Coppo's highly formal, abstracted treatment of material. Here he has gone even further, for we feel not only the texture of the cloth but we see through it. Cimabue has been able remarkably to portray diaphanous layers of material one above the other —something for which even the Arezzo cross has not prepared us.

For all these reasons the Santa Croce painting is an important landmark in the history of Western art. It stands at the threshold of (but does not enter) a new conceptual and stylistic age, for by changing the balance from a more symbolic to a more realistic idiom it paved the way for the almost total abandonment of the abstracted shorthand that had been a characteristic feature of Florentine painting. It is by no means a totally realistic work; it remains still very much within the framework of its age but is a herald of things to come. It must have been well known to the young Giotto.

Cimabue's *Maestà* (now in the Uffizi) is first recorded in the church of Santa Trinita in Florence (Plate 2). Its date is uncertain, but it most probably comes from the early 1280s and thus is slightly later than the artist's Arezzo *Crucifix*. The height of the painting is over twelve feet, and the Madonna is almost life size.

The Virgin sits on an elaborate, complicated throne whose base has three openings occupied by prophets. Two of these look upward, directing attention to the central figures of Mother and Child, who are framed by a gently articulated choir of angels standing in indeterminate space on either side of the throne. These elongated, subtle figures mirroring each other across the painting act not only as beautiful parentheses to the central figures but also give the picture a balanced symmetry; in fact, symmetry and equilibrium are the hallmarks of this panel.

That the *Santa Trinita Maestà* is from roughly the same point in

Cimabue's career as the San Domenico cross is indicated by its figures and drapery, which are not yet quite as developed as in the Santa Croce *Crucifix*. The problems posed by the *Maestà* format were quite different from those involved in painting the image of the dead Christ. It was necessary to construct a narrative in which many figures interacted. This was directed toward presenting a central theme, the Madonna and Child enthroned. A balance had to be achieved by which no part of the painting could rival the key image in importance. This Cimabue has brilliantly done. It was also necessary for the artist to come to grips with the problem of space. In the representation of the crucified Christ the conception of depth played almost no part. The figure was attached to a flat surface, so the real visual thrust was not back into space but from side to side. In the *Maestà* some backward movement had to be represented, for the Madonna was to be placed on a throne which, by its very nature, had to occupy space. Cimabue has set the throne in a frontal position. Although the sides of the ponderous structure come tentatively forward, the central niche below the Virgin's feet moves back a little. The Madonna overlaps the back of the throne, so a movement into depth is implied. But, on the whole, this is quite a flat picture, with little inward spatial development. There is no underpinning of spatial structure that fixes the elements in a determinable relationship to each other; the unity of the panel arises mainly from the sheer force of its beautifully placed and articulated figures. The *Santa Trinita Maestà* is very much in the tradition of earlier Florentine painting, even though it embodies interesting, if not wholly achieved, tentative spatial experiments.[10]

An interesting comparison with Cimabue's panel is found in another painting, which comes originally from Santa Maria Novella, the major Dominican church of Florence (Plate 3). This work is, as we have seen, by the Sienese artist Duccio di Buoninsegna. Although not firmly dated, there is good documentary reason to believe that it was commissioned in 1285 and is, therefore, a close contemporary of Cimabue's *Santa Trinita Madonna*.

Duccio, the foremost Sienese painter of the early Trecento, was one of the most important artists that Tuscan city ever produced. His career extended from the seventies of the Duecento to the second decade of the Trecento; he, like Cimabue, was of the generation just before Giotto.[11] The *Santa Maria Novella Madonna* (or *Rucellai Madonna*, as it is called, after the chapel in which it once stood) is, along with his *Maestà* from Siena Cathedral, one of Duccio's masterpieces.

A testimony to the esteem in which Duccio must have been held

in Florence was shown by commissioning him for one of the city's major altarpieces. Why the Florentines should have given this important painting to a rather young foreigner is not quite clear. Perhaps Duccio had already painted a work they admired, or maybe he was considered one of the most promising artists of the day. In any case, it is an early example of the artistic cross-currents that were to play so major a role in the developing schools of Siena and Florence. It is also extremely interesting to note that one of Duccio's closest followers, Ugolino da Siena, seems to have been given the commission for the high altarpiece of Santa Croce. This work, of about 1315, surely one of the most significant in Trecento Florence, was done at a time when Giotto was in much favor.[12] If Vasari is to be believed, Ugolino also did the high altarpiece for Santa Maria Novella, a painting that would have been placed very close to Duccio's *Rucellai Madonna*.[13] The presence of Sienese painters was not uncommon in Florence, and by the 1320s several of them were registered in the Florentine *Arte dei Medici e Speziali*.[14] The influence these artists had on the Florentine scene will be discussed later, but for the present let us observe, through Duccio, what the work of one of them was like.

Duccio's *Madonna*, like Cimabue's, is a huge gabled painting, a type quite popular in the late Duecento.[15] Just a glance at the work shows fundamental differences between it and Cimabue's panel. Duccio's is a simplified composition. The complicated substructure of the throne has been done away with, the number of angels reduced to six. These, like Cimabue's, are mirror images of their opposite numbers, but they kneel rather than stand while touching, or perhaps supporting, the throne. The spatial position of the two lowest angels is clear; they kneel on the ground. Not quite so certain is the placement of the upper figures. They, too, seem to kneel, but on what? Maybe they are meant to be floating in space, hovering near the throne as they touch it. Or are they supposed to be carrying the Virgin and Child upward? One can be sure only of the beautiful elongation and grace of these handsome figures.

The throne is placed at an angle to the picture plane. This is very different from Cimabue's picture, where the major orientation was planar rather than back into space. The increased simplicity of Duccio's composition and its spatial sophistication make it more easily comprehensible.

The *Rucellai Madonna* is a highly refined work of art. In its basic design and in the articulation of its decorative surface it is a delight to the careful eye; seldom has a painting matched its meticulous control.

Observe, for example, the line of the decorated border of the Madonna's robe as it gradually wends its way across the surface of the panel. It moves slowly, undulating, twisting and turning, forming one beautiful melodic decorative pattern after another. The robe's hem is a cascade of this controlled, pleasing motif. The Madonna herself has a calm, serene face with the still rather geometric features of almond eyes and long, thin nose. The monumentality of Cimabue and the entire Florentine school is replaced by the delicacy and warmth of the exquisite Sienese Madonna by Duccio.

The two works are very different in color. Cimabue's panel is a good example of the Florentine palette of the late Duecento. Warm, saturated earth colors predominate. Reds, browns, deep blues and other subdued colors play against the gold background. Generally speaking, the artist relies on basic shapes to define his forms; color is not given as important a role as in Duccio's work, where hue plays a major part in the creation of form. In Duccio's painting the palette is much lighter. Light purples, violets, blues and pinks are rendered with a delicacy and transparency unlike anything produced in Florence. The eye delights in the rare beauty of these colors.

The specific differences between the two panels represent, in many ways, the different tastes of the two cities. The monumental, highly formal quality of Cimabue's painting is really foreign to Duccio in particular and Siena in general. The Sienese painters' work was, in a sense, more concerned with the refined, elegant portrayal of religious narrative than with its stern, dogmatic message. It is often fantastic, regal, sumptuous. The light of heavenly spirit found its most perfectly wrought reflection in Siena, while the image of religious action and drama was best portrayed in Florence.

But painting was not the only art making rapid, confident strides toward a new style. Similar developments were occurring in sculpture. These, like the advances in painting, must have been admired and studied by the young Giotto.[16]

The first exciting event in Tuscan Duecento sculpture took place in 1260. In that year Nicola Pisano signed and dated his carved marble pulpit in the Baptistry at Pisa. Little is known about the sculptor, although in 1266 he is described as Nicola d'Apulia, and he may have his stylistic origins in that southern Italian region that experienced a short-lived renascence under Frederick II.[17] No work by Nicola is known before the Pisa pulpit, so it is with surprise that we first view its beautiful scenes, which are almost totally unlike the highly schematized, rather dry sculpture produced by earlier Tuscan artists.

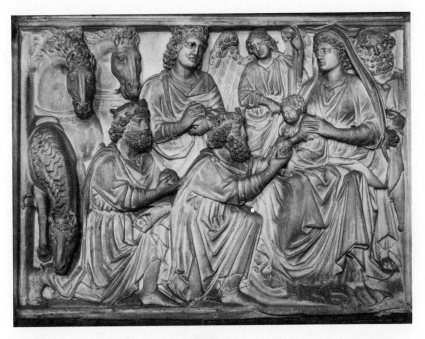

Plate 10. Nicola Pisano: *The Adoration of the Magi*. Pisa, Baptistry

In the *The Adoration of the Magi* (Plate 10) we are at once impressed by the balance and clarity of presentation. The sacred drama takes place with a solemn, almost ritual grace. To the right sits the majestic Madonna receiving, like some great queen, the two magi who kneel at her feet. Behind these figures is the third magus. An angel stands to the left of St. Joseph; at the far left wait three very powerful horses. Everything non-essential has been eliminated, and only a small piece of architectural cornice above the Virgin's head reminds one of the fact that the Adoration took place before a stable.

Each figure is conceived with a directness and simplicity that seems astounding for the mid-Duecento. The weight of the bodies, their decisive gestures and glances direct the spectator's attention toward the heart of the drama—the Child receiving the gifts. The rhythm of the outstretched arms in the first row of figures sends waves of form across the surface of the marble relief.

There are, of course, some ties with contemporary sculpture and painting. The basic geometry of the folds of the robes and the highly stylized hair have parallels in thirteenth-century painting; one has only to remember the Baptistry Christ (Plate 4) or the Santa Croce St. Francis (Plate 5). But the basic structural bones of the visual concep-

tion, the depth of the figures and their placement in space are strikingly innovative. We know that Nicola was interested in the antique sculpture that was found in Pisa during his time, for he incorporated copies of several Roman figures in his Pulpit.[18] He seems to have found this ancient sculpture an aid to the development of an increasingly realistic, monumental and balanced art, much as the painters sought out some of the same goals in the Byzantine style. But it appears that Nicola's art was ahead of its time, for it seems not to have had much immediate influence on painters or sculptors, and the artist had no faithful stylistic followers. He did, however, train two of the most important sculptors of the following generation—his son Giovanni and Arnolfo di Cambio, both of whom are documented working in his shop.[19] But the style of the Pisa Pulpit would have no worthy rival until the works of the young Giotto.

Arnolfo di Cambio, one of Nicola's best pupils and the architect of important Florentine buildings during the last years of the Duecento, is first heard of in 1265 working with his master on Nicola's second pulpit carried out for the Cathedral of Siena. He is documented in connection with several other works, but his single most important sculptural commission seems to have been the decoration of the façade of the new Cathedral of Florence begun around 1296.[20] Arnolfo was, as we have seen, *Capomaestro* of that building, the same position later held by Giotto.

Not all of Arnolfo's statues for the façade survive, but those that do show his consummate skill. The majestic marble *Virgin and Child* which dates from the late 1290s is impressive indeed (Plate 11). The powerful body of the mother is clearly defined beneath the simple robes; her shoulders, knees and legs are all evident under the heavy material that covers them. Much the same is true of the Child, who turns slightly in space as he bestows his blessing. The movement of the bodies is echoed by the beautiful drapery folds conceived in an almost prismatic fashion. Their measured and controlled articulation enlivens the surface, making it move.

Although this Madonna is as stylistically progressive as anything produced in Florence up to its time, it is still very much a creation of the late Duecento. With its great white glass eyes and its staring face it looks past the observer, out into space. Its large frontal body and the formal articulation of its drapery are really very much in the same mood as the Madonna from Cimabue's Santa Trinita panel. Both are of the type characteristic of late-thirteenth-century Florence, and both underline the Virgin's role as the rather distant, splendid Queen of

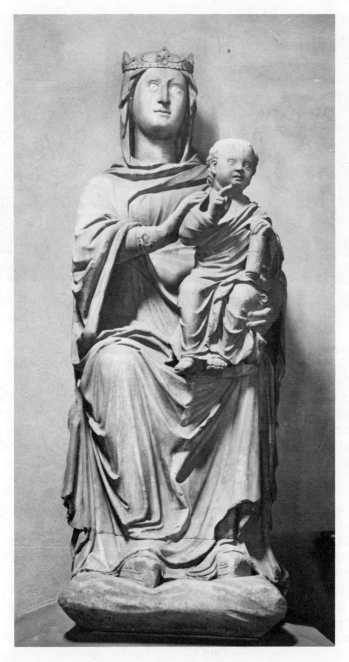

Plate 11. Arnolfo di Cambio: *Virgin and Child*. Florence, Museo
dell'Opera del Duomo

Plate 12. Giovanni Pisano: *Madonna and Child with Two Angels*.
Padua, Arena Chapel

Heaven. Arnolfo's statue must have made a strong impression on those who passed beneath it on their way into the enormous cathedral.

Giovanni Pisano (c. 1250–c. 1314), Nicola's other noteworthy pupil, is first heard of in 1265 working with his father and Arnolfo di Cambio on the Siena Pulpit. Giovanni seems to have emerged as an independent master by the 1280s, and in 1287 he is listed as *Capomaestro* of Siena Cathedral. He was the author of a vigorous and powerfully movemented group of free-standing life-size figures for the façade of the Siena Duomo and of carved marble pulpits for Sant'Andrea in Pistoia (finished 1301) and for the Cathedral of Pisa (1302–1310). One of his very beautiful Madonnas (along with two angels) was commissioned for the Arena Chapel, the site of Giotto's major work in fresco (Plate 12).

Giovanni's style is quite different from his father's and Arnolfo di Cambio's. His figures are not calm, grave and monumental but, instead, are marked by an attenuated angularity that imparts a sense of high drama and urgency. Giovanni's narratives teem with an animation and tension unique to his works. Unlike Nicola (active 1258–1278) or Arnolfo (died 1302?), Giovanni was an active contemporary of Giotto for a number of years. It is difficult to discern any influence that he may have exerted on Giotto, but the dramatic fervor of his narratives could have been in Giotto's memory when he painted the

Arena Chapel (Plates 23 and 24), where his scenes, like Giovanni's, are filled with an unwavering seriousness.

When Giotto began to work, a great body of painting and sculpture —much of it by important artists—lay behind him as a precious artistic heritage. He fell heir to an art that was slowly changing from abstraction to illusionism, a movement that was gradually gaining ground during the late Duecento, a period when a number of talented and productive artists were at work. These factors set the stage on which the young Giotto was to become the principal actor.

III

First Works

High up on the entrance wall of the sacristy of the Dominican church of Santa Maria Novella in Florence is a large and very beautiful *Crucifix* by Giotto,[1] one of the artist's first known works—c. 1290–c. 1300 (Plate 13).[2] A comparison of it with Cimabue's Santa Croce *Crucifix* (Plate 8) reveals the former's importance for the history of Florentine art.

The basic conception of the two Christ figures is strikingly different. Cimabue's, although more naturalistic than anything produced up to the time, seems symbolic when compared with the stark realism of Giotto's, where the vestiges of the old abstraction have been done away with and the spectator is confronted with the awesome image of a dead, greenish Christ hanging from a cross. No longer does the figure share the majestic iconic conception of even the last of Cimabue's Christs. The remote, heroic Son of God has been replaced by a very human image of a dead man divested of all the old associations of hierarchical grandeur which date back to the very beginning of Florentine art (Plate 14). Here is the first fully realistic portrayal of Christ in the history of Western painting.

There are, of course, profound religious differences between these two images of Christ. Although the figure is certainly dead in Cimabue's painting, his body exhibits a grace and rhythm—achieved through an abstraction of forms—that imparts a majesty to the shape. Christ is superhuman, a powerful being who will, without doubt, soon be resurrected. In Giotto's *Crucifix* there is a realistic rendering of the human body. The broad S-shaped curve is gone, and the body of Christ now moves not across the picture plane but back into space. There are clear levels of depth: The head hangs forward slumped on the chest, the torso recedes, the hips bump against the cross, the knees bend toward the observer. In Cimabue's painting we see the action but

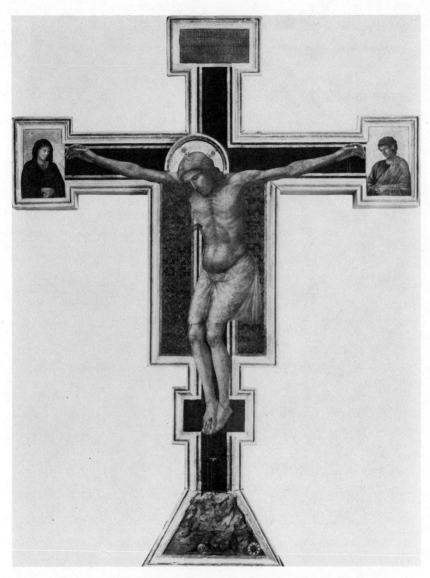

Plate 13. Giotto: *Crucifix*. Florence, Santa Maria Novella

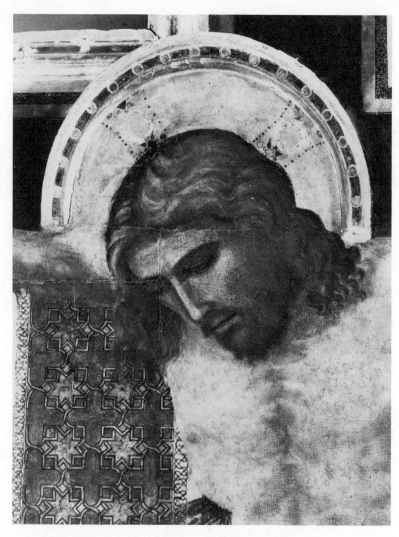

Plate 14. Giotto: Detail of Plate 13

do not empathize with it. In Giotto's *Crucifix* the evidence of the suffering inflicted by the crucifixion is painfully clear, for here the figure really hangs from the cross rather than being placed on it. The taut, outstretched arms connected to the straining shoulders are frighteningly real when compared to the beautiful, almost decorative, nonfunctional arms of the Santa Croce Christ. The whole body of Giotto's Christ seems to be sagging downward, brought earthward by its sheer weight and physical presence. We are no longer so certain of easy resurrection.

The use of light and shade to shape highlights and shadow has also undergone a drastic change. No longer is the broad, almost decorative use of highlighting seen. The modulation of light and dark over the surface is much more gradual, more naturalistic. Areas are fleshed out and made to appear real through a delicate, totally understood use of light. A good example of the difference between the two works may be seen by comparing the use of light on the chest and legs. This change from a more abstracted, decorative use of light to a manner that corresponds closely to what we see around us implies vastly different ways of visualizing and recording the world.

At first glance the limited palette of the Santa Maria Novella cross is not striking. This impression is sustained after more careful investigation, but the onlooker soon begins to see that with a restricted combination of subdued hues Giotto has created a work of coloristic restraint and taste. The delicate green of Christ's body, the strange red-orange of his fine hair, the beautiful red-black pattern of the apron and the mat black of the cross first come to our attention. There are, however, other equally satisfying combinations, such as the pink mantle and blue shirt of St. John (who also has red hair) in the right terminal or, in the other terminal, the deep blue of Mary's mantle and the touch of red in the material around her throat. One has only to study the way in which the transparent loincloth gradually changes from white to pink as it falls in front of the red of the apron to realize that even in this early work Giotto reveals a high degree of sensitivity to colors and their combination.

Who taught Giotto to paint like this? Unfortunately no documents identify his master, and since the artist's early style betrays little influence from any known painter, it is of little help in determining who his teacher was. The traditional favorite has been Cimabue. This idea, first mentioned early in the fifteenth century, may have been based on an oral tradition.[3] Could it be true? Cimabue was certainly the greatest Florentine artist of the late Duecento, and his workshop must have been

very large to undertake all the commissions he was awarded. It is, there-
fore, quite possible that Giotto was in the workshop and that he learned
the fundamentals of painting from Cimabue. In any case, since the style
of Cimabue was predominant in late-thirteenth-century Florence, Giot-
to could not have escaped coming into contact with it.

If this is true, how is it then possible for the Santa Maria Novella
Crucifix, which cannot date from more than a decade or so after the
Santa Croce cross, to be so different from it and anything else produced
in Florence up to that time, especially given the slow and gradual evolu-
tion of artists' style that we know was characteristic of the late thir-
teenth century?

This question does not really have any answer. Although the origins
of Giotto's style can be assumed to be in Cimabue's Florence, they have
been so assimilated and transformed by his visual genius that they are
almost unrecognizable. Such a transformation both in style and subject
is an amazing occurrence. A change of this magnitude has seldom
occurred; to fashion a new content with a new form is a great accom-
plishment.

There is, as we have said, no precise answer as to where Giotto's
early style came from. This lack of visible origins suggests a possible,
although not terribly plausible, alternative: that Giotto was self-trained,
an autodidact. Might he somehow have bypassed the traditional appren-
ticeship and thus brought a fresh approach to artistic problems? The
workshop method aided artists (and saved much time) by showing
them the solution to problems before they had worked them through.
There is a remote chance that Giotto, by avoiding these shortcuts and
working through problems himself, may have invented new and highly
original approaches to figurative art. In other words, a self-training
outside the bounds of conventional artistic thought and practice might
have created a highly unconventional attitude toward art. But while
it is fascinating to speculate on the prospect of Giotto being self-taught,
everything we know about the workshop and guild system of the
Duecento and Trecento argues against the fact, and there is no proof
that any of Giotto's artistic contemporaries were trained anywhere but
in the shop of a master. So the reason for the great difference between
Giotto's art and that of his most immediate forerunners is an unsolved
mystery.

There remain, however, several small indications of Giotto's link
with the past. For one thing, the type, shape and size of the *Crucifix*
are like those of the crosses painted by Cimabue and his contemporaries.
Panel shape, one of the most conservative elements of early Italian

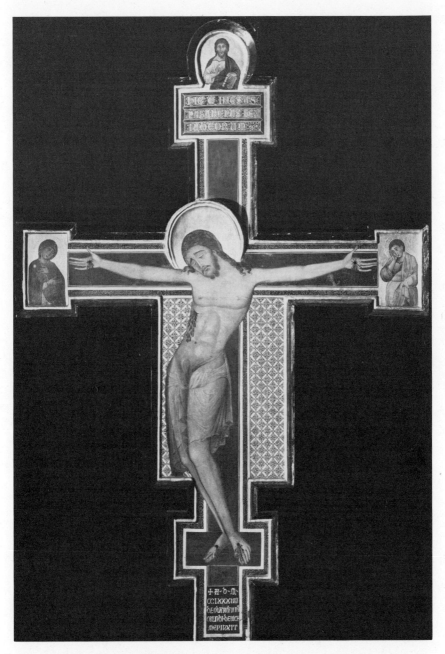

Plate 15. Deodato Orlandi: *Crucifix*. Lucca, Pinacoteca Nazionale

painting, tends to change only very slowly.[4] Another tie with the past is found in the drapery. That of the loincloth of Christ and the robes of St. John is rendered as soft and pliable, but it still, in a very small measure, retains some of the schematic stylization of fold patterns common to the Cimabue crucifixes. More advanced than even the latest effort by Cimabue, the drapery, nevertheless, falls in certain passages into patterned folds that vaguely recall that painter.

After the Santa Maria Novella *Crucifix* there was no returning to the old portrayal of the crucified Christ, either stylistically or iconographically. All over Tuscany and the rest of Italy artists began to copy the early style of Giotto. There are numerous examples of paintings by men, already quite fixed in their style, who suddenly made a number of fundamental changes to adjust to Giotto's idiom. A very good example is found in the work of Deodato Orlandi, a minor artist from the town of Lucca.[5] Deodato is of the greatest interest because of his habit of signing and dating his work. Thus, we can see that a *Crucifix*, now in the Lucca Pinacoteca, that he painted in 1288 is very much in the latest Florentine style (Plate 15). It is a version of a cross like Cimabue's Santa Croce *Crucifix*. But the cross Deodato painted for the small town of San Miniato al Tedesco in 1301 is a copy of Giotto's Santa Maria Novella *Crucifix* (Plate 16). This seems to indicate that Giotto's cross was finished when Deodato dated his work. But what is even more interesting is the total adaptation, one might even say plagiarism, of Deodato's copy. Of course, he did not really understand Giotto's stylistic principles; he simply copied them. His panel, like those of so many of the early copiers of Giotto, is a wooden caricature of the great original.[6]

The next of Giotto's extant early paintings, a *Madonna and Child with Angels*, is found, not in the grand buildings of one of the popular religious orders, but rather in the little church of San Giorgio alla Costa in Florence (Plate 17).[7]

By 1705 the church of San Giorgio was redecorated and Giotto's picture placed in its present position high up on the right altar wall. In a disastrous remodeling, the panel was drastically cut down to fit its new location. Strips of wood were removed on all sides, greatly changing the original compositional scheme. We know from part of a tiny column base remaining at the foremost end of the left arm rest that the throne must have had projecting sides. By analogy with similar types by Giotto's contemporaries and followers we also know that such a throne must have had a step. A reconstruction drawing of the original panel has been prepared, and from this and the painting as it remains

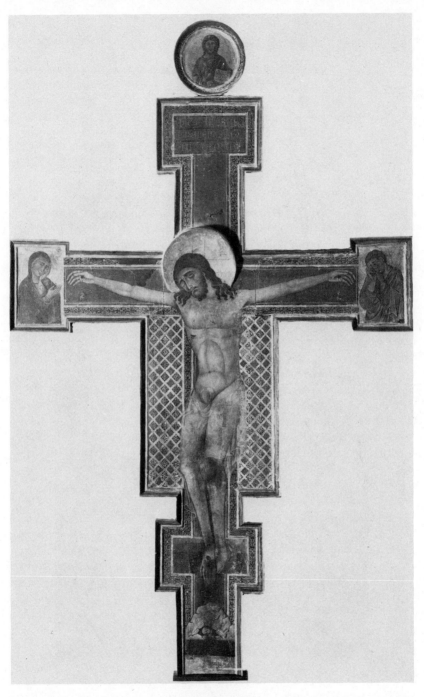

Plate 16. Deodato Orlandi: *Crucifix*. San Miniato al Tedesco, Conservatorio di Santa Chiara

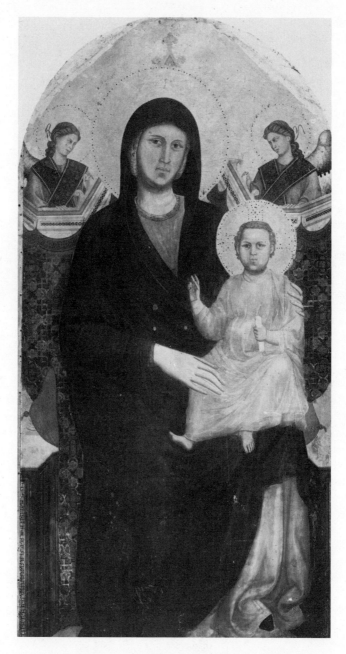

Plate 17. Giotto: *Madonna and Child with Angels.*
Florence, San Giorgio alla Costa

today we have an idea of how the picture appeared in Giotto's time (Plate 18).[8]

Consideration of the panel's original appearance is of utmost importance, for if the missing parts are replaced by a reconstruction drawing or in the mind's eye, the entire picture looks very different. The Madonna and Child were placed much deeper and more convincingly in space. They were the focus of the throne's architecture as it pulled the spectator's glance along its projecting sides to the very center of the composition. This focus, this concentration on the Madonna and her Child, is something very different from what previous artists had done. In the San Giorgio painting the spectator relates much more intimately to the images than he does with any earlier Madonna and Child. The Madonna is brought in closer rapport with the onlooker by simply reducing the bulk and size of the throne (which is now proportionally quite small when compared to that in Cimabue's Santa Trinita Madonna) and by decreasing the number of peripheral figures to two angels. This composition of the Madonna and Child flanked by two angels had been used well before Giotto. Madonnas in simple thrones also antedate the San Giorgio panel, but never had throne and angels been combined in such a simple, telling manner.[9] There is a psychological and physical closeness among the figures that is very new. This intimacy, which is one of the most attractive features of the work, reminds us of the type of uncomplicated closeness with holy images so often described in the *Little Flowers of Saint Francis* or other early Franciscan devotional literature where the humble brothers often have intimate visions of sacred beings.[10]

The date of the San Giorgio picture is unknown. There are no extant documents regarding it, and any dating must be based on the stylistic evidence of the picture itself.[11]

Color is often one of the best clues to the dating of an artist's work. In the case of the San Giorgio panel, the palette is light, rather narrow in range and extremely subtle. Red, rose, pink, off-white and blue predominate. The Child wears a pink mantle over a beautiful purplish-blue tunic. Much of the surface is relieved by the patterned cloth that hangs on the back of the throne, its black and red ornaments making an exquisite piece of pure decoration. This balanced, harmonious palette is certainly much like the one used in the Santa Maria Novella cross, and this strongly suggests that the pictures were painted about the same time.

The basic articulation of the bodies and their positions in space is sure and competent. The conception and realization of the drapery are

Plate 18. Reconstruction drawing of Plate 17. (After R. Offner, *Corpus of Florentine Painting*)

very close to the Santa Maria Novella cross. In the San Giorgio panel the soft, pliable, very delicate rendering of the Child's robe is reminiscent of the loincloth worn by Christ. Eyes, nose, lips and mouths of the figures from the San Giorgio panel are also like those of the Christ from Santa Maria Novella. They have lost almost all the strong geometric abstraction so characteristic of the artists of Cimabue's generation. The creation of the facial structure in which these features are placed and the subtle overall shading of the skin is as convincing and skillful as it is in the Santa Maria Novella painting. The head of the San Giorgio Madonna seems, perhaps, slightly more stylized than the face of Christ, and one can vaguely see connections between it and the head of Cimabue's Santa Trinita Madonna, but the ties are generic and do not prove that the San Giorgio panel was painted before the Santa Maria Novella cross, although it may have been.

The stylistic similarity would suggest that they belong to the same years. Since we have already dated the cross between c. 1290 and c. 1300, we can employ the same set of dates for the San Giorgio Madonna.

The Santa Maria Novella cross and the San Giorgio alla Costa Madonna are all that remain of the earliest period of Giotto's career. Together they form a coherent unit and are important landmarks in the artist's stylistic development. It is well to remember that there must have been other works that are now lost or destroyed and that these two remaining panels cannot be used to draw the total picture of the painter's first works. They are all we have, but they tell us much. The stylistic distance the young Giotto puts between himself and the older masters is one of the most amazing feats of Western art. His abandonment of conventions and his introduction of a new visual language was enough to make him famous forever. The two works we have just discussed can be viewed as representative of the first stage of the young painter's activity in Florence, and as such they are of paramount historical importance, for they made a return to the traditional iconographic and stylistic types impossible.[12]

But the Santa Maria Novella crucifix and the San Giorgio alla Costa Madonna are more than just records of the beginning of a legendary career. They are also very fine works of art. They leave, like all the rest of Giotto's work, an indelible memory. The palpable, graceful Christ swaying toward the onlooker, his head sunk onto the chest in total abandonment of life, is truly an astonishing image. The participation of Mary and John with their controlled but grief-stricken glances

is unforgettable. The calm, kind look of the San Giorgio Madonna and the confident, knowing benediction of her half-child, half-emperor son make a vivid and lasting impression. In both there is a weight and permanence that make the images timeless, above the temporal limitations of this world. In these early pictures one sees the power of Giotto in its first bloom. He is already an accomplished artist by the time he creates the Madonna and the crucifix, and his origins have been so transformed and assimilated that they are no longer discernible. These first performances of the artist just starting out on a brilliant career have all the freshness and vigor of youthful genius.

Before turning to Giotto's next panel—the *Ognissanti Madonna*—we need to discuss briefly the possibility of an influence on the artist's youthful works from outside Florence, for it has been postulated that he may have been swayed by some of the painting being done in Rome during the last decade of the thirteenth century.

Far and away the most famous Roman artist of this period was Pietro Cavallini, whose existence is recorded by written documents only twice—once in Rome in 1273 and again in Naples during 1308. A string of stylistic evidence makes it appear quite certain that he was responsible for a series of Roman mosaics, including the still extant six scenes of the life of the Virgin in Santa Maria in Trastevere and a fresco cycle (now largely destroyed) in Santa Cecilia in Trastevere.[13]

Cavallini's work seems to occupy an important historical position in the Roman Duecento, for it embodies a degree of clarity and naturalism not seen in the city since antiquity. His mosaic *Birth of the Virgin* from Santa Maria in Trastevere may date, like the rest of the cycle, from the early 1290s (Plate 19). Its well-ordered, harmonious and readily comprehensible composition reveals Cavallini's talent as a narrator. The wonderfully subtle use of the mosaic tesserae to create light and its effects on the buildings and robes shows that the artist's knowledge of early Christian mosaics (some of which he had restored) had been put to good use. Equally impressive are the majestic figures in the damaged fresco by Cavallini in Santa Cecilia in Trastevere. When the entire cycle (of which the remaining figures from the *Last Judgment* are just a part) was intact it must have been one of the greatest Roman works of the Duecento. Here Cavallini demonstrates his ability as a colorist in the varied, interesting hues in wonderful combinations seen on the soft, full robes and in the angels' multicolored wings.

On the evidence of his extant works it seems certain that Cavallini and several of his Roman artistic contemporaries were responsible for the creation of a progressive style that, although it was not to last in

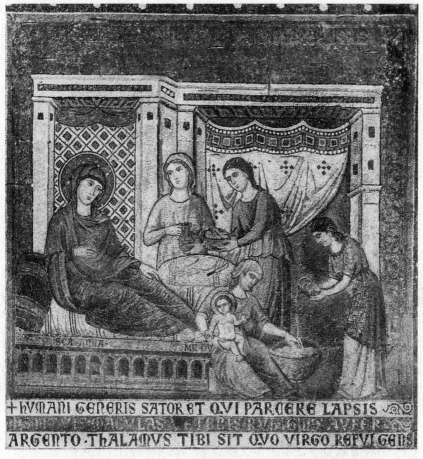

Plate 19. Pietro Cavallini: *Birth of the Virgin*. Rome, Santa Maria
in Trastevere

Rome, is one of the most interesting phenomena of late-thirteenth-
century Italian art.[14]

Now a document reveals that Giotto had been in Rome before
1313, but exactly when is unknown. Nor, it is worth repeating, do we
know the exact date of a single work by Cavallini. Thus, any specula-
tion about the influence Cavallini could have exerted on Giotto must
be tempered with the realization that the relative chronological position
of the two is unclear.

A comparison between Cavallini's *Birth of the Virgin* (Plate 19)
and the Santa Maria Novella cross or the San Giorgio alla Costa
Madonna by Giotto (Plates 13 and 17) shows that both artists were

interested in a coherent, convincing, well-articulated pictorial world. Their figures and the ambiance surrounding them are believable, while the narrative message of the pictures' subject is quickly understood. Both painters are well in advance of their predecessors. However, in the more detailed indicators of individual pictorial style—the positioning of figures in space, the construction of each body and the disposition of the various elements throughout the composition—there are numerous and fundamental differences between the two. Even in the earliest known works by Giotto the figures have a presence, ponderation and permanence that are alien to the masterful but basically more schematic work by Cavallini. One has only to contrast the way space is occupied by the Santa Maria Novella Christ with the much more spatially ambiguous figures in the Cavallini mosaic to see this. Further comparison with Cavallini's figures from the Santa Cecilia in Trastevere fresco reveals that, although these are clothed in broadly modeled robes that are subtly highlighted with distinct white brush strokes, they lack the brilliant articulation and convincing palpability of Giotto's actors. The abstract role of pattern plays a much greater part in Cavallini's work than it does in Giotto's. The geometry of architectural forms, the shapes of drapery decorations, the rhythm of the folded robes, the configuration of facial features and the arabesque of hair are much more prominent than in paintings by Giotto.

Any comparison of Giotto's work with Cavallini's will, it seems, reveal that Giotto was the greater, more advanced artist. This does not necessarily mean that he could not have been influenced by Cavallini; and indeed, as we have seen, their works, which can probably be dated to the 1290s, indicate that they were interested in some of the same stylistic principles. But the scarce documentary evidence does not allow us simply to assume, as so often has been done, the influence of Cavallini on Giotto. In fact, so unresolved is the chronology of the works that it is even possible that some influence could have gone the other way— that is, from the first paintings by Giotto (who was already famous by the very early years of the Trecento) to Cavallini. But until much more evidence is found on the chronological relationship of the works of the two artists the problem will remain unresolved. It does seem certain, however, that if Giotto was swayed by Cavallini (or Cimabue, or any other artist) early in his career, he so absorbed this influence and made it his own that no recognizable trace of it remains in the first paintings known to us.

The Giotto–Cavallini problem is sometimes connected to a series of undocumented frescoes (usually dated c. 1290) on the upper walls

of the two easternmost bays in the upper church of San Francesco, Assisi. These are, in turn, often discussed in connection with the paintings of the legend of St. Francis which cover the walls below them. As a survey of the very problematic Francis scenes forms the subject of Chapter VII, we will here concentrate only on the frescoes of the upper walls. Some, or all, of these (critical opinion is split on the subject) have been attributed to an artist called the Isaac Master after the two Assisi frescoes of *Jacob and Rebecca before Isaac* and *Esau Seeking the Blessing of Isaac* (Plate 20). These paintings, like the others in question, have suffered considerable damage.

There are two widespread theories (which we will briefly investigate) on the Isaac frescoes—1) that they are the work of Pietro Cavallini or another Roman artist close to him, 2) that they are by the hand of the young Giotto.[15]

A comparison of *Esau Seeking the Blessing of Isaac* with Cavallini's *Birth of the Virgin* in Santa Maria in Trastevere (Plate 19) does indeed reveal several stylistic similarities. The overall composition with the reclining figure in front of the two standing ones, all of whom are ordered in a highly schematic architectural surround, is alike, while the pose of the women holding the pitchers seems remarkably the same in both works. However, the relation of the figures to architecture, the way in which the bodies decisively occupy space, the basic proportional construction of each actor, plus the more delicate and sensitive articulation of the Assisi figures appear to indicate that we are here dealing with works by different artists. It thus seems unlikely that the Isaac Master can be identified with Cavallini, but can he possibly be the young Giotto?

If we contrast the Isaac fresco with any early work by Giotto we at once recognize many fundamental diversities. What is perhaps most immediately striking is the difference in palette. The colors of the San Giorgio alla Costa Madonna or the Santa Maria Novella cross are much more limited and somber than those of the Assisi painting. The mustard yellow, pinks, reds and strong whites of the Isaac scenes form combinations alien to the works of Giotto. Never in his earliest known paintings does one see shot colors such as the cloak of Isaac which changes from green-blue to yellow. Also foreign to Giotto's artistic concepts are the brightly highlighted, sharply chiseled garments or strongly modeled, highly plastic faces. The basic feeling for texture is different; the surface of the Assisi frescoes seems more movemented than Giotto's early Florentine panels.

Without doubt the Isaac frescoes (more than the others which share

Plate 20. Isaac Master: *Esau Seeking the Blessing of Isaac*. Assisi, San Francesco

The actors have great dignity and beauty. In this panel we see for the first time the figures of the mature Giotto. The positioning in space, the three semicircular rows and the two kneeling angels—who act as a base of a rough triangle that runs along the sides of the Madonna's body and ends above her head—are all carefully planned to give both solidity and variety to the picture. The simplicity of the construction of the bodies and Giotto's ability to make them sculptural is amazing. Each figure, through the bulk of its shape and the treatment of its surface (which clearly shows the extent of the body underneath the drapery), assumes a weight unmatched by any other earlier artist.

Let us compare for a moment the figural style of the kneeling angels to the two other works by Giotto discussed so far. The articulation of their bodies and, in fact, of every body in the Ognissanti altarpiece is directed toward the Madonna and Child. It is as though all the angels' energy were absorbed in the act of adoration. Their heads incline upward, their necks strain, their hands proffer vases of beautiful white and red flowers. The construction of their broad chests and sturdy legs is apparent as the drapery pulls across the body. The robes are creased only by the large, bold, deep folds. They are a marvel of balance as their powerful but graceful movements echo across the center of the picture. Although the figures from the San Giorgio Madonna and the Santa Maria Novella crucifix have a vivid spatial existence, they are not nearly as fully developed as these. They clearly occupy positions in space, but they have not attained the weight that we here witness. Their robes reveal the body beneath, but they are not yet the marvelously simple vestments of the Ognissanti panel. One can compare, for instance, the robe of the angel who holds the crown at the left of the Ognissanti throne to that worn by the Madonna from San Giorgio. The greater decisiveness of the former in the broad strokes of highlights and shadow which form and give substance to the material is readily apparent. Giotto has taken a major step toward the representation of physical presence in this new treatment of the figure.

The gravity of the scene portrayed in the picture is expressed by the faces of the group of heavenly onlookers. This is not the vision of the enthroned Madonna surrounded by a court of angels of the Santa Trinita panel, but, rather, the Virgin flanked by both saints and angels. There are more types to be found here; they include the fierce-looking old men with long flowing beards, the youthful, handsome male saints and the dignified winged angels of the first two rows. The scene is a still one. No one talks or even looks the other way, for the Queen of Heaven and her son sit in their midst.

the walls around them) are works of a very high quality. The vivid presence of the actors, their high sense of drama, strong individual personalities and emotions are seldom matched in early Italian painting. It is clear that the painter of the Isaac frescoes (who is unfortunately known only by the Assisi scenes) is a major master. But it is just this mastery that seems to indicate that he is already a mature painter. How very different are these highly resolved frescoes from the accomplished but much more youthful-feeling works of the early Giotto.

Lacking documentation, we have no sure dates for the Isaac frescoes. Current opinion generally dates them around the last decade of the Duecento, the period of the first works of Giotto. It seems, as we have said, however, that the style of the Assisi Isaac frescoes reveals that Giotto could not be their painter, who, on, the basis of compositional, figurative and coloristic indicators, seems much more Roman than Florentine. But could or did he influence Giotto? Again, as in the case of Cavallini, the answer is unclear. Without documentation we are unsure of the relative chronological positions of the artists; without a clearly definable example of the Isaac Master's style being used by Giotto we cannot assume any direct contact between them.

Perhaps the best way to view the Cavallini–Isaac Master–Giotto question is to realize that there were several artists active in Rome during the late Duecento who shared some of the same innovative and progressive goals held by Giotto. These men appear to be better, more original and historically more important than any of their predecessors, who were still very much in the mainstream of the older, highly stylized idiom characteristic of artists trained in the earlier thirteenth century. But lack of evidence for the dates of the works in question does not allow us to say a great deal more than this about their relationship to Giotto's first known paintings.

In the *Ognissanti Madonna*, Giotto's next extant panel, the artist moves another step forward. This huge painting comes, as we have seen, from the Florentine church of Ognissanti, or All Saints (Plate 1). It originally stood in the nave behind the high altar and was the most important panel painting in the church.[16] The work is in rather good condition, although it appears to have undergone at least one clumsy attempt at restoration during the early part of this century.[17]

Even though it is one of the artist's most famous and well-studied paintings, little is known about its commissioning and date. Its closest stylistic connections are with Giotto's frescoes in the Arena Chapel in Padua, which can be dated around 1306. This would be a logical date for the *Ognissanti Madonna* as well.

In size and type it is close to Cimabue's Santa Trinita panel; both have similar functions, but how different they are! The throne in the *Ognissanti Madonna* is the descendant of that which once graced the San Giorgio alla Costa panel. But the Madonna of Ognissanti, as we have seen, does not just sit on the throne; she is enclosed by it. The actual architecture of the back forms a shell over and around her and the Child. The strongly projecting side pieces act as architectural elements centering and framing the two figures. At the top of the throne a gable echoes the panel's gable. A step below the platform projects out toward the viewer. With the architecture of the throne alone, the artist has placed the central elements firmly in space, thus achieving a permanence and spatial balance. In Cimabue's work the Madonna and Child are also centered, but there the balance is much more precarious. The throne, although of grand proportions, does not act as a spatial anchor. It rests uneasily in space, framing the Madonna only from the shoulders down. Rather than the solidity of the Giotto panel there is an equipoise which suggests that the scene could shift at any moment. All is in arrested motion and the balance is only, one feels, temporary.

In the Ognissanti painting the peripheral figures and the architecture work beautifully together. They surround the Madonna in a semicircle much as the throne's shell encloses the holy group. There are layers of space now instead of the much more simple surface movement of Cimabue's figures. In other words, Giotto has placed the figures to the side of the throne in three rows that really appear to be one behind the other and to have a real existence back into the fictive space of the picture. This effect is complemented by two new developments. The artist has foreshortened a number of heads, which appear to tilt not across the surface of the panel but rather into space, or out of it toward the spectator (Plate 21). This is especially noticeable in the two angels standing to either side of the throne in the second row. Now not only does the architecture occupy pictorial space in a convincing way, but the figures as well attain a new, hitherto unknown spatial existence. The other new development is found in the interplay between figure and architecture. Observe how the two bearded saints look through the sides of the throne. This brilliant idea, which adds a weight to the visual extension of the architecture into space, may seem quite simple, but it had never appeared in Florentine painting before. And Giotto is so anxious to place the saints and angels securely in space that he does not mind covering some of their faces with the halos of those who stand in front—a daring invention.

Plate 21. Giotto: Detail of Plate 1

This Madonna is one of the supreme creations of Giotto's art. She sits firmly on the throne, her great body covered by the dark-blue mantle that spreads from her head down to the wide base of the throne, creating a rough triangle of its own. The monumental expanse of her body fills even the broad seat on which she sits. The folds of the robe are simple and expressive. The V-shaped grooves below the lap trace the course of the mantle as it falls over the knees, where one senses the weight of the heavy cloth, almost feeling its pull. From the *Ognissanti Madonna* on, this sensation of the palpability of material is always present in Giotto's work. The form of the Child, revealed under his drapery, is that of a miniature Hercules. The broad shoulders, sturdy chest and hefty legs form a compact and powerful small body.

In the facial features of the Madonna and in the saints and angels who observe her, the old-fashioned stylization, a trace of which lingered on in the two earlier panels, is gone. Nothing remains of the undulating play of line still just glimpsed in the earlier works. Here the break with the old style is final and complete.

In the *Ognissanti Madonna* Giotto was keenly aware of the possibilities inherent in the opposition of void and solid—a Florentine trait. The picture is a subtle symphony of interval; nowhere is this clearer than in the large area between the top angels' heads and the picture's gable, where (to either side of the throne) there is nothing but the shimmering expanse of gold. Many pictures from the late Duecento were backed by gold, but few artists knew how to take advantage of this material as well as Giotto. In the Ognissanti painting he holds the great weight of the assembled onlookers to a point just about equal with the head of the infant Christ. Thus, the occupied, solid area of the painting is really confined to only about three quarters of its surface, allowing the upper part of the throne to soar in the fictive space flowing freely around it. This imparts a lightness and grace to the painting that it would otherwise not have. It is the perfect foil for its sacred but earthbound figures.

The love of the play of pure geometric shapes (inherited from the Duecento; we have only to think of the St. Francis panel in Santa Croce [Plate 5]) is everywhere to be found in the *Ognissanti Madonna*. The beautiful contrast between the plastic oval of the Virgin's face and the flat, round plate of her halo is equaled by the echoing shapes of the halo and the arch of the throne above. The exquisite pattern of the halos of the angels and saints is measured and carefully planned. The whole picture is alive with geometric rhythm.

Between the two earlier works and the *Ognissanti Madonna* there

has been a color change. The palette is now darker, the colors more localized and compacted. They define the space they cover, strongly separating it from the rest of the composition. This use of color as a space-defining element is much more prominent in the Ognissanti panel than in the San Giorgio alla Costa Madonna or the Santa Maria Novella cross. Crisp, dense grays, creams, greens, reds, blues and pinks appear. The lighter, more translucent colors of the early works have disappeared. Color, like form, has moved out of the Duecento into the new century.

By the first years of the fourteenth century Giotto had entered into his early maturity. His training period was long over, the first fine works behind. In the *Ognissanti Madonna* we see the early flowering of the style that was to characterize Giotto's greatest work in fresco, the Arena Chapel.

IV

The Arena Chapel

The city of Padua lies about thirty miles to the southwest of Venice. There, in a small park filled with trees and green lawns, stands the Arena Chapel, one of the treasure houses of Italian painting. This modest red brick building, only about fifty paces long from the entrance wall to the altar, contains the most extensive and best preserved of Giotto's fresco cycles.[1]

The patron of this work was a wealthy Paduan named Enrico Scrovegni, who is seen presenting a model of the chapel in the lower left sections of the *Last Judgment* fresco on the entrance wall of the building (Plate 22). How Scrovegni came to commission Giotto for this work is unknown, but the very fact that he employed a foreign artist is testimony to Giotto's early reputation throughout Italy.

Like most of the artist's works, the paintings in the Arena Chapel have no documented date. It is, however, possible to date them with a certain degree of accuracy by using several archival records. We know that in 1300 Enrico Scrovegni acquired the land on which the chapel stands. On this property he also built a family palace (now destroyed) that was attached to the chapel. It seems certain that permission to build the chapel was given before March 1302, and in March 1304 a papal bull was issued granting indulgences to those who visited the structure. On March 16, 1305, the High Council of Venice decided to lend wall hangings to Scrovegni for the dedication of his chapel. This documentation indicates that no painting was likely before 1302. The frescoes seem, in any case, to have been finished by the date of the papal bull of March 1304 and, almost certainly, by the deliberation of the Venetian Council of 1305.[2]

Visual records indicate the near completion of the chapel by 1306. In the Museo Civico of Padua there are miniature paintings of the *Annunciation, Betrayal of Christ* and *Lamentation* that can be dated to

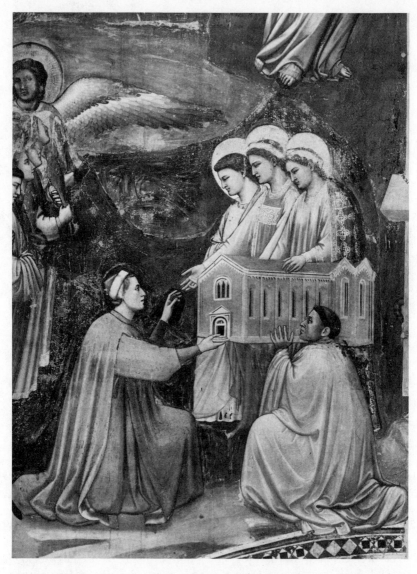

Plate 22. Giotto: *Enrico Scrovegni Presenting a Model of the Arena Chapel.*
Padua, Arena Chapel

1306.[3] There is no doubt that these small works copy the same scenes in the Arena Chapel. Thus, by 1306 a great deal of the actual painting had been completed. The year 1306 seems, therefore, to be the most logical single date to use for dating the frescoes of the chapel.

Giotto's frescoes seem to have generated both admiration and envy. There exists a curious document of January 9, 1305, in which the monks of the nearby Eremitani church complain about what they considered the excessive size and decoration of Enrico's chapel. Part of the text reads as follows:

I, Friar Giovanni di Soleo, Mayor and representative of the Mayoralty of the Chapter and Monastery of the holy Apostles Philip and James of the order of the Eremitani Brothers of Sant'Agostino, which are located in Padua in the borough called the Arena as is contained in public record written by the hand of the notary Federico, son of the Master Giovanni, I say and put before you that since the Prior of the aforesaid Monastery has lodged a complaint in your presence, that the noble and powerful soldier, Lord Enrico Scrovegni the magnificent, citizen of Padua, had made and newly constructed a new bell tower in the Arena at the church which is located there, in order to place huge new bells in it to the grave scandal, damage, prejudice and injury of the friars and monks who dwell in that place, or in other words of the aforementioned Monastery and those of the Order located there, and of the Convent and of the Church, and that, according to their sworn statements, there ought not to be a huge church in the Arena, but a small one with one altar in the manner of an oratory, and not with many altars, and further it ought to be without bells and without a bell tower according to the manner and form ascertained and contained in the document of the concession made of the aforementioned Lord Enrico by the then Lord Bishop of Padua. The form and manner of the concession is as follows:

That Lord Enrico will be allowed to construct in the Arena, or in that place which is called the Arena, without prejudice to the rights of others, a small church, almost in the manner of an oratory, for himself, his wife, his mother and his family, and that people ought not to be allowed to frequent this church. He should not have built a large church there and the many other things which have been made there more for pomp, vainglory and wealth than for praise, glory and honor of God. And again, these things have been done counter to the form and tenor of the concession of the Lord Bishop, whereby the aforementioned Prior in the name of the aforementioned Bishop begged you, according to the due power of your offices, to think us worthy to restrain the aforementioned and to let us see the document by which the concession of the Lord Bishop was made to the aforementioned Lord Enrico, that is, the document made or written by Lord Bartolommeo, the notary, and diligently examine the tenor of this

same document or concession and compel the aforementioned Enrico, by ecclesiastical censure, to observe the tenor of this document or concession and the pacts, conditions and manner contained or inserted in it and cause to be given to the above-mentioned Prior the aforementioned document or a copy thereof.[4]

This interesting document records a contemporary judgment of the chapel. The monks were obviously worried about the competition that Enrico's church was giving them and perhaps felt that the things in it "more for pomp, vainglory and wealth than for praise, glory and honor of God" were excessively attractive to the people of the area. It is clear that they considered it a private chapel (which it originally seems to have been) and thought that only Enrico and his family should use it. Perhaps by the date of the document the new frescoes of the famous Giotto—enhanced by the papal indulgence attached to the chapel— were serving as a powerful pull to worshipers. Such conditions would have given the monks of the Eremitani ample reason to seek to have the original concession enforced. We shall probably never know the exact circumstances of the demand, but it demonstrates that at an early date the small chapel was attracting considerable attention.

The chapel had a dual dedication to the Virgin of the Annunciation and the Virgin of Charity. The latter dedication has suggested to some critics the possibility that Enrico Scrovegni had built and dedicated the chapel as atonement for the usurious practices of his father, Reginaldo Scrovegni.[5] The older Scrovegni, a famous usurer, was responsible for the founding of the family fortune. His infamous reputation was forever fixed by Dante, who in the *Divine Comedy* placed him in the seventh circle of Hell. As we have seen, men left great sums of money for the construction and decoration of churches in the obvious attempt to give back to God some of the money they had usuriously taken from their fellow citizens. This practice of the restitution of usury was responsible, no doubt, for the commissioning of a great many works. That Enrico wished to expiate his father's sins through the building and decoration of the chapel is a possibility, but until more concrete evidence appears it remains only within the realm of speculation.

The actual process of the commissioning and planning of the iconographic program of Trecento fresco cycles is still a mystery. We have a number of wills in which money is left for the decoration of a church or chapel, but we know little about how the funds actually got to the artist.[6] In the case of the Arena Chapel the patron was living, so it was not necessary for intermediaries to administer the money. Enrico must have paid the artist directly. But who planned the program? The answer

to this question, one of the most important concerning any Trecento fresco program, is unknown. The fact is that we do not know who was responsible for the subjects of the great number of frescoes and panels of the fourteenth century. There seems to be some evidence that priests and monks were involved in the choosing of the subjects, but the actual method by which this took place is unknown, if, indeed, there was any usual procedure. Logic dictates that if the patron were living, he and the priest probably decided in concert on what the one wanted and what the other thought acceptable. Whether the artist played any role in the actual determination of subjects we do not know.[7] It seems impossible that Giotto, who, as we shall see, was one of the most sensitive and understanding of all pictorial narrators, did not at least adjust the narrative elements of the scenes to his own artistic needs.

The arrangement of the frescoes in the Arena Chapel is not as complicated as it might look at first glance. The east—or altar—wall contains, above the arch, God the Father sending Gabriel to tell Mary that she will bear the son of God (Plate 23). The west wall is covered by the *Last Judgment* (Plate 24). These opposing walls contain the beginning and end of the Christian drama. Between them is narrated the history of the lives of the Virgin's parents (Sts. Joachim and Anna) and the lives of the Virgin and of Christ. The stories of these principal figures, around whom so much of the sacred drama of Christianity revolves, are portrayed on the lateral walls of the chapel. The drama begins at the top of the right or south wall, next to the altar wall, with *The Expulsion of Joachim from the Temple.* It then proceeds to the right (as it does consistently in the chapel) through the upper narrative band on the right wall to the left-most scene on the top of the left or north wall. From here the action moves left to right through the *Annunciation* on the altar wall. The *Annunciation*—divided into two separate paintings—has an important symbolic role; for, as we have seen, one of the Chapel's dual dedications was to the Virgin of the Annunciation. From the *Annunciation*, the narration moves to the first fresco of the middle band on the right wall. Once more there is the left to right progression through the middle band; then the narration moves down to the lowest band for its final rotation. This narrative pattern is impossible for the spectator to grasp without actually turning in space, so he becomes aware not only of the movement between frescoes but also of his own physical participation in the development of the narrative. The chapel is not large, and it is easy to follow the paintings with the eye. But one really has to turn and actually pursue the path of the narrative rather than be just a passive onlooker.

Plate 23. View from the entrance wall. Padua, Arena Chapel

Plate 24. View from the altar wall. Padua, Arena Chapel

Below the lowest bands of narrative are the seven Virtues and seven Vices. The Vices are on the left wall (on the left hand of Christ in the *Last Judgment*), while the corresponding Virtues are opposed to them on the right wall. This lowest register of the wall is painted to resemble gray marble paneling, and each of the Virtues and Vices is ensconced in a fictive niche.[8] A high order of illusionism is found just above this level on the altar wall, where two frescoes are realistic portrayals of what appear to be two small rooms.[9]

The apse at the east end of the chapel contains a Madonna and Child and two angels by the famous sculptor Giovanni Pisano, the son of Nicola.[10] The frescoes of the later life of the Virgin in the apse date after Giotto's paintings and are by Paduan imitators.

There are two subdivisions on the barrel-vaulted ceiling. The eastern half contains a central medallion of the Blessing Christ surrounded by four prophets, also in medallions. These are all set against a blue field that was originally covered by gold stars. To the west this same scheme is repeated, with the Madonna and Child substituted for the Blessing Christ. A band of painted decoration runs across the vault, dividing it in half.

The chapel is perfect for frescoes, for there are no projecting architectural surfaces to interfere with the painting or to dictate its organization; the wall surface could be subdivided as the patron or the artist saw fit. There can be no doubt that this was a building intended from the very beginning for wall paintings. The only interrupting areas are the six windows on the right wall. Such perfectly suited architecture has led several critics to suggest that the chapel was designed by Giotto.[11] Giotto was, of course, *Capomaestro* of the Florentine Cathedral, and he probably designed the bell tower for that structure during the 1330s. There is no reason he could not have planned the Arena Chapel, but there are no documents recording the artist as architect of the building, nor do the old literary sources mention him as anything but the painter of the frescoes.

On entering the building the onlooker is conscious only of the totally painted surface and its decorative quality. The light, almost gay, overall effect of the combined colors first amazes and then delights. The second impression is of the great areas into which the walls are divided, not by architecture but by paint and color. The three highly colorful narrative strips unite into one wide, glorious, multihued band that exists between the blue of the vault and the gray of the lowest level. It contains a predominance of light violets, pale reds and yellows, set off by grays, white, cream and some green and blue. In strong

natural light the chapel is a rainbow of soft colors. The onlooker feels himself in a large room rather than a chapel. It is an inviting and happy place. One is content just to enjoy the play of beautiful color as it dances across the surface of this humanly scaled building.

As the visitor lingers longer he is impressed with the pictorial organization of the walls. He begins to see how absolutely simple are their divisions and how easily their message may be grasped. The flow of stories from left to right, top to bottom is understood at once, and the spectator knows, almost immediately, how to read the cycle.

This simplicity stands as testimony to Giotto's genius as a fresco painter. In the Arena Chapel the artist was faced with a very different problem from that which had confronted him in the works for Santa Maria Novella, San Giorgio alla Costa or Ognissanti. For those earlier commissions he made paintings that were to be placed in an already decorated church. His panels existed in the vacuum of their own compositions and lived within their own spatial boundaries. In the Arena Chapel he had to create an entire ambiance. He conceived of his task as a totality, and we must first view it as a whole. Only then can we break it down into its components.

As we shall see, Giotto masterfully directed every inch of the surface toward a simple, coherent and yet highly decorative whole. Everything is carefully kept within bounds so as not to spoil this overall effect. There is, throughout the entire cycle, the most subtle and brilliant color and compositional harmony; no color or part of the decoration is ever allowed to predominate. There exists a beautiful equilibrium between vault, narrative bands and the fictive marble decoration. The presence of the six windows on the right wall is not disturbing, since they have been so perfectly integrated into the scheme. The fictive marble borders that frame the fresco panels do not read as real architecture, for they are meant to fool no one. Instead they are seen as painted articulators of the simple, easy-to-read narrative cycle.

In a certain sense this decorative quality connects Giotto with his Duecento predecessors. When they painted a fresco or a panel their overriding concern was with the total formal quality of the work. The still play of beautiful geometric forms and the exquisite intermeshing of fields of abstract color dominate in the paintings of every good master of the late thirteenth century. This concern for the abstract whole, for art as form, is also the primary sensation received from the Arena Chapel.

But Giotto did not leave the matter there. He was also concerned with the clear articulation of religious drama in the narrative frescoes.

He had stories to tell and he wanted them to be understood. The decorative quality of the frescoes had to be harmonized with the narrative demands. Or, to put it another way, the narrative demands of the individual stories had to be integrated in the overall scheme of the chapel. A marvelous tension thus exists between narrative and decoration.

But before going on to the separate scenes it is necessary to see how a fresco was made, for without this knowledge one can never fully understand the Arena Chapel.[12] The first step was the preparation of the wall, which had to be clean and dry. To this was applied a coat of rough plaster called the *arriccio*, which when dry was the surface on which the artist began to work. During the Trecento the usual practice was to lay out on the dry *arriccio* the design of the painting in a red pigment called sinopia. This name gradually began to be used for the design as well as the pigment, and we now refer to this preparatory underdrawing as a sinopia or to more than one of these as sinopie. These free drawings helped the artist see what the composition would look like in its actual dimensions and in its permanent location and how it would relate to any neighboring paintings. Although it is possible that the first ideation of the fresco may have been put down on a piece of paper, its actual physical formation took place on the wall.[13] This process helped to establish a monumental, full-scaled idea of composition that also carried over into panel painting.

Once the sinopie were laid out the artist could begin the actual fresco painting. In the true, or *buon fresco,* method this consisted of covering the *arriccio* with patches of a new coat of plaster called the *intonaco.* This was very fine and hard; sometimes marble dust was added to make it even smoother. Pigment, suspended in a lime-water solution, was then applied to the plaster while it was still damp. If the plaster was allowed to dry, the pigment would not adhere properly, since a chemical reaction between it and the pigment suspended in lime water is necessary for a proper bond between paint and surface. Therefore, the artist could lay in only as much plaster as he could paint in one session, and he had to finish painting before it dried. In strong raking light, the individual patches of plaster are often visible, and from them we can see something of the working method. Painting almost always began at the top and proceeded downward, since both wet plaster and pigment tended to drip. As the patches of wet plaster were applied they slowly covered the design on the surface underneath. The sinopia gave the artist a reference point and allowed him to keep a sense of proportion and scale as he worked on the wall.

Another method of painting walls also existed during the Trecento.

This is called *fresco secco*, and it is a technique whereby paint is applied not to wet but to dry plaster. The artist using the *secco* method simply paints (with an egg vehicle) directly on a wall that has been plastered, allowed to dry and has then been slightly dampened. This was an easier method of painting, since underdrawings could be quite detailed and there was no rush to finish the work before the plaster patch dried. In Florence the common method of wall painting was true fresco. There were, however, certain pigments, such as the blue used for the sky and for the Virgin's robe, that changed color when applied to the wet wall. This meant that they had to be put on after the rest of the painting was finished and the wall dry. Detailed decoration, such as painted embroidery, was also painted in *secco*. True fresco is a much more permanent and durable technique than *fresco secco*, for the latter tends to peel and fade. The areas that were painted in *secco* on frescoes otherwise done in true fresco have often disappeared.

The Paduan paintings are done in *buon fresco*, and on the whole they are in good condition. There have been pigment losses in areas that were painted in *secco*, such as the blue of some of the skies and certain decorative motifs. In general the colors have held up well, and although there appears to have been some fading and hue change, the palette is still bright. The paintings, which are now quite free of repaint, were cleaned several years ago.[14] There are a number of areas that have been damaged either through abrasion or dampness. These include the left side of the *Last Judgment*, the left-hand section of the Triumphal Arch and the *Carrying of the Cross*. But all in all, the Arena Chapel paintings are the best-preserved frescoes we have by Giotto's hand.

The nature of fresco technique was fully understood by Giotto. He knew it was a method that demanded a sure, rapid hand and a style equal to the large areas to be painted. All of his decoration, each of his narratives and every figure are conceived with a breadth and scope worthy of the walls they occupy. The idea of the wall, that surface on which the paint was to be applied, was for the fresco painter the measure of all things. Each brush stroke in the Arena Chapel is aimed toward the preservation of the integrity of the wall. Never once does the master allow the idea of fresco as wall decoration to be forgotten. What fictive pictorial space the decoration creates is minimal. The stories that Giotto had to tell needed to be placed in a convincing depth, and they had to have a certain amount of lateral expansion. But never are they allowed to punch spatial holes in the surface of the wall. To represent deep space within the individual frescoes or to make the painted architecture appear as though it had a powerful three-dimensional weight was un-

thinkable to Giotto. He knew that the fresco was a complement to the surface of the wall, not its destroyer. He understood that fresco painting could achieve its highest level only when it respected the flatness of the walls it covered and matched their monumental proportions with its own.

All great artists have had a deep understanding of the material with which they labored—Donatello for wood and bronze, Michelangelo for marble and Rembrandt for oil. Giotto worked during the classic age of fresco painting; it was only then that the actual conception and execution of the fresco was carried out on the spot to be painted. After c. 1450 cartoons were used to transfer drawings to the wall surface, and the ideation and much of the designing were carried out in the painter's workshop, far away from the site. The feeling for the actual wall forced Trecento painters to think in monumental terms both for decoration and narrative.[15] The idea of the expansion of narrative within one fresco and the relation of fresco to fresco and decoration to fresco is at the very core of this art. It is in his masterly comprehension of these relationships and the technique used to create them that Giotto proved himself a superb artist.

The absolute control Giotto exercises over the narrative frescoes can be seen in the opening painting of the cycle, *The Expulsion of Joachim from the Temple* (Plate 25).[16] The elderly Joachim, the future father of Mary, brought a sacrificial offering to the temple of Jerusalem, but since he had no children his offering was refused and he was expelled. The basic themes of this scene as Giotto represents it are rejection and acceptance, and both are drawn with the utmost economy. The temple, or its surrogate, is set at an angle to the picture plane. It moves diagonally into space from the front border of the fresco toward the upper left. The movement is very gentle, establishing the space of the picture without detracting from the surface of the wall. There are no other architectural or landscape elements in the painting. The area above and to the right of the temple is blue.

The temple itself is represented by its most characteristic parts. There is a tabernacle supported on four columns under which stands the altar, the spiritual center of the structure. In the background is a pulpit entered by a flight of stairs. Altar and pulpit, prayer and preaching are, after all, the two most important aspects of a religious building. Giotto, realizing this, represented both in the simplest, most direct form possible. The altar and the two figures in front of it are surrounded by a marble wall. Undoubtedly this stands for the precinct of the temple, but it also has a deeper meaning, for inside a priest blesses a young

Plate 25. Giotto: *The Expulsion of Joachim from the Temple.*
Padua, Arena Chapel

man, a man who, we assume, has children and whose sacrifice has been
accepted. He is within the structure of the temple psychologically as
well as physically, sheltered both by the high walls and by the accept-
ance of his offering.

Making the strongest possible contrast to the scene of acceptance is
the plight of the pathetic Joachim, who is not only outside the sheltering
walls but is being thrust away from the temple. As the old man turns
and looks hopelessly back, the majestic priest puts his left hand against
Joachim's shoulder and, at the same time, pulls his sleeve with the other
hand. The magnificent arm of the priest and the tilt of his body directly
express the act of expulsion. The great void to the right of the temple,
into which Joachim is about to step (and thus begin the sequence of
stories narrated in the chapel), symbolizes both the physical and psycho-
logical alienation that is taking place. Our sympathies are certainly with
the poor old man clutching the tiny sheep, as he stands on the edge of
nothingness, barred from the temple and rejected by his priests.

The simplicity of the painting, its most economic portrayal of
setting and action reveal a great deal about Giotto as a narrative artist.
He tells the story in the most direct way possible, so that each element

plays an important—one might almost say decisive—role. Giotto always reduces the narrative to its absolutely essential elements. This applies not only to the architecture and decorative accoutrements involved in each story but also to the number of people allowed to act in it. Only in scenes where there is a need for a great many people, such as the *Carrying of the Cross*, will one see more than just the bare number required to tell the story. The *Expulsion* is an accurate, acute portrayal of the account of Joachim's trials, populated by only four people. Giotto's ability to condense and to expose the very heart of drama is shared by few; we have to look to artists like Masaccio or Rembrandt or Mozart to find his equal.

The *Expulsion of Joachim* is the first of Giotto's narrative paintings we have seen. The earlier extant panels were more iconic in nature; they were images of either the dead Christ or the Virgin and Child with angels and saints. But even in these works the trend toward such masterly simplification and direct presentation existed. One has only to think of the *San Giorgio alla Costa Madonna* or the *Ognissanti Madonna* to understand some of the steps that led to the *Expulsion*.

After the expulsion it was made clear by divine signs to Joachim and his wife Anna that they would have a child; this would be Mary, the mother of Christ. The next scenes in the chapel represent separate events in their lives, and in the fifth, *The Meeting at the Golden Gate*, the elderly couple are brought together at last (Plate 26). The event takes place before the Golden Gate in Jerusalem, where an angel had told Joachim that he would meet Anna. The solemn and tragic note of the first scene is here replaced by a happy meeting. To the left of center Joachim and Anna come together in one of the most memorable embraces in the history of art. Each has been told of the miracle that is to take place, and they are overjoyed. This old and barren couple will soon have a child, a fact they both know and share in this great meeting. The sheer bulk of their two bodies arched toward each other imparts a solidity and stability very different from the *Expulsion* scene. The meshing of their two halos unites them as they tenderly hold each other. Giotto's great range of expressive gesture allows him to operate between widely spaced emotional poles. Compare, for instance, the intimate caress of Anna's hands against her husband's head with the rough, brutal pull of the priest's arm on Joachim's sleeve. The embrace is totally human and causes us to empathize strongly with the action.

There is also a strong formal relationship between the frescoes of *Expulsion* and *Meeting at the Golden Gate*. The former, with its quick rightward movement, opens the drama while propelling the onlooker

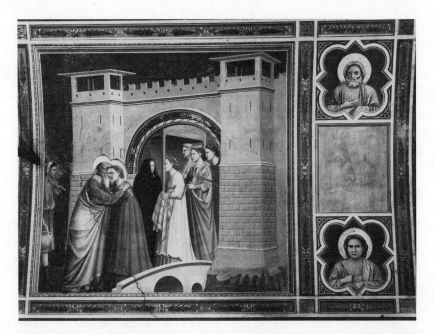

Plate 26. Giotto: *The Meeting at the Golden Gate*. Padua, Arena Chapel

down the register that ends with the much calmer, more static *Meeting*, in which Joachim enters the embrace from outside the picture, the opposite of his role in the *Expulsion*. The thrusting of the priest's arm and Joachim's perilous position are countered and halted by the series of soft, rounded arches seen in the *Meeting*. Thus the very shapes and rhythms of the two frescoes open and close the first register of the right wall and, by contrast, give a fundamentally deeper meaning to each scene. Such stylistic parallelism can be found throughout the chapel. The onlooker who examines the formal relationship between the frescoes of *Visitation* and *Betrayal*, the *Raising of Lazarus*, the *Noli me Tangere* and the *Lamentation*, and others, will see that the juxtaposition between the most basic visual elements of the story is symptomatic of the iconographic relationship between the events in question. Giotto's absolute control of his material and his total understanding of its spiritual meaning has allowed him to create a physical and psychological network of interrelations that is almost beyond belief.

We are not the only onlookers at the meeting, for just inside the gate a group of women is also present. Four do not try to control their emotions as they watch Joachim and Anna; necks crane forward and mouths open in amazement and glee. Their glances toward the embrace direct our eyes, and we, like the women, share the good news.

The older woman just to their left turns her head away. Does she wish to let the couple embrace in private, or is there some other reason for her averted gaze? The meaning of the action is not quite certain, and she is one of those rare figures in the work of Giotto whose purpose is not crystal clear.[17] On the other side of the happy pair stands a man holding a straw basket and a stick. He is obviously intent on entering the gate but has paused for a moment to observe the scene before him. He also serves as a kind of human bracket, closing the left side of the scene with the verticality of his body.

The architecture in this fresco is a great complement to the action. The city gate is a solid, permanent structure that visually echoes the embrace. The oval formed by the two bodies and the shapes of their halos finds its counterpart in the curve of the arch, which opens to the city behind. This same arch shelters the group of onlookers and echoes the arc formed by their heads. The great towers to either side of the gate are strong vertical elements that give the fresco an upward motion impossible without their inclusion. Behind the gate Giotto has included a single building meant to symbolize Jerusalem. This little open structure stands for all the buildings of the city. Such pictorial shorthand is characteristic of the artist throughout the Arena Chapel.

When the treatment of the figures in this scene is examined it becomes immediately clear that they are descendants of the saints and angels of the *Ognissanti Madonna*. The same breadth of the shoulders and torsos appears, as does identical use of the broad fold pattern in the robes. Once again body and drapery work together to produce figures of monumental bearing who stand firmly on the earth, confident of their intrinsic power. They act with slow, dignified movements that perfectly express the state of their minds. Not since the early work of Nicola Pisano had Italy known such beings.

We have seen Giotto strike two different psychological notes in the same stylistic key. In the *Expulsion* the rejection of the sacrifice of Joachim and his expulsion from the temple formed the core of the fresco. A happier message emanates from the *Meeting at the Golden Gate*, for Joachim and Anna embrace with the sure knowledge that they will have a child.

The next scene to be surveyed, *The Flight into Egypt* (which appears after ten frescoes of the life of the Virgin), also projects a single message—that of escape (Plate 27). The biblical text narrates that an angel appeared to the dreaming Joseph and told him to flee:

Arise, and take the young child and his mother, and flee into Egypt,

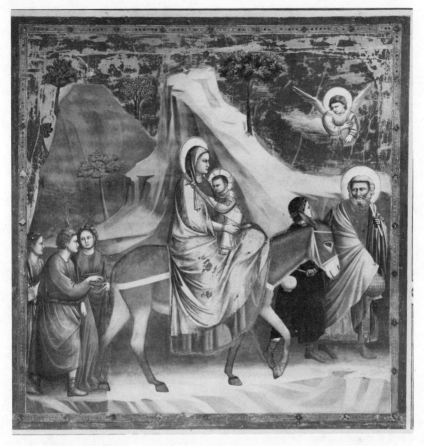

Plate 27. Giotto: *The Flight into Egypt*. Padua, Arena Chapel

and be thou there until I bring thee word: for Herod will seek the young
child to destroy him.

When he arose, he took the young child and his mother by night, and
departed into Egypt. (Matthew 2:13–14)

Giotto's interpretation of the story is, as usual, straightforward. To
the right one sees the angel pointing the way to Egypt. This apparition
hovers over Joseph but looks at Mary as though urging the little group
to greater speed. Joseph is at the very right of the fresco, his sleeve
almost touching the painting's border. He walks on with a purposeful
stride but turns his head back to look at his wife and the Child. Our
glance follows that of Joseph and arrives at the towering figure of the
Virgin holding the Child as she rides on the back of the donkey. Her
face is in full profile, and her gaze is directed past her husband out into

the distance over which she soon will travel. This subtle rhythm of glance and gesture between the angel, Joseph and Mary animates the picture, giving it immediate drama.

Behind the donkey are three youths. The glance of one is directed at the figure with the outstretched arm who looks toward Mary. These boys complete the friezelike development of the picture. All the figures are confined to a rather shallow foreground plane. The real action of flight takes place not from foreground to background but from left to right, the direction of the major compositional rhythms of the scene and of the entire register of frescoes. The marching feet and the intervals of void punctuate the space of the foreground plane and enliven it.

The beat of the flight is carefully echoed by the background. A great stony hill rising behind Mary not only sets her and the Child apart from the rest of the composition by repeating the triangle formed by their torsos but also echoes, on the right, the large triangle that runs from the head of Mary through Christ and down to Joseph's outstretched arm and, on the left, from the Virgin's head toward the heads of the youths. It knits the entire composition together, giving it a cohesive strength and unity.

Even though this is a scene that by its very nature needs landscape, Giotto has held spatial development to a minimum. Knowing that the representation of deep background space would create an illusionistic window in the wall, the artist has made the two mountains relate intimately to the rhythms of the foreground; they also mask any hint of deep space existing behind.

The single relieving note in the composition is struck by the Child. He is bound to his mother by a loop of cloth around her neck, and as he holds on to it he looks backward to see what is happening. The roundness of his infant body and the look of amusement on his face momentarily breaks the tension of the scene. His is a human, childlike action in the midst of a flight for life.

The sense one has of the urgency of the flight and the awful plight of the little group is testimony to Giotto's genius. His understanding of the nature of the story and his ability to distill its most psychologically striking message is extraordinary.

From the *Flight into Egypt* the story continues along the walls of the chapel. After four scenes from Christ's childhood and early adulthood, the narrative comes to *The Raising of Lazarus*, one of the most powerful frescoes in the cycle (Plate 28).

The text narrates how as Jesus wept before the tomb of Lazarus

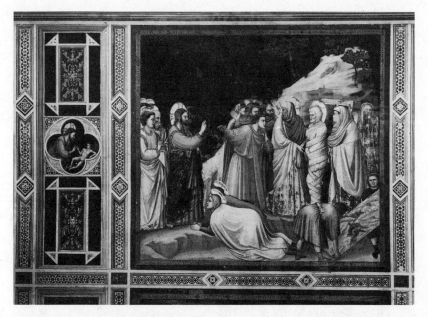

Plate 28. Giotto: *The Raising of Lazarus*. Padua, Arena Chapel

the Jews asked "could not this man, which opened the eyes of the blind, have caused that even this man should not have died?"

The passage continues:

Jesus therefore again groaning in himself cometh to the grave. It was a cave, and a stone lay upon it. Jesus said, "Take ye away the stone." Martha, the sister of him that was dead, saith unto him, "Lord, by this time he stinketh: for he hath been dead four days."

Jesus saith unto her, "Said I not unto thee, that, if thou wouldest believe, thou shouldest see the glory of God?"

Then they took away the stone from the place where the dead was laid. And Jesus lifted up his eyes, and said, "Father I thank thee that thou hast heard me.

"And I knew that thou hearest me always; but because of the people which stand by I said it, that they may believe that thou hast sent me."

And when he thus had spoken, he cried with a loud voice, "Lazarus, come forth."

And he that was dead came forth, bound hand and foot with grave-clothes; and his face was bound about with a napkin. Jesus saith unto them, "Loose him, and let him go." (John 11:38–44)

Giotto has characteristically picked the moment of highest tension— the moment when Lazarus emerges from the tomb. There are many

artistic options within any story, and the painter has a certain amount of freedom in their choice. Giotto, as we shall see, almost always chooses the most dramatic single moment.

The traditional location of the most important action in a painting before Giotto's time was the very center of the composition, but Giotto often shifts the action. For example, in the *Raising of Lazarus* the center of the action does not occur in the center of the fresco. That spot is occupied by one of the onlookers, who raises his arm in astonishment as he intently observes the miracle. His left hand is held to his face with the index finger touching the chin in a traditional gesture of wonderment. His head cranes forward; the neck is stretched to its limit. The right arm is beautifully foreshortened, with a delicate hand cupped in surprise. Thus the man's body leans into space, his head in the direction of Lazarus, while his right hand moves violently in the opposite way toward Christ. This figure is a pivot around which a good deal of the composition revolves; he is the visual link between two parts of the composition.

To the left of the figure is Christ, his arm raised in the act of performing the miracle. His huge eye is fixed on Lazarus; he stands still and tall like some great lonely column. Between Christ's hand, which one feels works the miracle, and the hand of the pivotal figure there is a void. The flow of figures which starts at the very left of the picture is interrupted, and the hand of Christ stands out in isolation. Then the action continues across this gap almost as if an invisible electric charge jumps the space from the hand of Christ to the outstretched arm. This charge is rhythmically carried through the arm of the pivotal figure, up through his strained neck and head and then caught by the hooded figure who turns in the direction of Christ while actually holding Lazarus. One feels that the great energy of Christ's gesture is thus physically transmitted over the void between the two groups of figures and finally to Lazarus via the lowered hand of the cloaked figure touching his side. It is an exciting and moving concept.

To the right of Lazarus action is directed toward Christ by the figure with the covered face who looks toward Christ as he supports the horrible figure who has just left the tomb. Behind these principal actors one sees a whole range of glances and gestures expressive of the action that is taking place in the foreground.

Martha and Mary, Lazarus' sisters, kneel at Christ's feet. Their bodies express both the hope of resurrection and wonderment at the miracle Christ is performing. The taut, suppliant positions of the women reveal the bulk of their bodies, the weight of their presence. Like great

boulders, they decisively and permanently occupy the ground on which they are placed, their shapes and glances forming a bridge between the foreground and Christ.

In the *Raising of Lazarus* it is clear that the light source is from the left, for it is the left side of the figures and the landscape that receives the strongest illumination. Such constant, clear articulation of light is found throughout the Arena frescoes, and it is fascinating to discover that the painted light source on the left and right walls always comes from the direction of the window on the entrance wall, as though the scenes were lit from this opening. This is a unifying feature, for it thus appears that each fresco and every object in it exists within the same atmosphere. Such careful and consistent lighting is indicative of Giotto's desire to tie together the numerous frescoes.

The narrative continues through the *Entry into Jerusalem* and the *Expulsion of the Merchants from the Temple* to *The Pact of Judas* on the altar wall (Plate 29). There are a number of great personal confrontations portrayed in the Arena Chapel. The encounter between Joachim and the priest is full of anger and rejection, that between Joachim and Anna laden with joy and the opposition of Christ and Lazarus filled with wonderment. *The Pact of Judas* is charged with evil.

Judas, one of Christ's followers, is seen in the act of agreeing to betray his master for thirty pieces of silver.[18] This scene is placed on the altar wall because Giotto, or the cycle's planner, wished both to oppose it to the *Visitation*, a scene of joyful meeting, on the other side of the altar wall and to use it as the first episode of the *Passion* series. The pact, the beginning of Christ's passion, represents the most heinous act in Christian history and one that especially appalled the Trecento. In Dante's *Inferno* Judas occupies the center of the lowest level of Hell.

In the fresco the hideous Judas is seen clutching the money bag while he agrees to betray Christ. The three chief rabbis are to the right, the devil behind him. The composition is developed on a long shallow plane, and there is no background except the small portico that frames the two figures to the right. The interaction between the five vertical shapes is beautifully measured, while the exchange of evil glances and the secretive gesturing of the hands also impart a sinister air. There can be no doubt that the devil has Judas in his grip, for he actually shoves him toward the priest. His awful dark claw on Judas' shoulder is proof that the traitor is a lost man. The horrible, misshapen figure of the devil is indeed frightening.

The priests in this fresco form a good example of the figural style in the Arena Chapel. The bodies are slightly elongated, the heads per-

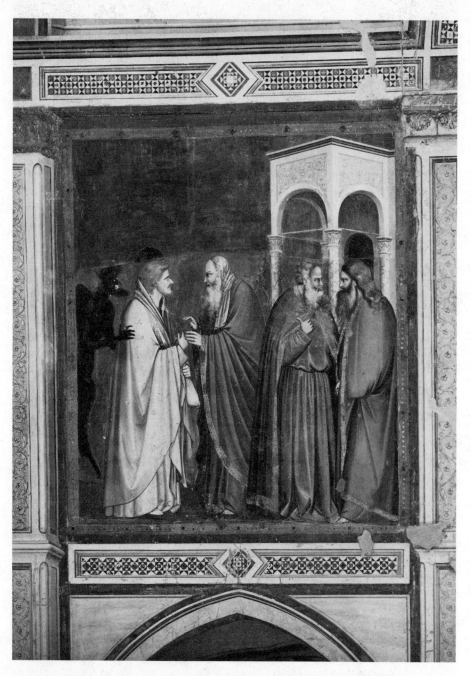

Plate 29. Giotto: *The Pact of Judas*. Padua, Arena Chapel

haps unrealistically small. Such body construction, however, firmly anchors the figure to the ground by forming a great base for the head. The size of the forms indicates that these are substantial men who move slowly and with great dignity. Nowhere in the entire Arena Chapel does one really feel that the figures are like those we encounter in the streets. They belong to a different and higher race who act always with an unflinching seriousness of purpose. Even great happiness is restrained and measured. Evil and sorrow exist, but emotions are held within bounds. Thus, even the minor gesture of one priest to another in *The Pact of Judas* is enough to reveal that Judas is in the devil's clutches and has lost his soul. These small but direct actions play a vital part in the artist's paintings, for they clearly reveal a state of mind or the meaning of a look.

Before leaving the painting we should briefly discuss it in relation to the fresco across from it on the altar wall, *The Visitation*. In both scenes five figures stand near the threshold of a small building. This is significant, for the two stories function almost like thresholds in the chapel's narrative. The meeting of the pregnant Mary and Elizabeth is fraught with the future meaning of life yet to come, while the *Pact* is, as we have seen, a decisive action that leads directly to Christ's passion and death. The marked similarity in the overall composition of these two stories makes the very different nature of their messages—life vs. death—even more separate. Such compositional juxtaposition is typical of Giotto's masterful intertwining of the formal, psychological and iconographic levels of the Arena frescoes.[19]

The Pact of Judas is, after two frescoes (*The Last Supper* and *The Washing of the Feet*), followed by the fulfillment of the bargain made with the chief priests, *The Betrayal of Christ*. Here Giotto has painted one of his finest frescoes (Plate 30).

As always, it is necessary to read the text to understand that the artist has chosen to portray a highly specific dramatic moment:

And while he yet spake, lo, Judas, one of the twelve, came, and with him a great multitude with swords and staves, from the chief priests and elders of the people.

Now he that betrayed him gave them a sign, saying, Whomsoever I shall kiss, that same is he: hold him fast.

And forthwith he came to Jesus, and said, Hail, master; and kissed him.

And Jesus said unto him, Friend, wherefore art thou come? Then came they, and laid hands on Jesus, and took him.

And, behold one of them which were with Jesus stretched out his hand,

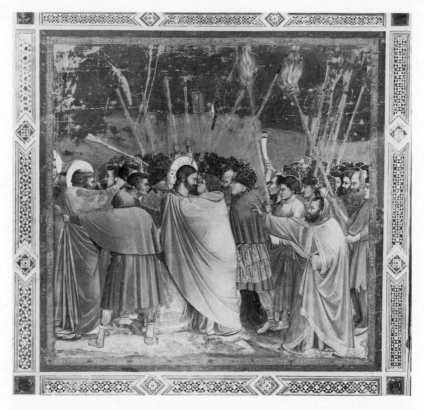

Plate 30. Giotto: *The Betrayal of Christ*. Padua, Arena Chapel

and drew his sword, and struck a servant of the high priest's and smote off his ear.

Then said Jesus unto him, Put up again thy sword into his place: for all they that take the sword shall perish with the sword.

Thinkest thou that I cannot now pray to my Father, and he shall presently give me more than twelve legions of angels? (Matthew 26:47–53)

Turning to the fresco, we see that Christ and Judas are just slightly to the left of center. The linked notions of betrayal and capture are clearly evident. The body of Christ is visible only from the knees down, for he is enfolded by the great yellow cloak of the evil Judas. The capture is not only psychological but actual. Christ is held fast, the heavy folds of the material completely encircling his form. He looks down at Judas, fully aware of what is happening. Judas looks back, his distorted features resembling the face of some mean animal. Between the heads of Christ and Judas are two soldiers' brutal, smirking faces.

Behind encircles a swarm of black helmets which, without revealing a single face or body, suggests a vast and menacing crowd of soldiers. They complete the semicircle that, like the robe of Judas, encloses Christ. Behind this semicircle and to either side wave uplifted spears and lit torches suggesting more people, more agitation, more confusion.

Violent actions also take place to either side of the central group. To the right one of the priests points out Judas to the soldiers and urges them on. We follow his accusing hand and are led once more back to the calm figure of Christ. The priest is a magnificent, powerful being who is beautifully clothed in voluminous heavy folds whose texture we can almost feel. His gesture and the twist of his body into space help us to enter the picture from the right side, turning our attention not toward the background but in the direction of Christ.

To the left we see Peter cutting off the ear of the slave of the high priest. His huge arm is poised purposefully; direct and unstoppable, it slices the ear from the head. Behind Peter is the disappearing head and halo of one of the apostles who all fled during the capture of Christ. The robe of another, held by the man daringly posed with his back to the spectator, is seen to the immediate right of the border. The sense of the flight of the apostles is marvelously conveyed by actually making them disappear behind the space of the frame. They, of course, escape to the side rather than the back, since Giotto is always anxious to keep spatial development in depth as limited as possible.

Now it is clear from the fact that Peter attacks the slave that the moment of action is after the kiss, for the Bible says it was only after this that he cut off the ear. This means the central figures are facing one another in that instant after the kiss when Christ asked his betrayer, "Friend, wherefore art thou come?" Judas has drawn back, just comprehending what has occurred and realizing only now that Christ knew he would be the betrayer. This is one of the most horrible confrontations, not only for Christ but for Judas, who hanged himself afterward. How much more dramatic is this split second than that before the kiss, or the kiss itself. The realization by Judas of the magnitude of his crime and the resignation of Christ to his fate are at once the most dramatic and psychologically gripping moments of the entire scene. It is a testimony to Giotto's sensitive reading of the text that he always fully understands and is able to transmit the greatest dramatic impact of the action described by the stories.[20]

The fresco of *Christ Before Caiaphas* follows *The Betrayal* and is, in turn, followed by *The Mocking of Christ*, perhaps the most brutal

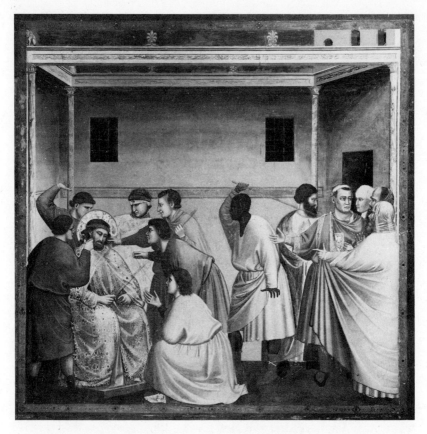

Plate 31. Giotto: *The Mocking of Christ*. Padua, Arena Chapel

scene in the entire Passion series (Plate 31). The text of the story reads:

Then the soldiers of the governor took Jesus into the common hall, and gathered unto him the whole band of soldiers.

And they stripped him, and put on him a scarlet robe.

And when they had platted a crown of thorns, they put it upon his head, and a reed in his right hand: and they bowed the knee before him, and mocked him, saying, Hail, King of the Jews!

And they spit upon him, and took the reed, and smote him on the head.

And after that they had mocked him, they took the robe off from him, and put his own raiment on him, and led him away to crucify him. (Matthew 27:27–31)

Once again Giotto has chosen not to use the center of the composition for the most important action. Christ sits at the low left side, almost

in the corner, the very essence of humiliation expressed by the location and position of his body. By relegating the most important figure to a corner and placing his head at a low level Giotto has marvelously conveyed Christ's plight and shame. Everything else in the painting is aimed at reinforcing the same idea. No heads rise above the dado which runs across the center of the room. Everything is kept low, and only the non-figurative elements of the fresco are allowed to rise to the upper parts of the composition. Christ is the focus of almost all the glances in the painting. To the right two men gesture toward the seated figure, leading the eye to the heart of the action.

Christ is surrounded by his tormentors. One raises his hand to strike, two others pull Christ's beard, while yet another spits on him. A figure kneels in front, jeering and saying, according to Matthew, "Hail, King of the Jews!" Behind this figure a black man is about to strike with a stick.

But what is the reaction of Christ to all this? How does Giotto choose to portray his behavior at this crucial moment of the Passion? What we see here is not the heroic, triumphant Christ but a very human figure who is overcome by the horrible events that swirl around him. If we look carefully we see that his body is slumped back into the chair, his head at an angle, indicating total despair, and his great hands rest heavily and limply on his knees. He is without doubt a powerful figure but one who has lost the capacity to act. This is confirmed by his eyes, which are slightly open but do not see, for they are glazed, unable to focus. Christ is unconscious and has succumbed physically and mentally to the torture he is undergoing. Giotto is always keenly aware of the most basic human emotions and reactions of each of his figures whether it is Joachim, Judas or Christ. We relate to the simple, direct portrayal of these feelings and so are drawn closer to the figures and the fresco they inhabit. The economic form and the clear content work together to constitute a simple, seamless whole.

This is the first scene we have discussed that takes place indoors. The Governor's headquarters is represented by a cut-away room open toward the spectator. The building is supported by four columns and its back wall is pierced by two simple windows. Above, to the right, one sees the windows of another building. This is not architecture meant to impress by its reality. It is similar to good stage architecture, meant to set the scene effectively for the action while interfering as little as possible with the narrative. In *The Mocking of Christ* it allows the spectator to sense the low position of Christ while providing a

large, almost blank wall surface against which the action develops.
Such architecture also helps control the development into space by
providing the narrow plane on which the action takes place and then
stopping the lateral expansion by its visible side walls. Giotto's treat-
ment of architecture is very different from that of the painters before
him, who used it in a much less realistic fashion. Artists like Coppo
and Cimabue often included vividly colored buildings that were
usually out of scale with the figures represented. These were meant to
suggest but not illustrate the locale.[21]

 The Mocking of Christ is followed by *The Road to Calvary* and the
Crucifixion. The Lamentation (Plate 32) begins the sequence of frescoes

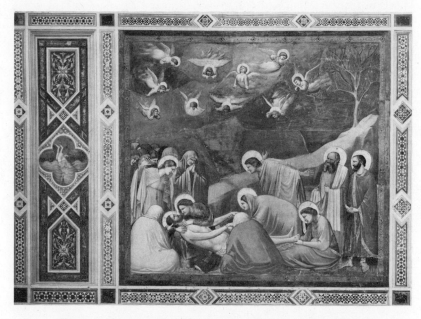

Plate 32. Giotto: *The Lamentation.* Padua, Arena Chapel

that narrates the events after the Crucifixion. On the ground lies the
body of the dead Christ. Once more the focus is shifted to the left,
but here in a lower position than even that of *The Mocking.* All at-
tention is directed to the head of Christ by the long, undulating ridge
of flinty rock that points like a great crooked arrow down toward
his face. At its top stands a leafless tree whose symbolic message of
death and eventual rebirth is clear.

Mary holds Christ in her arms, her face stricken with grief and her body pressed close to his. This is not only the Virgin and Christ but a very human mother and son. Here one is painfully reminded of the Virgin who holds her infant son in Giotto's *Nativity* fresco.[22] Christ's limp hands are held by another of the Marys, who gazes with unbelief at the prone figure. His feet are supported by the sorrowing Mary Magdalen, who completes the great oval enclosing the other Mary, the Virgin and the two seated figures who have their backs turned to the spectators, their boulderlike shapes expressive of a deep but anonymous grief. At each side of the fresco are other mourning figures. The woman with outstretched hands at the left is echoed by the figure of St. John on the right. His arms are flung so far back and his body bent so far forward that he resembles an eagle in flight. The violently sorrow-filled gestures indicate that the body of Christ has just been laid down, and it is only now that his followers first express their enormous grief.

This is mirrored by the angels who hover overhead. Their contorted bodies writhe in torment, and one can almost hear the violent beating of their wings above the cries of human sadness. Some wail into the air; others tear their hair or wring their hands. It is as if the whole cosmos—landscape and trees, humanity and heaven—mourns for the pathetic figure lying on the ground.

The quatrefoil in the left decorative border next to the fresco illustrates Jonah being swallowed by the whale. He was released in three days, a prefiguration of the resurrection of Christ. So this tiny painting is a symbol of hope next to one of the bleakest and most moving pictures ever painted.[23]

A detail of St. John clearly reveals Giotto's treatment of surface (Plate 33). One sees how broadly painted the robe is, the large, bold brush strokes perfectly suited to the rapid and free fresco technique. The daring fold patterns ripple across the surface of the robe like a cascade. One senses that the material is coarse and heavy and can almost feel its weight as it hangs from the body. The outline of the lower part of the face and the neck is not rigidly delineated but only gradually differentiated from the background by a subtle bank of shadow. This line is not static but undulates with great control. The figure has a free, broad, almost abstracted quality that marvelously expresses its function.

Three remaining scenes—the *Noli me Tangere*, the *Ascension* and the *Pentecost*—bring Christ's drama to a close. As the spectator turns to leave he is confronted by the traditional entrance wall scene of

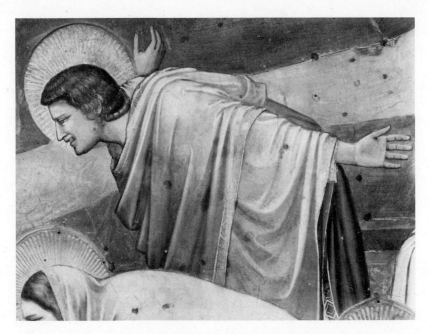

Plate 33. Giotto: Detail of Plate 32

The Last Judgment (Plate 24). Over the doorway Christ sits enthroned, blessing with his right hand and damning with his left. To either side of this majestic figure unfold the representations of heaven and hell. This fresco is the last episode of the story which began with the *Annunciation to Mary* on the opposite wall. Hundreds of figures take part in *The Last Judgment*, and each plays a role in this final scene of the great drama, but aside from the Judging Christ in the center, the painting appears slightly mechanistic and confused. Undoubtedly this is because it is the single fresco in the chapel that Giotto could not humanize, since its dimensions were so vast and the requirements of its iconography so complex. The clear, concise and intimate world of the smaller paintings had to give way to a complicated and impersonal machine.

Thus with *The Last Judgment* we see that the Arena Chapel is really a pictorial chronicle of the events of the Christian drama, and on its walls one sees the beginnings, progress and eventual conclusion of that history. Its frescoes have an existence beyond decoration and narrative, for they illustrate a concept of the world and its destiny relevant to all those who look at and believe in their message.

Giotto also painted a wooden cross for the Arena Chapel which is now in the Museo Civico of Padua (Plate 34).[24] A fruitful comparison

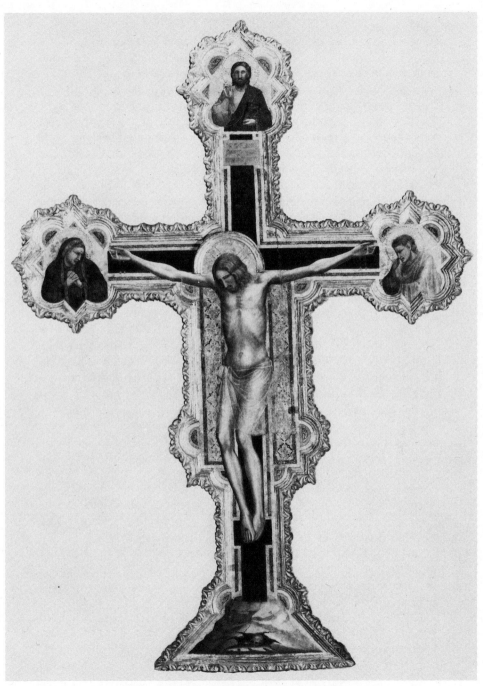

Plate 34. Giotto: *Crucifix*. Padua, Museo Civico

is made by contrasting it with Giotto's earlier cross from Santa Maria Novella. Although smaller and more elaborate than the Florentine cross, the Paduan painting is clearly its stylistic descendant. There is more confidence in the handling of the anatomy and less agitation in Christ's position. The modeling and general treatment of highlight and shadow are more confident and secure. All of the figures seem to occupy space more decisively, and they themselves belong to a slightly more heroic and monumental race. On the other hand, the Santa Maria Novella cross has a frail simplicity that is lacking in the Paduan painting. It still retains some of the interesting and really quite marvelously tentative feeling that is common to it and the San Giorgio alla Costa Madonna. The delicate palette and the filmy treatment of the light and shadow endow these panels with a freshness that was only of the artist's youth. In the cross at the Museo Civico we confront the mature Giotto, the famous painter of the Arena Chapel and the head of what must have been a large shop.

Giotto did not paint all the Arena Chapel himself. He needed helpers to erect the scaffolds which covered the walls and allowed the painters access to the surface that had to be painted. Others were surely employed to plaster the walls, to mix colors and to help with the painting itself. No payment documents are extant, so we have no idea who these people were or how many they numbered. But strangely enough there are no obvious areas of stylistic difference in the chapel.[25] Even to the well-trained eye each fresco is of a stylistically harmonious nature. That this was possible with such a large workshop indicates the high perfection of the working methods of a Trecento shop. As Cennino states, the young students were encouraged to copy the style of their masters and to make it their own.[26] This ability to submerge artistic individuality is responsible for the creation of pictorial unity in large fresco cycles such as the Arena Chapel. There can be no doubt that there was also a master plan for the frescoes. This probably consisted of rather careful underdrawings of some type. No sinopie have been recovered from the Arena Chapel, but this does not mean there were none. Perhaps they exist and have not been discovered, or it is possible that preparatory drawings done in some other material or in another fashion exist under the frescoes. It is inconceivable that such a carefully balanced, measured work could have been completed without rather detailed guidelines. These guidelines must have contributed to the achievement of a stylistic unity, for by following them the artists working under Giotto's direction had to adhere to the master's own system of proportion, space and line. It is also likely that

Giotto kept tight personal control over the artists working for him and that a great deal of each scene is by his own hand. Assistants may have put in the large, broad areas, such as the sky or mountains, but one must logically assume that Giotto, as the master in charge, was responsible for most of the more important details in the chapel. In any case, probably no one painting is the product of a single hand but, rather, the result of a combined effort of the shop. There can, however, be no question that the ideation of the entire decorative scheme as well as the individual frescoes was the creation of the mind of Giotto. It was he who planned the cycle and it was he who was certainly responsible for its execution.

The Arena Chapel remains the most beautiful and important fresco cycle of the Trecento. It is Giotto's masterpiece. Before he began work in Padua he was already a well-known and sought-after painter. By the time the Arena Chapel was finished he must have been the most famous artist in Italy and, perhaps, all Europe. We know very little about the major work that immediately followed the Arena Chapel, for it has not survived. The next substantial evidence of his progress is found in two fresco cycles in the church of Santa Croce in Florence. These are in the Bardi and Peruzzi Chapels, and they reveal not the Giotto of the Paduan paintings but a more fully developed, more mature and, perhaps, even more penetrating artist.

V

Santa Croce—The Bardi and Peruzzi Chapels

 The Bardi and Peruzzi Chapels are situated off the right transept of the great Franciscan church of Santa Croce in Florence, the first and second chapels to the right of the choir (Plate 35). Each contains a single tall lancet window and is roofed by a quadripartite vault.[1]

As is the case with most of Giotto's work, no documentation exists for the Bardi Chapel. We do not know when it was painted nor how long the painting took. The Bardi were one of the great Florentine banking families, and the chapel is just one of at least three that they, or branches of their clan, had in Santa Croce.[2] In the Trecento, as in later times, families actually owned chapels in the Florentine churches. They were allowed to decorate their walls, hang coats of arms in them and even to sell them to other families.[3]

There is little reference to the Bardi Chapel in the older literature. The pre-Vasari sources mention four chapels in Santa Croce by Giotto, but they do not really describe which ones are meant.[4] Vasari himself is more specific. He says, "In the first of these [chapels], that of M. Ridolfo dei Bardi, in which the bell-ropes hang, is the life of St. Francis, at whose death a number of friars display very faithfully the emotion of weeping."[5] The second chapel, Vasari tells us, is the Peruzzi's and the third that of the Giugni family.[6] The latter no longer has paintings, and no fourteenth-century documents survive to connect Giotto's name with it. The fourth chapel mentioned by Vasari is that once belonging to the Tosinghi-Spinelli family.[7] This is on the other side of the transept, across from the Bardi and Peruzzi, and nothing remains of its decoration except an *Assumption of the Virgin* painted on the wall above the chapel. This is certainly not by Giotto and has been

Plate 35. Bardi and Peruzzi Chapels. Florence, Santa Croce.
(Far left, Bardi; middle, Peruzzi)

convincingly attributed to the Maestro di Figline, a minor follower of the master.[8] The Bardi Chapel, as we can now see, is not documented to Giotto either by contemporary work payments or specifically attributed to him in the earliest literature. There has been little doubt, however, that it is by Giotto.[9]

In the early eighteenth century the taste for the Trecento was at its nadir, and the frescoes of Giotto and his contemporaries in Santa Croce were considered crude. Many were covered and not rediscovered until the nineteenth century. This is, in fact, what happened to the Bardi frescoes, which were found under a coat of whitewash only in 1853. As soon as they were discovered they were restored. In mid-nineteenth-century terms this meant a repainting of the surface. When the whitewash was removed in the 1850s the paintings were in a very bad state of repair. Much paint had been lost, and there were two huge areas of damage where tombs had been set into the walls. The restorer, Gaetano Bianchi, imaginatively filled in these gaps and freshened the rest of the surface. Unfortunately, the result was an almost modern set of frescoes.[10]

The paintings existed in this state until the 1950s, when a modern restoration removed all the Bianchi repaint. Since a great deal of original pigment had been lost, the recent restoration left large areas of blank wall. At first sight the result is disconcerting, but we must remember that what remains is truly Giotto's, and, although in rather bad condition, it does reveal his original intentions.

The cycle consists of six narrative frescoes. Three are on the left wall and three on the right. The narrative begins in the lunette of the left wall with *Francis Renouncing Worldly Goods*. It continues in the opposite lunette with the *Approval of the Franciscan Rule*. It then moves back to the left wall and the *Apparition of St. Francis at Arles*. The second painting of the opposite wall illustrates the *Trial by Fire*. At the bottom left is the *Death of St. Francis* and the *Verification of the Stigmata*. The cycle ends on the right wall with the *Visions of Brother Agostino and Bishop Guido of Assisi*.[11]

The vault contains the remains of four painted medallions, and the intrados of the entrance arch is decorated with quatrefoils containing busts of saints. On the altar wall, to each side of the stained-glass window, were four figures. Only three of these remain. They are Saints Louis of Toulouse, Clare and Elizabeth of Hungary, all Franciscans.

Another fresco, on the transept wall above the entrance arch, also belongs to the cycle, although it is not actually within the chapel. This

Stigmatization of St. Francis depicts the saint receiving the stigmata in the rocky landscape near La Verna. The fresco is related to the *Assumption of Mary* in the same position over the Tosinghi-Spinelli chapel just to the other side of the choir, for St. Francis received the stigmata on the day of the celebration of the Feast of the Assumption.[12]

Before turning to a discussion of some of the individual frescoes it might be well to point out that much of the paint, even where it exists in relatively large patches, has been damaged. A great deal of the subtle surface of the fresco has worn away, and chemical changes have altered some of the original hues. At first glance one is struck by how much more somber the Bardi frescoes seem than those at Padua. This impression comes mainly from the variegated brown-gray habits worn by the Franciscans, who figure so predominantly in the majority of the scenes. Giotto surely realized that this would happen and took advantage of it by utilizing this cool hue not only as a unifying force from scene to scene but also as a coloristic symbol of the Franciscans. But it is not only the Franciscan habits that are subdued. The overall palette is here more limited. The colors of the Arena Chapel are modified. The brighter, compacted yellows, blues and gray-whites have been replaced by a generally more restrained set of hues. Aside from the brown-gray of the habits, reds, whites and purples are seen. There are a number of saturated colors, but they are rather isolated and are the exception rather than the rule. Some higher whites, purples and yellows do appear, striking an unusual note against the carefully constructed palette.

One of the most interesting frescoes in the Bardi Chapel is *The Trial by Fire* (Plate 36). This concerns St. Francis' trip to Egypt and his efforts to convert the sultan of that country. We see the sultan sitting on a magnificent throne in the center of the composition. He looks to his right at a group of his advisers, who flee rather than submit to a test of fire that Francis has suggested to demonstrate the veracity of Christianity. To the right, Francis and a brother are seen before a very hot fire. The saint shields his face from the flames as he makes ready to enter them. It is, however, clear to the sultan that the faith of Francis is indeed the stronger; in fact, he later converted to Christianity.

Giotto has seen that the real center of the narrative is not Francis but the sultan, for it is around him that the action revolves and it is he who manifests the profound psychological changes that will lead to his eventual conversion. By placing the sultan in the exact center of the composition and by raising him on a high throne Giotto has physically

Plate 36. Giotto: *The Trial by Fire*. Florence, Santa Croce, Bardi Chapel

isolated the ruler from the rest of the action. Then, by making his head turn in one direction, toward his fleeing subjects, and his arm and shoulder in another, toward Francis, the artist has made the physical tension of the sultan's body mirror his mental tension. The majestic and powerful ruler is torn and perplexed by the events that take place to either side. He is the pivot point of the fresco, and the spectator's glance keeps darting from him to the groups flanking the throne. This highly ingenious invention inspired several copies in the Trecento and Quattrocento.

The scene is set against a wall decorated with finials and hung with drapery. At each end two small side walls project outward. They both have doors, and through the one on the left the first of the sultan's men disappears. Above the wall is an expanse of blue sky. The introduction of such a broad backing wall is seldom found in Padua, where a simple single element was rarely allowed to set the stage for the entire action in the fresco. Perhaps it is utilized in the Bardi Chapel because there is more longitudinal space. The frescoes are no longer square but rectangular. We do not know why the change in shape took place, but the most likely reason seems to be found in the shape of the chapel itself. Its high but not terribly wide walls seem much more adequately

suited to the longer rectangular format than the square one. And, in fact, most of the other transept chapels in the church contain frescoes of the same shape. There is no doubt, however, that had he or his patron wanted, Giotto could have made two square frescoes fit comfortably into the space now occupied by each of the Bardi paintings, except, of course, for the lunettes whose shape is dictated by the chapel's vault. It thus seems as though Giotto was quite interested in the flow of the narrative across the picture plane at the time he painted the Bardi Chapel. This can be seen by observing how he extends his figures across the surface of *The Trial by Fire*. The rhythm of the movement from side to side is more attenuated than in any of the frescoes we have seen in the Arena Chapel; the elaborate group of the sultan's men is a good case in point.

To the side of the sultan stand two blacks (Plate 37). They, like the ruler, observe the fleeing group. The foremost tries to restrain the bearded man next to him while pointing out what is happening on the other side of the fresco. The beautiful light yellow robe and white turban of the man with the beard are magnificently rendered by large, flashing brush strokes that give the surface a vivacity and life of its own. This exquisitely rendered figure holding his robes in preparation for flight is one of Giotto's most beautiful creations. The V-shaped folds of the heavy material form a swelling crescendo of line as they move up the body. The impression of the ampleness of the cloth and the breadth of its extension is marvelous indeed. Here is fresco painting at its best. One can almost imagine Giotto standing on the scaffold before the fresco, painting in this great passage with the sure, rapid strokes of a broad, heavily loaded brush. There is a confidence and ability about this figure that is unmatched in Trecento Florence, and it is equal to the best figures of the Arena Chapel. The robes of this man blend into those of the figure to the left, who is even more intent on fleeing, his body bent and his head directed toward escape through the door. Halfway through this door we see yet another figure. Although this area is badly damaged, one can still make out the hood and back of this man who has achieved his goal, escape. This passage can profitably be compared to *The Betrayal of Christ* in Padua, where the apostles flee out of the picture space. There, however, the treatment seems less sophisticated than it does in the Bardi Chapel.

It is almost as though this group to the left of the sultan represents the flight of one man. Its cinematic quality can be compared to the sequence experienced by viewing successive film frames of the action of a single person. All the motions that each of the sultan's men have

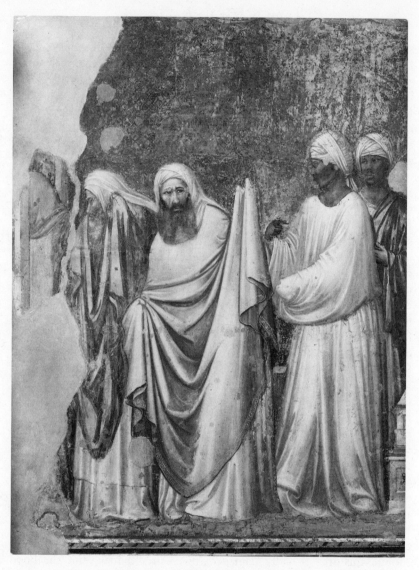

Plate 37. Giotto: Detail of Plate 36

gone or will go through—fear, preparation for flight and escape—are represented by these three men.

As in the Paduan frescoes, the development of background space is quite restricted. The idea of the total decoration of the chapel has not been forgotten and has, if anything, been reinforced. The actual space is smaller and the viewer closer to the frescoes. Thus, any major breaks in the wall surface by the introduction of deep illusionistic perspective would be even more obvious.

The *Trial by Fire*, like all the other paintings in the Bardi Chapel, shows many affinities with the Paduan frescoes. The basic mode of composition, a consistent light source that coincides with the light from the chapel's window, the construction of the space and of the figures who inhabit that space, all remain more or less the same. The color is different but not so much so that one would not recognize the palette of the Bardi Chapel as Giotto's. But with all these similarities there are also modifications. The figures are slightly more elongated and move with a newly found grace. The treatment of drapery seems more fluid and elaborate and does not reveal quite as much of the figure underneath as it did in the Arena Chapel. The Bardi paintings appear to be broader and more relaxed. There is more amplitude and less of the ferocious intellectual and visual concentration on exposition of narrative found in the Paduan paintings.

Complex architecture appears for the first time in *The Apparition of St. Francis at Arles* (Plate 38). This illustrates the saint's miraculous appearance to the brothers of the convent at Arles during a sermon by St. Anthony of Padua. The scene takes place within a pavilionlike cloister. Covered by a pink tile roof, the structure is supported by four slender piers. Two gray-green side walls move toward the spectator. This portrayal of the projecting walls to either side is quite like that of the composition of the *Trial by Fire*. Francis appears inside the central arch of the building, his arms upraised. Behind is yet another wall, with what appear to be painted decorations. It is at once obvious that there are various layers of space involved in this building. It is not the simple, straightforward architecture of the *Mocking of Christ* or of any of the other frescoes at Padua. The very complexity of this building is evidence of Giotto's increasing interest in the presentation of the figure in action within an ambiance that has spatial development of its own. This will become an even more important factor in the compositional construction of the Peruzzi Chapel.

In the *Apparition*, and in many other frescoes in the Bardi and Peruzzi cycles, the walls of the buildings farthest from the chapels'

Plate 38. Giotto: *The Apparition of St. Francis at Arles.*
Florence, Santa Croce, Bardi Chapel

real entrance arches are more oblique than those nearer the arches.
These sharply oblique walls reveal more of their surface, indicating
that the spectator's view of them is to the right or left, depending at
which of the chapel's walls he is looking. It seems that Giotto wished
to make the frescoes' architecture generally correspond to a single
point of view set near the entrance arches, thus securely locating the
onlooker's position in relation to the paintings and so establishing a
highly unified relationship with the viewer.

Giotto uses certain other devices that indicate an ever-increasing
desire to make the spatial play of the picture more complex. One notes
that only one of the side walls has a door and that this leads out into
another part of the building not clearly visible. We can see the roof
from above while looking into the space underneath the brothers'
benches. There is a lack of that absolute clarity of the function of each
architectural member found in the Arena Chapel. Symbolic architec-
ture, such as the Golden Gate at Padua, has been replaced by structures
in which people actually seem to live and act.[13] Like real architecture,
it has all the spatial and structural complications associated with a
three-dimensional object existing in the physical world.

There can be no doubt this spatial development demonstrates a
desire by Giotto to enlarge the boundaries of pictorial representa-

tion. The balance of the Arena Chapel is classic; perhaps never before in Europe had such a perfectly harmonious formal and intellectual world been portrayed. But like all things classic, this conception could not last even in the mind that forged it. Giotto must have realized that there were other challenges and problems involved in the representation of narrative drama than he had confronted in Padua, no matter how perfect his solution had been there. The *Apparition of St. Francis at Arles* and the other Bardi frescoes show the master grappling with new ideas and struggling to give them concrete form.

Perhaps the desire to make this a spatially interesting scene caused Giotto to ease up a bit on the concentrated narrative exposition usually found in his frescoes. There is a curious absence of drama in this fresco, partially, perhaps, because it is not a story filled with tension. The apparition of Francis seems to be taking place without much agitation on the part of the brothers. They are arranged in two groups in front of him. Some read, some look up, but hardly anyone appears startled. There are several daring features, such as the row of tonsured heads just peeping up behind the low wall on the right side. This device to represent people enclosed by space was used as early as the Paduan *Expulsion of Joachim from the Temple* (Plate 25), but here not even the faces are allowed to show. The silent and anonymous row of figures with their backs turned to the onlooker in the left foreground suggest the great boulderlike shapes of the seated figures in the *Lamentation*. Francis himself is meant to hover in the air, but Giotto's figural construction implies so much weight that it is difficult for him to depict a floating figure convincingly.[14] Only with figures in violent action, like the angels in the *Lamentation*, has he been able to give hovering shapes more believability (Plate 32).

The lateral spatial development so characteristic of the scenes in the Bardi is continued and brought to a logical conclusion in *The Death of St. Francis and the Verification of the Stigmata* (Plate 39).[15] This scene closes the cycle by depicting the saint's soul ascending to heaven and the confirmation of the stigmata by the skeptic Jerome, who thrusts his fingers into the wound in Francis' side. Unfortunately, the painting has been badly disfigured by the large lacunae where a tomb was set into the wall while the cycle was still covered with whitewash.

Once again the narrative extends laterally across the surface of the fresco. Action takes place before a paneled wall terminated by two projecting walls, each with a door leading out of the central area. On the basis of a copy of this fresco by Taddeo Gaddi in the Florentine Accademia there is some reason to believe that the two ghostlike areas

Plate 39. Giotto: *The Death of St. Francis and the Verification of the
Stigmata*. Florence, Santa Croce, Bardi Chapel

to either side of the ascending Francis once contained gable roofs.[16]
If this is so, they would have added a vertical thrust to the now pre-
dominantly horizontal composition.

Of course the main focus of attention is the body of Francis lying
in the center of the composition, and all of the action is directed toward
it. At each end of the fresco stand groups which function as figural
parentheses, enframing the central scene. These contain sturdy, dignified
figures, both lay and clerical. They act as a silent chorus, each express-
ing the grief felt in the passing of the saint, while their vertical bodies
enclose the much more complicated movement of the center.

Around Francis is enacted one of the most beautiful and pathetic
displays of human emotion ever painted by Giotto. Three figures kneel
in front of the saint, their bodies arched in intense concentration. One
of them, Jerome, lifts the cloak and places his fingers into the sacred
wound to discover that it is in fact real, a holy stigmata.

Behind the saint one sees Giotto's composition at its best. The
monks are shown in a beautifully expressive display of mourning. This
is not the crescendo of grief that one sees in the *Lamentation* of the
Arena Chapel but a more restrained adagio of sorrow. The configura-
tion of raised hands, bowed heads and contorted faces remains in one's

mind long after leaving the chapel. Slow, silent and measured, the beautiful rhythm of the majestic Franciscans sways around the recumbent body of their leader. The still, geometric figure that the shapes perform is one of the most sophisticated passages in all the painter's work. Especially touching are the monks who kiss Francis' hand and feet. But it is not these brothers who observe the soul of the saint ascend to heaven. This great privilege is reserved for a single person—the monk just behind the head of the saint. It is he, and he alone, who looks up and raises his hand in amazement as he sees Francis' soul borne off by the angels. The large, free brush strokes define and shape this simple Franciscan's habit, making it into a glorious garment. This alive and sensitive figure is typical of Giotto's later style.

A detail of this part of the fresco reveals how broadly the figures are painted (Plate 40). There is even more synthesis than in the Arena

Plate 40. Giotto: Detail of Plate 39

Chapel. The abstraction of body and drapery is also greater, and the brush seems to slash across the surface of the wall with complete and masterful confidence and economy. Note the folds in the monks' robes or the abstracted treatment of the facial features.

On the whole, the stylistic and iconographic ties between the

Bardi and the Arena Chapels are rather easy to understand. Both fresco cycles are surely in the mainstream of Giotto's development as an artist, and each contains the same understanding and portrayal of narrative. That is not to say there are no changes, for there are. Differences in format, palette, space and treatment of the figure are seen everywhere. These, however, are not the result of a different artist at work but rather of a process of artistic evolution. We do not know how much time elapsed between the painting of the Arena and Bardi Chapels, but, on the basis of the stylistic evidence, it must be measured in decades rather than years. On the walls of the Bardi Chapel we see an even more confident artist, one with greater powers of representation but a painter still working within the conceptual boundary of the style first seen in Padua. In the Peruzzi Chapel this is no longer so.

The Peruzzi Chapel adjoins the Bardi (Plate 35). Its frescoes are of identical size and shape and, like those in the Bardi, were whitewashed, only to be rediscovered in 1841 and then overpainted.[17] Like the Bardi, it is roofed by a quadripartite vault decorated with four painted medallions and fronted by a pointed entrance arch with frescoes of half-length figures on the intrados. It also shares the same division of six frescoes, three to a wall. A lancet window with stained glass gives illumination to the chapel; on the wall around it were painted other decorations now lost. Above the window's arch remains a fresco medallion of the Apocalyptic Lamb.

At first glance the Peruzzi frescoes seem to be better preserved than those of the Bardi Chapel, but closer observation finds this not to be the case. Unlike the paintings in the Bardi Chapel, they have been painted *al secco*; the plaster was allowed to dry before the pigment was applied. This technique allows for a less hurried application of the paint, but it is less durable, especially when mistreated. Although there are no huge areas of total paint loss in the Peruzzi, there is a general overall ruin. Much of the upper layers of pigment has been abraded or fallen away; it is as though the frescoes had been skinned. The vibrant life imparted by the final layer of paint is missing, and the essential subtle highlights, shadows and detailed decorations are lost. In the places of worst damage the frescoes have been worn away so badly that they seem ghostly images of their original splendor.[18]

One has to be especially cautious when describing the colors of the Peruzzi frescoes, since they have undergone much abrasion and change. There are, however, certain basic statements that can be made. In the first place, the color is quite different from that of the Bardi frescoes

or, for that matter, from the Paduan paintings. It is, without doubt, lighter and more variegated. Colors are higher keyed; greens, yellows, purples, blues and pinks are dominant. Nowhere are the hues as localized as in the frescoes of the Bardi and Arena Chapels. The light gray and cream architecture of the former has in places turned to pink and green, giving a strange, new, almost gay note to the paintings. A whole new set of color harmonies appear. Purple and yellow, pink and green, yellow and pink, pink and white are placed side by side in a way quite foreign to the earlier painting. One feels that there is an almost pastel quality to the overall coloristic effect of the chapel. Hues seem to float across the surface of the painting, imparting more lightness than in any other of Giotto's works.

The frescoes were paid for by the powerful Peruzzi family, who, like the Bardi, were engaged in the lucrative profession of international banking. Unfortunately, no records of the commissioning or payment of Giotto have survived, and no securely documented date can be assigned to the paintings.[19]

The left wall of the chapel contains scenes of the life of St. John the Baptist, while the right wall is devoted to the legend of John the Evangelist. Most likely the fresco's theme was dictated by the patron's first name—Giovanni, or John.[20] The lunette of the left wall contains the *Annunciation to Zacharias*, the middle fresco depicts the *Birth and Naming of the Saint* and the lower painting his *Beheading* and the *Feast of Herod. John the Evangelist on Patmos* forms the subject for the lunette of the right wall; the next fresco illustrates John's *Raising of Drusiana*, and the lowest and last painting depicts his *Assumption*. All the frescoes, like those in the Arena and Bardi Chapels, are lit in the direction of the tall lancet window, the chapel's actual light source.

There is one simple difference between the flow of narrative in the Bardi and Peruzzi Chapels. In the Bardi it is necessary to go back and forth from one wall to another to follow the story in chronological sequence, while in the Peruzzi one must read down one wall and then go to the top of the other and follow the frescoes downward. This is, of course, a logical arrangement for the division of a chapel when each wall is to be devoted to separate subjects. It is interesting to note the three types of narrative pattern Giotto uses in the Arena, Bardi and Peruzzi cycles. In the first, one follows the narrative around from left to right, top to bottom. The second goes from wall to wall, moving from the highest to the lowest fresco. The third is a simple lunette-to-lowest-fresco scheme on each wall. Each of the arrangements is, however, perfectly suited to both its subject and location and gives proof

of Giotto's unfailing ability to articulate correctly and sensitively the narrative sequence.[21]

The *Feast of Herod and the Presentation of the Head of St. John the Baptist* (Plate 41), the lowest fresco on the left wall, contains a

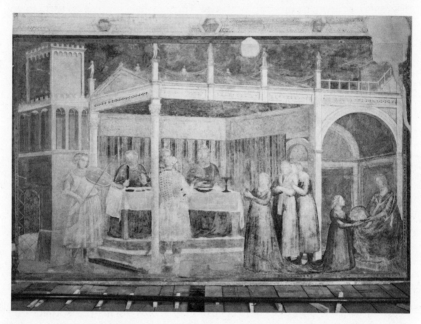

Plate 41. Giotto: *The Feast of Herod and the Presentation of the Head of St. John the Baptist.* Florence, Santa Croce, Peruzzi Chapel

rather amazing departure in Giotto's art. Two separate scenes that took place at two different moments in time are seen occurring simultaneously. This simultaneous narrative is quite foreign to Giotto's style as it evolved from the Arena Chapel.

Unlike the frescoes of the Arena Chapel, or the Bardi for that matter, there is no single focus in the *Feast of Herod*. To the far lower left is the headless body of St. John protruding from the prison in which he had been held and executed.[22] The center of the fresco is devoted to the banquet itself. Herod and his men sit behind a table, viewing the saint's severed head, which has just been brought in on a salver. To the right, Salome interrupts her dance to stare at the grisly spectacle. Behind her two servants look on with fascination at the horrible sight. At the far right the head is seen once more as Salome presents it to her mother Herodias, the perpetrator of the crime. Thus,

we see the head and Salome twice in two consecutive scenes. Obviously there can be no single highly dramatic moment to the fresco. The concept of the whole painting revolving around the central most dramatic second that was the foundation of the frescoes in the Arena and Bardi Chapels is alien to the Peruzzi *Feast of Herod*. One at once wonders why Giotto has abandoned this previously vital part of his art. When one looks at the other paintings in the Peruzzi Chapel one sees that the Herod scene is not the unique example of the simultaneous narrative, for the fresco above it, *The Birth and Naming of St. John the Baptist*, also contains two stories.

Why should Giotto have done this? There are any number of plausible answers, but two remain the most logical. The first is that it was the wish of the patron to have the artist include the two stories. This is, of course, entirely possible and can never be overlooked. But in light of Giotto's increasing experimentation in the use of space in the Bardi Chapel it may make more sense to consider the frescoes with simultaneous narratives part of the artist's development toward the representation of a more spatially complicated composition. Could not the painter have become interested in the portrayal of various moments in time, in the sequence of the narrative, as well as in the increased complexity of architecture and the space within it? Simultaneous narration was, of course, used in much pre-Giottesque art, but never before had it appeared in such convincing space and thus seemed so real.

In fact architecture, and a rather more complicated architecture than we have seen so far, sets the scene for the Herod fresco. The body of John the Baptist is placed in the tower, which, by its shape and pink color, is slightly isolated from the rest of the composition. Then there is the pavilion in which the banquet takes place. The rectangular room covered by a gabled roof decorated with small classically inspired nudes —probably to suggest a pagan setting—defines the space allotted for the dining scene. The transition between it and the tower is somewhat masked by the beautiful shape of the viola player (whose striped robe echoes the movement of his bow) positioned between the two sections of the painting. A door separates the *Feast* from the *Presentation* of the Baptist's Head to Herodias. This act is framed by the architectural boundaries of the little vaulted room before which it takes place. A connection between the *Presentation* and the *Banquet* section also exists in the long train of Salome's green gown, the hem of which touches the robes of the other figure of Salome to unite this dual representation.[23]

Even the architecture as a whole is given a different emphasis, for the building in which the two scenes take place does not run exactly parallel to the picture plane. Instead, it is set at an angle and moves slightly back into space. The vaulted room seems, for example, farther back than the column against which the man holding the head of the Baptist stands. The viewer gets a good indication of this recession when he looks at the two steps on which the table is placed.

Now the creation of such a space is quite foreign to the principles of Giotto's art as we have seen them thus far. True, some recession of architecture was observed as early as the first scene of the Arena Chapel in the temple in the *Expulsion of Joachim* (Plate 25). But never in any previous fresco did Giotto create such a strong recession. Nor was he ever before so interested in the sheer spatial complexities of architectural space. The play of the gable, columns and arches of the building and the way the vaulted room is seen from the banqueting hall are quite new.

Innovation and movement away from old principles also characterizes the middle fresco of the right wall, *The Raising of Drusiana* (Plate 42). The scene is a simple one. The center of the composition is occupied by Drusiana, who, miraculously brought to life by St. John,

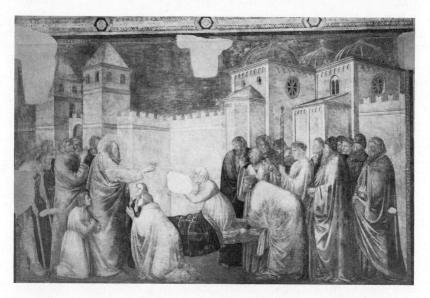

Plate 42. Giotto: *The Raising of Drusiana*. Florence, Santa Croce, Peruzzi Chapel

sits up on the bier and clasps her hands together in a gesture of prayerful thanks. John, backed by onlookers and almost surrounded by kneeling figures, performs the miracle with his outstretched hand. To the right of Drusiana there is another group of spectators. This is larger than that on the left, but both act as brackets enframing the central scene of the miraculous raising. Behind the foreground action appears a walled city complete with towers and domes in a scale that has never before been seen in any of Giotto's frescoes.

A good comparison with the *Raising of Drusiana* is the *Raising of Lazarus* from the Arena Chapel (Plate 28). Both frescoes center around a resurrection and are generally composed in the same manner. In the Paduan fresco Christ stands to the left and with the force of his upraised hand brings Lazarus back to life. The Peruzzi painting repeats the same scheme, replacing Christ with St. John and Lazarus with Drusiana. Kneeling figures appear in front of each of the miracle workers. There seems to be little doubt that the artist recalled his Paduan fresco of years before when he designed the *Raising of Drusiana*, and the similarities are the strongest in the overall compositional arrangement of the paintings. But a comparison of the two works quickly reveals just how much Giotto's style has evolved since the Arena Chapel.

The fresco at Padua is charged with almost electric energy. Everything is concentrated on the great miracle that is being performed. Each nerve and muscle of the individual figures appears to be devoted to the great act that is taking place. Only the bare essentials have been included. The landscape has been reduced to the rocky hill behind Lazarus which acts as a foil and support for the scene before it. Our eyes focus on the splendid figure of Christ, whose isolated hand alone seems capable of performing the resurrection.

In the Peruzzi fresco this enormous concentration is lessened. The wide horizontal expansion of the picture tends to relax the action across the entire surface. The grouping of the figures is neither as tight nor as directed as in the Lazarus fresco. We sense that we are in the presence of a miracle, but that tense excitement associated with almost all the Arena frescoes is gone. Instead of distilled drama we are here presented with a more open and free treatment of narrative. On the shallow foreground plane the elegant and elongated figures seem to be performing some exquisite ritual. They work miracles, pray, are amazed or look on with a more detached attitude than we have ever seen in a work by Giotto. The great space between the hand of John and Drusiana does not seem so pregnant with energy as is the void around the hand of

Christ in the Paduan fresco. The supernatural quality of the Arena Chapel painting—well illustrated by the beautifully evocative display of hands and their gestures—is totally missing from the *Raising of Drusiana*. This is not to say that the Peruzzi fresco is inferior to the Lazarus scene, for in many ways it is not. Rather, it is different, depending on the slow rhythm of the vertical bodies and the sweeping drapery to unite the horizontal expanse of the work.

Again as in the *Apparition of St. Francis at Arles* or *The Feast of Herod*, the single-minded concentration on the dramatic heart of the story has been slackened. A good illustration of this looser narrative construction may be seen in the background of the *Raising of Drusiana*. Never has Giotto created such an open and monumental backdrop for his painted drama. To be sure, the gate in the Arena Chapel *Meeting at the Golden Gate* (Plate 26) is large and impressive, but it is symbolic architecture meant to suggest the portal and the town beyond. Here we have a much more realistic portrayal of what a medieval city must have looked like from the outside. The turning of the wall and the various angles and shapes of the buildings and the size of the structure in relation to the people who stand before them suggests a great expanse of space. By introducing similar spatial characteristics into the other paintings we have surveyed in the Bardi and Peruzzi Chapels, Giotto has moved away from the austerely conceived scenes of the Paduan frescoes toward a new, more open and accessible presentation of sacred narrative. We can now feel more rapport with the environment; our eyes are allowed to wander over the manifold and interesting details that make up the human ambiance. These ghostly images on the walls of the Bardi and Peruzzi Chapels clearly reveal that Giotto was after something more than the classical rendition of charged human drama which he so masterfully achieved in Padua. Like every great artist he always strove to solve new problems and was constantly adjusting and modifying his style. The differences we see between Padua and Florence are the result of new experiences and further artistic development.

One of these new experiences may have been Giotto's introduction to the then most celebrated panel painting in Tuscany, Duccio's *Maestà*, originally painted for the high altar of the Sienese cathedral and now in the Museo dell'Opera del Duomo in Siena.[24] So famous was this work that a reduced variation of it by Duccio's follower, Ugolino da Siena, was placed on the high altar of Santa Croce around 1320.[25] The very fact that a Sienese artist would have been given such an important

Florentine commission indicates the renown of Duccio and the *Maestà*. This large work, painted between 1308 and 1311, was begun about two years after the Arena paintings and finished well before the Bardi and Peruzzi Chapels. There can be little doubt that Giotto knew the painting or copies of it.

What the *Maestà* contained and the Paduan frescoes did not was a fascination with and love for the complexities of the world around us. Thus, in six scenes from the back of the *Maestà* devoted to the representation of the Passion, one sees Duccio's joy in representing the natural ambiance (Plate 43). With grace and beauty he places the little

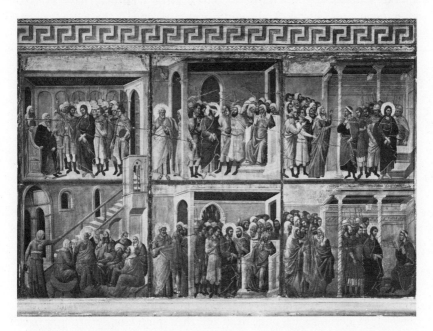

Plate 43. Duccio: Passion Scenes. Detail of the *Maestà*. Siena, Museo dell'Opera del Duomo

stories in spatially fascinating and rather complicated locales; a staircase, for instance, daringly connects the two different but related panels of the *Denial of Peter* and *Christ Before Annas*. Architecture is used as an interesting and decorative accessory rather than as a symbolic stage setting; we are charmed by the coffered ceilings and detail of architectural decoration. The pink, gray, green and cream

buildings act as settings for the vivid hues that swirl in and about them. Deep reds, greens, blues, pinks, purples and roses are all delicately combined in beautiful and original color harmonies.

Our eyes delight in what we see in the *Maestà*, even in its most terrifying narratives of the Passion. While the *Maestà* lacks the moral seriousness of Giotto's monumental narratives in the Arena Chapel, it has an accessibility and charm that is immediately appealing. Its small, fragile figures exist in a world that is comfortably like our own. It must have been these qualities that both endeared Duccio's painting to the Sienese and helped make the *Maestà* such a famous work of art.

But Duccio was not the sole Sienese artist who may have exerted an influence on Giotto. Ambrogio Lorenzetti, one of the most brilliant painters of the generation after Duccio, was active in Florence during the twenties and, in fact, enrolled in the Florentine painters guild in that decade.[26] He seems to have executed a number of important works in the city, and his influence on some of Giotto's followers has been proven.[27] In the *St. Nicholas Resurrects a Boy Killed by the Devil* (a panel from a now dispersed altarpiece Ambrogio painted for the Florentine church of San Procolo) one sees some interesting, if generic, stylistic affinities with the Peruzzi Chapel (Plate 44).[28] The painting, now in the Uffizi Gallery, illustrates not one but three separate episodes. The spectator is, however, not immediately conscious of this, for, like the multiple narratives in the Peruzzi Chapel, the total impression of the scene is a unified one.

In the upper right is a banqueting scene. We notice at once that the table is seen from below and observe how remarkably skillfully the table and the people behind it are foreshortened. At the landing at the top of the staircase a small boy is being lured outside by the devil dressed as a pilgrim. The devil is then seen strangling the youth at the foot of the stairs to the lower left. In a small room to the right the same child is seen twice, once dead and then miraculously brought back to life by St. Nicholas, who hovers in the upper left of the panel. Thus, the youth is seen four times and the devil twice. The action of the tale takes place in an ambiance as complicated as the narrative itself. Architecture is complex and rendered with a great concern for the individual spatial qualities of the buildings. Ceilings are seen from below, walls from the side and stairs both from below and above. How very different this kind of Sienese composition is from the Arena Chapel, and yet how like it is to the Peruzzi. The great trio of Sienese painters—Ambrogio Lorenzetti, his brother Pietro[29] and Simone Martini[30]—were all members of the generation that followed Duccio. We

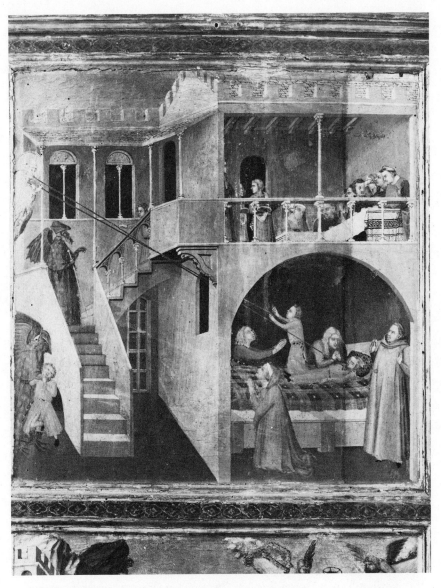

Plate 44. Ambrogio Lorenzetti: *St Nicholas Resurrects a Boy Killed by the Devil*. Florence, Uffizi Gallery

do not know exactly when they were born, but they appear to have been younger than Giotto. In any case, their first works are not documented till the second decade of the Trecento. Each was a very progressive artist of the highest quality, and there can be little doubt that their work was well known throughout Tuscany in general and Florence in particular. It seems impossible that an artist as sensitive as Giotto would have ignored their painting, especially in light of the fresh and often startling spatial and narrative innovations found in it. It is then possible that the change in Giotto's style that we observe from the Arena to the Bardi to the Peruzzi Chapels could have been, in some measure, influenced by the innovative and beautiful painting produced by Duccio and his Sienese followers.

Even if the influence of the Sienese was definitely proven, this would not be the whole story, for Giotto was too great an artist to be so swayed by a single source. We must visualize him as always varying his style and see his career as containing any number of changes. However, each stylistic modification stands on the shoulders of the previous work. From his early experience with the Santa Maria Novella cross and the *San Giorgio alla Costa Madonna*, he was able to create the *Ognissanti Madonna*. On this base he then formed the style that he was to employ with such stunning results in the Arena Chapel, and from the style developed painting these frescoes he shaped the later Florentine Bardi and Peruzzi cycles.

It is unfortunate that we do not have more evidence to document this stylistic journey. This is especially true for the Bardi and Peruzzi Chapels, since not a single record survives that gives us a clue to the accurate dating of their frescoes. How, then, are we to try to decide when they were painted? We are certain that the Bardi and Peruzzi Chapels must be later than the Arena Chapel. Common stylistic sense makes this very clear. It also seems certain that a rather long span of time had passed between Padua and the beginning of the Bardi Chapel, which must be the first of the two Florentine cycles since its style is so much closer to the Arena Chapel than that of the Peruzzi. Thus, logic would seem to indicate a chronology from the Arena Chapel to the Bardi and then to the Peruzzi Chapel. Modern scholarship has suggested that the Florentine cycles must date from the last two decades of Giotto's lifetime.[31] Considering the significant development of the artist's style from the Arena to the Bardi paintings, this seems to make sense. It thus seems wise to set up a provisionary date for the two Florentine chapels somewhere between the mid-twenties and early thirties. It seems unlikely that they could be much earlier than the

first of these dates, although it is quite possible that they may be a bit later than the second.

The Bardi and Peruzzi Chapels are the last of the master's extant works. As we look back on the number and progression of the paintings we realize that Giotto is known through only a small fraction of his total production. Literary sources and documents tell us that a great many important paintings have been destroyed or lost.[32] It is essential to keep this in mind, for we should always strive to remember the gaps that the destruction of works have created in any artist's *oeuvre*.

Fortunately, however, enough evidence remains for us to understand most of the major developments in Giotto's career. These can be conveniently divided into three stages on the basis of the remaining evidence. The early works of the painter emerged free from the weighty tradition of the Duecento and established the young Giotto as a force in Florence and in the rest of Italy. Even today they amaze the onlooker by the freshness of their vision and the beauty of their form. The Arena Chapel represents the second period of the artist's progression as we know it from remaining works. Here he is at the peak of his classic maturity. Confident, intellectual and in complete control of his style, he paints the single greatest work of fresco decoration. By the time of the Bardi and Peruzzi Chapels this style has already undergone certain modifications. We see an older Giotto who is not interested in tightening the sacred narrative but who wishes, rather, to expand its physical limits while decreasing its compacted drama. These three stages are an amazing record of development and change for any artist. But they are really astounding for the career of a Trecento painter who had been trained in the workshop tradition that emphasized conformity and minimal stylistic innovation. How even more thrilling the picture would be if we had Giotto's total production before our eyes.

During the last few years before his death in 1337 Giotto must have occupied an almost unique place in Florence. No other Florentine before him had enjoyed such success. From his earliest paintings, through the large works for famous patrons outside the city, to the late cycles in Santa Croce, he had been continually showered with important commissions. At the same time a legend developed around him, and, as we shall see in Chapter VIII, Giotto's fame was both sudden and long-lasting. In 1334 he had been appointed *Capomaestro* of the Duomo and communal works of Florence; the words of that document, as we know, make it clear that he was already a venerated figure. But even well before this he must have been the most famous and respected artist ever to have worked in Florence. The old Giotto must surely have

sensed that he was destined to occupy a prominent place in the history of Florentine painting and in the history of Florence itself.

One of the most important aspects of an artist's career is the kind of influence it exerts, for how it changes and modifies the future is often a good index of its importance. With Giotto this is especially true. His Santa Maria Novella cross and *San Giorgio alla Costa Madonna* shattered forever the traditional representations of their respective iconographic and stylistic types. Much the same happened with the Arena Chapel. Never again would Trecento Florentine narrative painting be able to unfold without reminiscences of Giotto and the principles of the Paduan frescoes. The later chapels in Santa Croce also had a profound effect on the painting of Giotto's contemporaries and followers. They, in fact, were the most influential of his frescoes, since they were in Florence and readily accessible to the painters of that city. The fascinating effect of Giotto's influence on his fellow artists and followers forms a chapter in itself.

VI

Giotto's Heirs

 The stylistic impact of Giotto's first works reverberated through Florence. We have already seen how a painter like Deodato Orlandi was so influenced by the Santa Maria Novella cross that he abandoned both his previous style and format to follow Giotto's lead. But Deodato was a rather provincial artist who took only the external forms of Giotto's painting without any real understanding of how they worked together. He produced a translation without understanding the language.

In Florence itself things were different. It should always be remembered that the art of the Trecento was basically conservative; striking innovation was the exception rather than the rule. The slow, gradual evolution of style was the result of the workshop training that every artist had to have. Thus, the history of Florentine art, even in its later periods, is generally characterized by the harmonious succession of one style by another with smooth transitions and few violent disturbances. There are, of course, some notable exceptions, and Masaccio, Donatello, Leonardo da Vinci and Michelangelo are among them. Giotto, however, was responsible for the strongest and most basic mutation in the history of the city's art. He single-handedly redirected the entire conception of form and narrative away from the iconic, highly formal Duecento conceptual tradition, making a return to the old stylistic idiom all but impossible.

There were in Florence a number of Giotto's contemporaries who, like Giotto himself, had been trained by the masters of Cimabue's generation. Many of their first works are still squarely within the Duecento tradition, and there is no doubt that without Giotto they would have continued to paint in the framework of that style. However, with the advent of Giotto's early works their idiom was outmoded and eclipsed. A new world of form and image had been opened; the old

style was gone forever. Many of these men must have undergone a rather profound crisis, for, trained in one way of looking at and representing the sacred drama of Christianity, they were now forced to portray it in another.[1]

One of the most revealing indications of the acceptance of Giotto's style is found in the kind of patronage it attracted. The early Santa Maria Novella cross is among the most important panels in a major Florentine church. The Arena Chapel is further testimony to the artist's fame. To commission Giotto to paint a cross or a fresco must have been prestigious indeed. Giotto's contemporaries were, therefore, forced to change their styles not only for artistic reasons but for financial ones as well. Their art was old-fashioned, Giotto's à la mode. It is certainly a tribute to the culture of Florence and the rest of Italy that the style of Giotto was at once recognized and accorded the accolades it merited.

After Giotto's first brilliant stylistic essays very few works in the unbroken tradition of the Duecento were produced in Florence. So immediate and powerful was the style of the young Giotto that almost every Florentine painter began to imitate him. True, most of these were not great artists, and a number would be susceptible to any strong outside influence, but nonetheless it remains an amazing fact that the style of the young Giotto had such a profound and lasting influence.

One of the most interesting of these figures was Jacopo del Casentino.[2] Not a Florentine, he was raised, and most likely given his first training, in Arezzo, a small provincial Tuscan town. When he arrived in Florence he was probably a young, competent but minor artist working in a modified Cimabuesque idiom. This must have been just about the time that the first works of Giotto were appearing, and these certainly had a profound impact on Jacopo. When we look at his charming *Madonna and Child* from Pozzolàtico near Florence we cannot but compare it to Giotto (Plate 45). The basic foundations of the forms and their relationships to each other are clearly derived from a panel such as the *Ognissanti Madonna*. The grave and measured spirit and the monumental quality of Giotto's great work is also hinted at in the painting—although not achieved, for there is an utterly captivating innocence about the gentle Virgin and her playful son that is especially Jacopo's. But this and almost everything else about the panel is accomplished with the tools that Giotto had forged in pictures like the *Ognissanti Madonna*.

In this painting by Jacopo, and in several others by his hand, one is aware of a certain discomfort. The basic Duecento love of form as pattern is evident in the decorations of the material, the curls and the

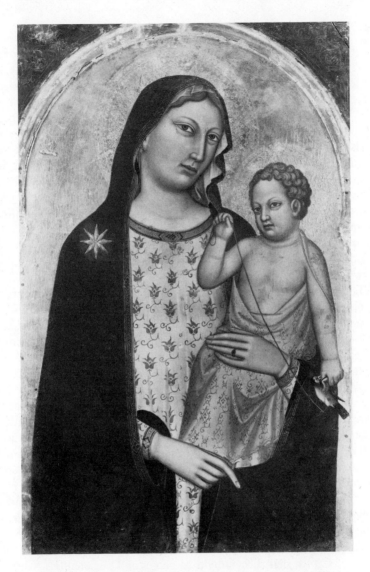

Plate 45. Jacopo del Casentino: *Madonna and Child.*
Pozzolàtico, Santo Stefano

slow, undulating rhythm of the arms and hands. The curvature of the facial features, especially the nose and eyes, betrays an older but submerged tradition underlying the up-to-date Giottesque Madonna. It is as though beneath this intimate, soft Madonna there lies Jacopo's real love, the stylized and more formal way of the very late Duecento.

Giotto's Florentine contemporaries produced numerous frescoes and panels whose style forms a fascinating, although not terribly important, episode in the history of Trecento painting. The works of these men are noteworthy chiefly for what they reveal about the impact of the influence of a single great master on a group of lesser artists. In a certain sense their paintings are like dull mirrors in which we can dimly discern the impact made by the young Giotto on contemporary Florence. This is not only interesting for Trecento Florence but for any of those periods when the works of an individual act as a turning point in the history of art.

There remains another group of painters whose position lies between the older generation influenced by Giotto and Giotto's followers. These are the anonymous members of his shop who produced a number of paintings that have been at one time or another attributed to the master himself. There are, in fact, three paintings signed with Giotto's name which we have not discussed since it seems certain that he neither designed nor executed them. These panels in Bologna, Paris and Florence are probably signed to give them an authenticity that their style lacks.[3] In short, all the signed works seem to have little to do with the master himself, and it appears most likely that they originated in the shop of Giotto but were quickly turned over to pupils or helpers to design and execute. Probably Giotto was too busy to attend personally to these paintings. Unfortunately, discussion of these rather weak works has often obscured the fact that they are products of the shop and not of the master. To include them in the catalogue of Giotto's work is to cloud his stylistic development and qualitative level. The artists of these panels worked in an idiom so submerged in the principles and techniques of Giotto that their individual names and personalities will probably never be uncovered. The very existence of such paintings serves as an indication of how powerful the Trecento workshop tradition could be.

Aside from this anonymous group, the painters who most directly felt the influence of Giotto were those members of the generation that grew up while Giotto was still alive. Unlike Jacopo del Casentino, these painters were not already trained in the style of the Duecento. Giotto's art came as no surprise to them, for it was becoming the

accepted standard in Florence as they were being taught. A number were quite good artists, and their individual styles are well known.

Some of the painters of this new generation may also have worked in Giotto's shop. Unfortunately, we do not know the shop's composition, since no work documents survive. We can safely assume that with so much painting to do in so many places the master would have needed many assistants. It may be possible that several painters, like Taddeo Gaddi, whom we know was with Giotto for twenty-four years, stayed in the shop till the master's death, while others left it after they had received their training and had participated on several of its projects. A few of these men must have worked on the anonymous panels signed by Giotto. They are usually referred to as *Giotteschi* and have had a rather bad critical reception from their day to ours. They have been considered slavish followers of Giotto, and this is quite unfair, for none of the leading personalities usually identified as a pupil of Giotto, or at least as a member of his shop, is an unthinking imitator of his style.[4] Certainly while they worked with him their idiom was subordinated to his designs, and all of Giotto's fresco cycles appear as a seamless whole. But as they left the shop each developed in his own way, taking what he wished from his teacher and leaving behind that which did not interest him.

The three major artists in the Florentine ambiance of Giotto each seem to have been associated with the artist at some time, either as a member of his shop or as a youthful stylistic follower.

One of these, Bernardo Daddi (active c. 1320–1348), was really much more at ease with panels than with frescoes.[5] His paintings reveal his interest in the portrayal of graceful figures in detailed and delicate settings. Bernardo's beautiful, sweet Madonnas (Plate 46) and elegant narratives blazed a new path in Florentine art. They are, however, achieved within the idiom of Giotto, and, although Bernardo's aims are different from those of his stylistic master, he owes the very basis of his visual conception to Giotto. Interestingly enough, he was also swayed by the Sienese painters active in Florence, and their works are clearly reflected in his panels. Such influence is another indication of how powerful the spatial and decorative qualities brought by the Sienese must have been.

Maso di Banco, who is documented in the 1340s, is the second of the three major artists to emerge from the shadow of Giotto.[6] Of them all, he is probably the one who best understood the goals of the master and strove to carry them out, albeit in a modified way. His works are quite scarce, and he is known only through a handful of panels and a

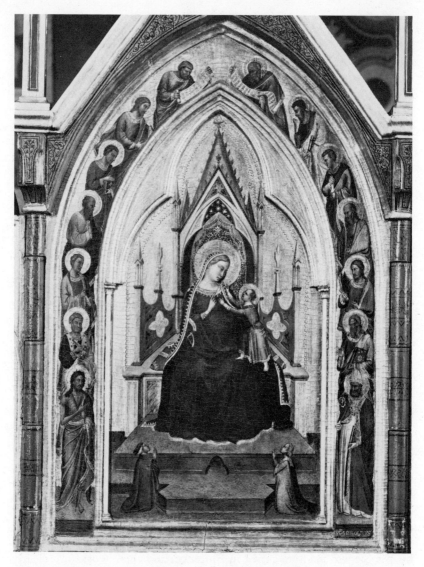

Plate 46. Bernardo Daddi: *Madonna and Child with Saints, Prophets and Donors*. Florence, Oratorio del Bigallo

single fresco cycle dedicated to St. Sylvester in the Bardi–Bardi di Vernio Chapel in Santa Croce, one scene from which will serve to illustrate some of the basic principles of his art.[7]

In the fresco St. Sylvester is seen performing two miracles (Plate 47). To the left, he subdues a dragon who has just killed two men who

Plate 47. Maso di Banco: *St. Sylvester Subdues the Dragon and Brings to Life the Two Sorcerers.* Florence, Santa Croce, Bardi-Bardi di Vernio Chapel

are then brought back to life in the right central section of the painting. The use of the simultaneous narrative has already been seen in Giotto's Peruzzi Chapel and the St. Nicholas altarpiece by Ambrogio Lorenzetti. It is from the former and from the Bardi Chapel that Maso and most of Giotto's Florentine followers who were coming to maturity in the twenties and thirties of the Trecento drew much inspiration. In this connection it is interesting to note that the influence of the Arena Chapel, Giotto's single most famous work, is less apparent in Florence than is that of the late cycles in Santa Croce. The geographic and chronological proximity of the later works made them the touchstones of the painter's influence. The oblique setting of the architecture in Maso's fresco is inspired by the Bardi and Peruzzi frescoes, as is the interest in the various layers of space which the buildings describe.

Like Giotto's figures, the people in Maso's drama keep rather close to the foreground plane. Their actions are grave and dignified, reminiscent of the actions in Giotto's Santa Croce cycles. The construction of the bodies and the proportion of the head to body also seem to owe much to Giotto.

But a second glance clearly indicates that Maso is not at all painting according to the strict principles of Giotto's art. Never for a moment would we attribute the St. Sylvester fresco to Giotto, for it is of an entirely different spirit. Where Giotto is always clear, straightforward and intellectual, even in the Peruzzi Chapel, Maso is evocative. The great smooth buildings rising up in the background, the ruin of the Roman forum where the miracle takes place and the lone column standing starkly in the foreground all impart an air of mystery. It evokes wonderment and awe in a way foreign to any picture by Giotto, including the Peruzzi scenes, where the setting is of great importance. The locale of the action is as vital as the action itself.

It is extremely hard to judge how close coloristically the Maso frescoes were to Giotto's late cycles. In the 1930s they were subjected to a partial repainting that falsified them. From what can still be made out, a number of light hues were employed by the master. Pale pinks, light grays, reds and whites are used, and there prevails a color harmony that seems to owe much to the palette of the late Giotto.

Yet when the spectator leaves the presence of Maso's frescoes he carries away with him the memory of monumental, harmonious form in a decorous and dignified setting. These are the sensations that one also associates with the Arena Chapel, and in a certain sense the overall compositional effect of the Bardi–Bardi di Vernio paintings often reminds one of the Paduan frescoes. Was it possible that Maso knew them either through drawings or lost frescoes by Giotto that reproduced their style? It is a tantalizing question that will probably never be answered. But the fact remains that of the three most worthy followers, Maso is the closest to Giotto in the totality of his art.

The third of the three artistic personalities to emerge from the circle of the late Giotto is Taddeo Gaddi.[8] We know more about Taddeo than Bernardo Daddi or Maso di Banco. Cennino Cennini tells us that Taddeo was for twenty-four years a pupil of Giotto.[9] Whether it was possible for such an artist to accept independent commissions while still in a shop other than his own has not yet been determined. However, there exists in the small Tuscan town of Castelfiorentino Taddeo's codified copy of the *Ognissanti Madonna*, which seems to be among his earliest works and quite possibly executed while he was in

Giotto's shop.[10] Unfortunately, we do not know when Taddeo was born, so the exact period of his stay in the shop cannot be determined. Since he died by 1366 and had obviously been working on independent commissions for some years, one may guess that his period with Giotto took place during the second, third and fourth decades of the century. Thus, he may have joined the shop of Giotto shortly after the Paduan frescoes and stayed with it till the death of the master.

Taddeo's independent stylistic development, as we can trace it through his autograph pictures, is interesting indeed. His first works are very much in the style and spirit of Giotto. In fact, he executed a series of small paintings for the sacristy of Santa Croce which are, in parts, copies of the Bardi frescoes.[11] But even in these early works he shows a tendency to modify the master's composition and to introduce his own figure types into the pictures.

In the Baroncelli Chapel, which is located in the end of the right transept of the church of Santa Croce, Taddeo painted a large fresco cycle of the *Life of the Virgin*. No documents survive for this work, and it is very hard to determine its exact stylistic position in the artist's career.[12] Surely, however, it must be later than the Bardi and Peruzzi Chapels, to which it owes a good deal. What Taddeo did was to continue the stylistic progression started by Giotto in the late fresco cycles but without the great skill the older artist possessed. His scenes are highly detailed and full of peripheral action; they bewilder and amuse the eye by their rich narrative and profusion of form. They are homey and comforting in a way that a painting by Giotto could never be.

In these paintings Taddeo also develops the representation of atmospheric effects, a goal toward which the late Giotto might have been striving in a fresco like *The Raising of Drusiana*. In a remarkable *Annunciation to the Shepherds*, the artist is able to capture the dark softness of night and the radiating golden glow of an angel's heavenly presence (Plate 48). One almost feels the color and light saturate the air.

Giotto's lighter palette as developed in the Peruzzi Chapel also had a profound effect on Taddeo. Light greens, grays, warm pinks and whites are seen in abundance. It is fascinating to observe the effect which the Peruzzi Chapel had on the palettes of the entire generation of painters who followed Giotto. In much of their work the lighter, gayer hues appear, and color leads a more independent life than it had before the painting of the Peruzzi frescoes.

One of the last of the close associates of Giotto, Taddeo was still painting modified variants of the *Ognissanti Madonna* as late as 1355.

Plate 48. Taddeo Gaddi: *Annunciation to the Shepherds*. Florence, Santa Croce, Baroncelli Chapel

A Madonna of that year, now preserved in the Uffizi Gallery, is a masterfully executed Giottesque painting.[13] But Taddeo outlived his artistic moment, for shortly after the middle of the century fashionable painting in Florence began to turn away from the confident, rather optimistic idiom initiated by Giotto and carried out by men like Bernardo Daddi, Maso di Banco and Gaddi.

This change took place partly because there was a new generation of artists in Florence. Of all the close associates and followers of Giotto only Taddeo was still living after 1350, and by that time his painting must have seemed somewhat old-fashioned. The young artists who were working around mid-century and slightly after were, after all, not even born when the Arena Chapel was painted and were probably only infants when the Bardi and Peruzzi Chapels were under way. They did not have the immediate, firsthand experience of the master's shocking new style that the older artists had had. They grew up with the tradition of Giotto much as Giotto had grown up in the tradition of Cimabue.

In the summer of 1348 there was a great plague that devastated Florence, killing about half of the population and almost bringing the city's cultural life to a halt. Numerous painters were swept away and many important patrons were also killed. An important study has suggested that the spiritual and physical havoc of the events of 1348 were responsible for a profound iconographic and stylistic change in the art of Florence.[14] The psychological shock of the loss of life and the destruction of wealth and position created, it is reasoned, an introverted, remote style that was in revolt against the more monumental and humane art of Giotto. According to the study, the art of the period was more hierarchical and dogmatic, less immediate and accessible to the on looker; and, it is suggested, artists after mid-century looked back and drew inspiration from Duecento painting.

There can be no doubt that there were stylistic changes after mid-century; it would, in fact, be surprising to find a period of Florentine art in which there were none. But one must ask if these modifications were the result of the Black Death or of the different tastes of the new patrons and artists who began to work around this period. It is, in fact, rare that cataclysmic events such as war or plague have profound effects on style, which seems to move along according to its own momentum. One has only to look for changes in style directly related to major historical events to realize that most often contemporary actions have only limited reactions and reflections in the style of a period. This is not to say that they have no effect on art, for some-

times they do. But one most often finds their influences in the iconography—the subject of the picture and its interpretation—rather than in the style in which that picture is painted.

But before going any further with the discussion of this problem it might be well to look at several concrete examples of what we have been discussing abstractly. One of the most interesting is not by a member of the new generation of painters who began to be active around 1350 but by no less a follower of Giotto than Taddeo Gaddi. This is the central panel of his altarpiece executed for the church of San Giovanni Fuorcivitas in Pistoia, a city not very far from Florence (Plate 49).[15] We do not know the exact date of the completion of this work, but a document suggests that Taddeo received final payment for it in 1353.

One is at first attracted by the profusion of ornament that seems to be almost everywhere on the panel—the cloth held behind the Madonna's head, the pattern of the pillow on which she sits, her embroidered mantle, the decoration of the Child's robe. All this distracts the eye from the more solid and palpable elements of the forms. It acts as a visual static that disturbs the surface of the panel, making it seem even more spatially shallow than it really is. The figures themselves have lost a great deal of the monumentality they once had in the works of the younger Taddeo. It is difficult to define the exact position of the Madonna in space. Her body seems to be seated, and yet one cannot be quite sure. The Child also appears to occupy a rather spatially ambiguous position. To complicate further this somewhat confusing composition, six cherubim hold up the cloth behind the Virgin. The idea of seeing these bodiless, hovering figures behind a Madonna by Giotto is all but unthinkable, since they give the panel an unstable and momentary quality.

The overall feeling of the panel is planar, as though there are shallow layers of space one behind the other. From the foreground to the background, space is organized in flat, almost steplike recessions. This is, of course, very different from the spatial principles of Giotto at any period, especially his last. Giotto's space was never constricting but adjusted and controlled to let the figures move as they needed to, unlike the stifling force it has become in Taddeo's Pistoia panel.

There is also a more closed, aloof air about the Madonna and her Child. They seem psychologically withdrawn from the spectator. The Virgin looks out at the viewer with a tilted head and an inscrutable expression. This is no longer the confident and happy figure that played such an important role in Taddeo's earlier panels. The Child, absorbed

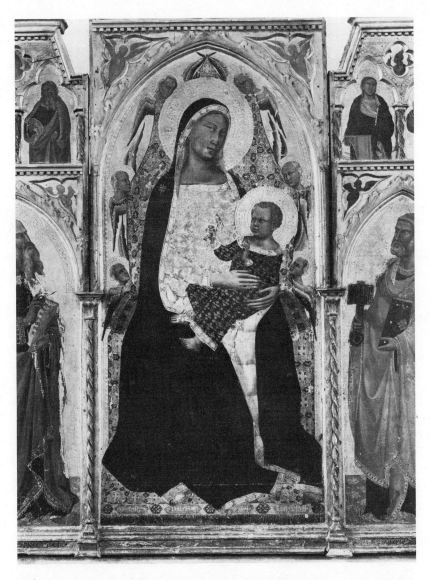

Plate 49. Taddeo Gaddi: *Madonna and Child*. Central panel of the San Giovanni Fuorcivitas polyptych. Pistoia, San Giovanni Fuorcivitas

in play with the tiny bird, does not even acknowledge the spectator's presence.

One can readily see that this panel is stylistically far from Giotto's *Ognissanti Madonna* or any of the other works by the artist. Spatially it is restricted. Movement has become hard and stiff. The limits of the space and the figures positioned in it are hard to define. A sense of uneasiness is created. Finally, the figures are withdrawn and psychologically isolated from the onlooker. The monumentality and openness of a panel like the *Ognissanti Madonna* have been replaced by a somewhat uncertain, rather confusing cold composition. The panel is exclusive and does not, like Giotto's painting, invite the worshiper to partake in either its space or action.

As late as the mid-fifties, however, Taddeo was also capable of producing a Madonna panel very much in form and spirit like the *Ognissanti Madonna*. His *Madonna and Child with Angels* in the Uffizi of 1355 still stands almost squarely in the tradition begun by Giotto. It is only in his last two extant polyptychs, the one under discussion and another altarpiece now in the church of Santa Felicita in Florence, that his style shows great change.[16] Without doubt one of the reasons for this was the influence of the generation of younger, popular painters who were producing their first works during the fifties.

Perhaps the best of these, and certainly one of the most original and influential, was Andrea di Cione, called Orcagna.[17] Orcagna, known by only one polyptych and the remains of a great fresco, is documented in Florence between 1343 and 1368. Exactly where he received his training is unknown, but it must have been with some member of Taddeo's generation steeped in Giotto's style.

But when we turn to Orcagna's large polyptych with Christ and saints in the Strozzi Chapel in the church of Santa Maria Novella in Florence, we see that its style is quite different from that of Giotto. The *Strozzi Altarpiece* (Plate 50) is signed and dated 1357 and therefore roughly contemporary with Taddeo Gaddi's Pistoia altarpiece. They share a number of stylistic characteristics, and it seems likely that Taddeo was deeply influenced by Orcagna's panel or an earlier one like it.

In the central part of the *Strozzi Altarpiece* Christ appears enthroned and surrounded by a *mandorla* of cherubim. He seems really to hover rather than to sit, and it looks as if his great, wide body is suspended in air instead of on some solid support. The strange red and blue ring of cherubim are also aflutter. They emanate a strange reddish-white light which gives an eerie glow to the area they enclose. But very

Plate 50. Orcagna: *Strozzi Altarpiece*. Florence, Santa Maria Novella,
Strozzi Chapel

quickly the spectator's glance is fixed on the head of Christ, who
stares not at him but through him into space. The symmetrical face
with its large, open eyes is stern and unforgiving, not unlike that of a
Christ of the Last Judgment. This is the kind of spatial and psycho-
logical isolation that we saw in Taddeo Gaddi's work, but here it is
even more explicit and exclusive.

A great wide triangle is formed from Christ's head through his
outstretched arms and down to the kneeling figure of Sts. Peter and
Thomas Aquinas. Both Peter on the right and Thomas on the left are
fervently intent on receiving the key and book that Christ offers. While
they gaze fixedly at Christ he seems not to notice their presence. This
is the first indication of the disparity of the figures on this altarpiece.
Often a polyptych is utilized by the artist as a *tour de force* of com-
positional harmony. One figure relates to the next and all to each other.
Here Orcagna has chosen to do just the opposite.

Peter and Thomas are backed by the Virgin and St. John the
Baptist. Although the Virgin touches St. Thomas and gestures toward
her son, the object of her gaze is uncertain. This is partially because
it is rather hard to determine her spatial plane. Is Christ in front of
Thomas, between Thomas and the Virgin or behind her? It is difficult to

say, and for this reason the spectator feels restless and uncomfortable with the work. This is, of course, a very different sensation from what one experiences while looking at any painting by Giotto, where the placement in space of the figures standing on the earth is quite clear.

John the Baptist is a frightening figure. He points toward Christ but stares, like Christ, out past the spectator. His hair shirt and flamelike locks add to the feeling of ascetic disarray. Instead of the engaged young man of the Arena Chapel we see a lean, aloof desert saint.

In each of the outside compartments Orcagna has placed two saints. Because of their size, proximity and lack of exact spatial placement, they look uncomfortably crowded in their setting; there does not seem to be room for them to move. This adds a further note of confusion and complexity to an already confused and complex panel.

Color also plays an important role in the painting. It is not used as it was by Giotto or any of his close followers. They, for the most part, looked on color as a tool to help them construct and coordinate their compositions. It was to help define figures, to knit scenes together and to emphasize sections of any given painting. But in Orcagna's hands it becomes not an agent of clarity but of disquiet. Hot reds are placed next to cool blues. Pinks clash with greens, greens with blues, and strident and uncoordinated patches of orange, black, yellow and rose flash across the panel. Color separates the actors, makes them conflict with each other and creates strident notes all over the surface of the polyptych. Underlining this disjointed and uneasy palette is the bright red of the cloth spread across what seems to be the ground on which the figures stand. But if one looks carefully this appears to rise up much too steeply to be such a support, and, in fact, the two musician angels below Christ do not even appear to have a firm footing on it.

Some of the characteristics of Orcagna's *Strozzi Altarpiece* were translated into a fresco by a painter of the same generation, Andrea da Firenze. His principal work is a fresco cycle in the Spanish Chapel (the chapter house in the cloister of Santa Maria Novella), which was entirely painted by the artist around 1366–1368.[18] The cycle is, therefore, a decade later than the *Strozzi Altarpiece* of 1357.

One glimpse at the Spanish Chapel immediately reveals how far Andrea is from Giotto. The walls illustrating *The Way to Salvation* and *The Way to Calvary, The Crucifixion, and the Descent into Limbo* are a riot of form and color totally unlike any frescoes we have yet seen (Plate 51).

There are several stories on each wall, yet there has been no attempt

Plate 51. Andrea da Firenze: Spanish Chapel. Florence, Santa Maria Novella

to divide one from the other by painted borders. The result is a confused display of action across and up the surface. Figures do not stand on a stable ground plane but rather exist on what seems to be an incline rising from the bottom of the walls to the top. The introduction into the frescoes of literally scores of accessory figures would have been abhorrent to the immediate followers of Giotto. On the *Crucifixion* wall scores of people form vast crowds around the crosses; many are on horseback, some on foot. A great variety in facial type and costume also adds to the generally overcrowded, confused feeling. It is as though we are looking at some grand tapestry covered with decorative figures but lacking in spatial definition.

The *Way to Salvation* is equally bewildering. The action starts at the bottom right and gradually works its way up to the figure of Christ in Judgment at the top. But this progression is not immediately apparent to the onlooker, as it would be in a painting by Giotto. The figures appear stacked one on top of another, and the plane on which they stand seems to rise up sharply behind them. As in the Orcagna altarpiece, space has been rearranged to create uncertainty instead of clarity.

Andrea's palette is disturbing but lovely. Strident notes of now

faded yellow-gold, white, pink, green, violet, lavender and gray seem to detach themselves from the fresco and exist in their own decorative right. Color plays no unifying role.

In both the *Strozzi Altarpiece* and the Spanish Chapel the iconographic program is doctrinaire and complicated. Such learned, often difficult-to-understand stories and images are another characteristic of the style that arose around mid-century. It is, of course, a perfect complement to the harsh, introverted spatial and coloristic developments of the time.

As we have seen, it has been suggested that the style practiced by the late Taddeo Gaddi, Orcagna, Andrea da Firenze and several other important artists working in the third quarter of the Trecento is directly attributable to the effects, both psychological and physical, of the Black Death. It is argued that a dispirited and depopulated city turned to this stilted art out of fear and guilt. But changes in style are of such a complex nature that they seldom lend themselves to single explanations.

In the first place, around the date of the plague a new generation of artists began to work in Florence. It is obvious from their painting that many were rejecting some of the principles of Giotto and his followers, while striving for their own stylistic goals. Such change has been the case with every generation of artists to appear on the Florentine scene; it can be seen among Giotto's own personal followers—for example, in Maso's use of architecture. The modification is slow and within the framework of the workshop tradition, but it is there nevertheless.

Secondly, there appear to be some signs of the development of this style before the Black Death. Taddeo Gaddi and Bernardo Daddi were among a number of artists who seem to have become interested in a more hierarchical iconographic presentation.[19]

The third reason for not readily accepting the plague explanation for the change is a bit more complicated. We do not really know how popular the uneasy and distant style of Orcagna and his circle was. In fact, it seems to have been only one among a number of styles rather than the sole idiom. Most of the prime examples used to document and describe the so-called Black Death style come from one church in Florence—Santa Maria Novella. Those paintings we have just discussed are there and several others as well. On the other hand, a number of artists who did not work for the Dominicans of that church seem to have painted in quite a different style during almost the same period; Giovanni del Biondo (active 1356–1399) and Niccolò di Pietro Gerini

(active 1368–1415) are two.[20] Thus, we have to ask ourselves what role the patronage of Santa Maria Novella had on its paintings and their iconography. Could it not have been possible that the patrons, both lay and clerical, of the church were interested in a more hierarchical, dogmatic and introverted type of imagery than, for example, the Franciscans? It is amazing to find that in the Franciscan church of Santa Croce there is not a single contemporary work firmly in the iconographic and formal style of the *Strozzi Altarpiece* or the Spanish Chapel.[21]

Finally, we should consider what impact contemporary events have on style. This is a problem not only of the mid-fourteenth century but of every epoch in the history of art. Do they produce style changes? Do they work on an almost one-to-one basis with art? For the most part, the answers to these questions seem to be no. Experience tells us that artists may often respond to changes by adjusting their subject matter to portray new messages. But style is quite a different thing, with its own history. It may adjust gradually to a new content or vice versa, but the process is slow. Thus, to suggest that the plague of 1348 is responsible for not only a change in iconography but also in the formal vocabularies of the artists in question is to take a bold step. We shall probably never know what exactly is the cause of any new movement in art, but we must constantly be careful not to oversimplify what often takes place through the most subtle and gradual processes.

Of course, the Black Death must have had some very concrete effects on the artists of mid-Trecento Florence, a number of whom seem to have perished in 1348, as did many potential patrons. Immigrants from the countryside who made their fortune in the city after the plague may have had a taste quite different from the older urban families who were the most active patrons before. Much money was left for the decoration of the churches and charitable organizations of Florence in the wills of those who died in the Black Death. The redistribution of power and wealth probably changed, to some degree, the older patterns of patronage and thus directly touched the artist. However, its effects on the style of the individual artist are, as we have seen, not so easily definable.

Whatever the cause of the stylistic change that finds its most penetrating expression in the works of Orcagna and Andrea da Firenze, its duration was not great. By the end of the third quarter of the fourteenth century it had run its course and was being replaced by a new idiom. Like the period of around 1350, the opening years of the last quarter of the Trecento saw the rise of a new generation of artists. These men

were quite removed from Giotto; they had been born long after the triumphant progression of his style. To them he was an old master, a personality surrounded by the myths that, as we shall see, had already begun to grow around his fame.

It may have been just this fame that was responsible for a new interest in Giotto. Of course, all during the period up to c. 1375, including the time of Orcagna and his circle, the basic principles of the art of Giotto had been used. There was never any thought of going back to the idiom of Duecento art. Even though Orcagna is a long way from Giotto and his basic mode of representing scenes very different from the master, his stylistic origin is to be found in Giotto himself. To return to the old highly abstracted, decorative and iconic world was impossible, although in spirit, if not in form, Orcagna came close to it.

The years around 1375 saw a renewed interest in both the form and content of Giotto's art. It was this revival that was to help prepare the way for the early Renaissance of the fifteenth century. Spinello Aretino, Antonio Veneziano and Agnolo Gaddi (the son of Taddeo) were the three most outstanding artists of this period.[22] Each was a rather prolific painter, and their works formed the touchstone for the generation of the early 1400s. All were active in Florence from around the beginning of the last quarter of the century to c. 1400.

Agnolo Gaddi's altarpiece of the *Madonna and Child with Four Saints and Angels* (c. 1390) in the National Gallery of Art in Washington is a good example of the new stylistic mode which came to the fore in Florence during the last quarter of the Trecento (Plate 52). The central figure of the Madonna is once more seated firmly in space. The bulk of her body is enclosed by the projecting arms of the throne which repeat a formula as old as the *San Giorgio alla Costa Madonna* (Plate 17). How different this is from the much more rigid, planar and insecure Virgin of the Pistoia Polyptych by Taddeo Gaddi (Plate 49) or the hovering figure of Christ from Orcagna's *Strozzi Altarpiece* (Plate 50). The baby, too, stands squarely on his mother's lap, his arms around her neck. Human contact with the spectator—the Child looks out at us— and between the figures is the rule rather than the exception. As in the *Ognissanti Madonna*, the Virgin and Child are the focus of attention (Plate 1). A choir of angels stands behind the throne adoring the figures, while in front others make heavenly music. Solid, earthbound, worshiping angels have replaced the floating, mysterious cherubim found in both the paintings by Taddeo and Orcagna.

There is also far less spatial confusion. The lateral standing saints are steady on the ground and in the space around them. Their heavy,

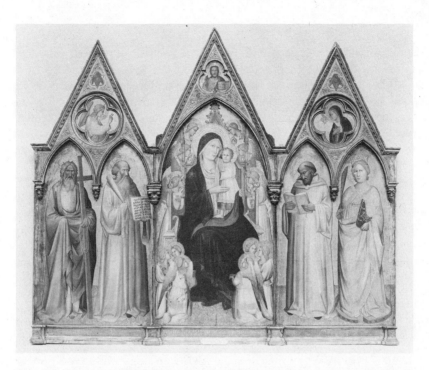

Plate 52. Agnolo Gaddi: *Madonna and Child with Four Saints and Angels.*
Washington, National Gallery of Art

massive bodies covered with ample, weighty material remind one of
the figures of the Bardi and the Peruzzi Chapels. They securely inhabit
the space of the picture, their physical presence firmly established,
forever fixed. It is evident that for Agnolo Gaddi the possibilities of the
narrow, planar spatial arrangement of Orcagna were exhausted. He was
not interested in the hieratic, isolated world formed by that artist and
his circle. It seems evident that Agnolo used the famous Giotto as a
model to help him overcome the heritage of his immediate past.

The increased presence, solidity and calm of Agnolo Gaddi's Na-
tional Gallery altarpiece finds an echo in its palette. The sharp, jarring
color juxtapositions so characteristic of the *Strozzi Altarpiece* are gone.
In their stead one finds lovely whites, pinks, greens and yellows. Once
more, as in the paintings of Giotto and his close followers at the be-
ginning of the century, local, compacted colors prevail and are used as
building blocks in the formal arrangement. This is not to say that
Agnolo Gaddi used the same palette as the early Taddeo Gaddi or
Giotto himself, for he did not, but in the use of color to aid the con-

struction of form his palette is much more like that of the first followers of Giotto than of Orcagna and his circle.

This movement away from the style of Orcagna toward a more solid and stable presentation was not limited to panel painting. In the frescoes of Agnolo Gaddi, Antonio Veneziano and Spinello Aretino one finds an increasing clarity of composition.[23] Grave figures like those in Spinello's San Miniato al Monte frescoes of c. 1387 (Plate 53) often

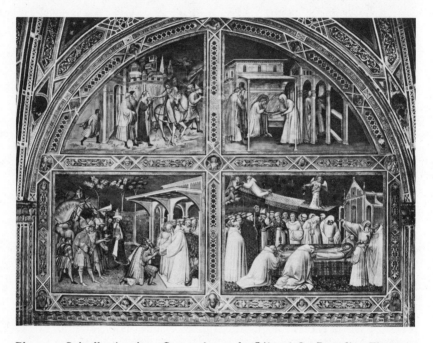

Plate 53. Spinello Aretino: *Scenes from the Life of St. Benedict*. Florence, San Miniato al Monte

move with dignified action through a calm and stable space. There can be no doubt that the painters of the late Trecento were interested in Giotto, for there are numerous cases of their borrowing compositions or formal motifs from his work.[24] It is clear that they were anxious to move away from the style of the circle of Orcagna, and what better way to do it than to take up some of the principles of one of the greatest Florentine masters. Thus, by the dawn of the new century Florence had undergone yet another stylistic shift, the third in a century. The work of Agnolo Gaddi and his contemporaries was to have important ramifications, for it helped to set the scene for the burst of creative

activity that was to take place during the early years of the Quattro-
cento.

It is not within the scope of this book to describe the events of the
early Renaissance. It, like every stylistic period, is made up of varied
and extremely subtle crosscurrents. But there can be no doubt that the
most important painter of this period, Masaccio, was heavily influenced
by both Giotto and the artists of the late Trecento who were active in
Florence. These latter were, after all, the modern artists of his early
training. Masaccio lived a short but significant life (1401–1428), and
his great frescoes of the twenties in the Brancacci Chapel served as the
illustrated textbooks for a whole generation of artists.[25] In his principal
panel painting, the *Madonna and Child with Angels* (1426) in the
National Gallery of London, he exhibits all the characteristics that make
his style so fresh and exciting (Plate 54). The ponderous Madonna,
strongly foreshortened and seen from slightly below, holds a mighty
Child, half little boy, half Atlas. We are drawn into the picture and
participate as spectators in a direct, immediate fashion as though we
personally witness the scene. The rapport with the object viewed has
changed; the last vestiges of a distant and iconic presentation are done
away with.

This revolutionary style has its origins in two separate sources. One
is the artist's own creative genius. This is a mysterious and often un-
explainable phenomenon. The second is in the art by which he has been
influenced. In the case of Masaccio, the memory of Giotto must have
been a powerful force. The grave yet accessible Mary of the *Ognissanti
Madonna* is the direct spiritual and physical ancestor of the Virgin in
London. Without Giotto, Masaccio is impossible—so much so that he
has been called "Giotto born again."[26]

But the painters of the late Trecento must also be given their share
of credit for preparing the path that Masaccio was to tread. For by
redirecting the art of Florence away from the idiom of Orcagna back
toward Giotto they created the stylistic and psychological ambiance
for the young Masaccio. Their measured, easily understood composi-
tions and stable, ponderous figures set the stage for the developments
of Masaccio and a few of his colleagues. One must never underrate
Masaccio's genius, but it is also necessary to understand that he did not
work in a stylistic and spiritual vacuum.

Even as late as the last decades of the fifteenth century the memory
of Giotto lingered on in Florence. By that time he had a strong literary
reputation and was a venerated historical figure among artists.

Domenico Ghirlandaio, one of the best of the late Quattrocento

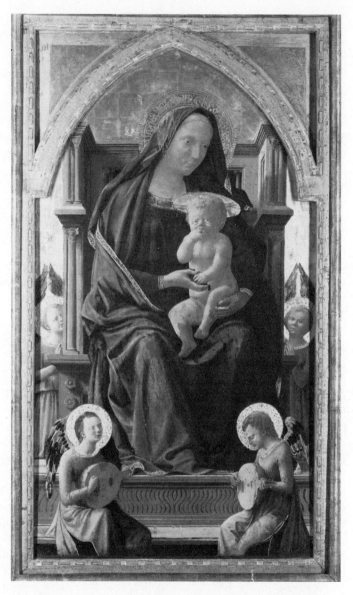

Plate 54. Masaccio: *Madonna and Child with Angels.*
London, National Gallery

painters, when called on to paint the *Death of St. Francis and the Verification of the Stigmata* for the Sassetti Chapel (finished 1485) in the Florentine church of Santa Trinita (Plate 55), could pay no greater compliment to Giotto than to imitate his fresco of the same subject in the Bardi Chapel (Plate 39).[27] A long distance has been traveled and the stylistic events of almost two hundred years have intervened, but it is amazing how clearly Ghirlandaio understood and respected the composition and spirit of the father of Florentine painting. The basic arrangement of the body lying in the center flanked by two groups remains the same. The exquisite patterns of the bending bodies and bowed heads of the brothers is preserved and honored. In place of the stark wall in the Bardi Chapel fresco, one now finds an elaborate row of columns and an apse fronting a beautiful landscape; the world is now a less stern, more open place. Ghirlandaio looked long and hard at Giotto's fresco; it was his model, and Giotto's guiding stylistic principles were his as well. That a painting close to two centuries old could serve as such a vital source is testimony to Giotto's great genius, his masterful hand and the lasting influence of his nearly perfect art.

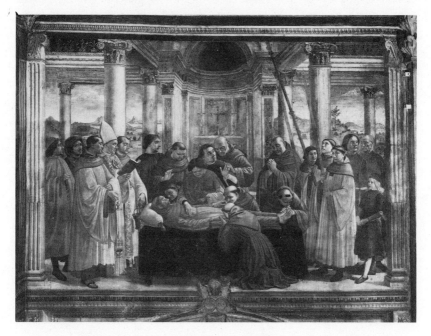

Plate 55. Ghirlandaio: *The Death of St. Francis and the Verification of the Stigmata.* Florence, Santa Trinita, Sassetti Chapel

VII

Assisi

On the hill of Assisi rising above the plain of Spoleto sits the great gleaming basilica of San Francesco, where, in the depths of the lower of two superimposed churches, is the tomb of St. Francis. It is strange indeed that this great preacher of poverty and humility should lie surrounded by the foundations of what is one of the most sumptuously decorated structures in Christendom. Construction of the church began shortly after the saint's death in 1226. When it was finished, artists from many parts of Italy were called in to decorate its walls, and the building became a thesaurus of frescoes of the Roman, Sienese and Florentine schools of the late Duecento and early Trecento.[1]

The most famous paintings in the church are the twenty-eight undocumented scenes of the *Legend of St. Francis* which cover the lower portions of the left and right walls of the nave and of the entrance wall of the upper church (Plate 56). The *Legend* begins at the transept end of the right wall, moves to the entrance wall and then across this to the left nave wall. From this point it continues across the left wall, ending next to the transept, opposite its beginning. On each wall the scenes are divided into four bays; the first three from the transept contain three scenes each, while the last has four frescoes. Two paintings flank the entrance on either side of the door. This is the largest, most complete cycle devoted to the saint's life and the most iconographically important, since it is housed in the principal church of the Franciscan order.[2]

As early as c. 1450 the Florentine sculptor Lorenzo Ghiberti mentioned frescoes by Giotto in San Francesco.[3] By Vasari's time belief in his authorship of the cycle had crystallized. Vasari says:

In the upper church of this town [Assisi] he painted a series of thirty-two scenes in fresco of the life of St. Francis, under the course which runs

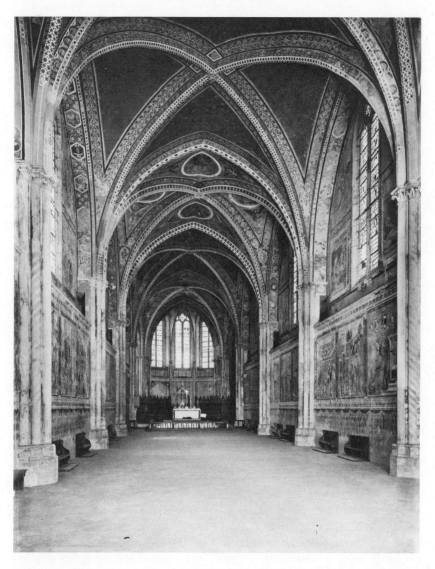

Plate 56. View from entrance wall. Assisi, San Francesco, upper church

round the church, below the windows, sixteen on each side, with such perfection that he acquired the highest reputation thereby. In truth the work exhibits great variety, not only in the gestures and postures of the different figures, but in the composition of each subject, besides which it is very interesting to see the various costumes of those times and certain imitations and observations of Nature.[4]

Aside from forgetting about the two scenes on the entrance wall and counting too many frescoes, Vasari has given us a rather clear description of the *Legend*. His attribution of the paintings to Giotto remained unquestioned for around three centuries.

During the last hundred years or so the traditional assignment of the *Legend* to Giotto has been challenged. In fact, the problem of the attribution of the frescoes is now one of the most animated in the history of Italian art. At first the debate was quite simple. Students were interested in answering the question—did Giotto paint the Francis scenes? Now the problem is slightly more complicated as art historians have begun to wonder if perhaps Giotto played a role in the Assisi frescoes other than that of the head of the shop responsible for the paintings. The argument has been a lengthy one. Scholars have divided into camps, and opinions have fossilized.[5] In truth the whole Assisi question has become one of the classic problems in the history of art. It, like the date of the Brancacci Chapel by Masaccio and Masolino or the attribution of the various parts of the Ghent Altarpiece to Hubert or Jan van Eyck, is one of those eternally fascinating problems that seems ever to elude solution, if indeed a solution is possible.

Obviously, it is beyond the scope of a book such as this to try to investigate fully the hundreds of ramifications that the Assisi question carries with it. Rather it is hoped that, by concentrating on just a few frescoes and comparing them with the works we have already seen, the reader will be able to develop an insight into the paintings themselves. Discussions of these frescoes have been placed in this chapter so as not to confuse the progression of Giotto's style as seen through his more securely attributed works. Of course, if one believes that ultimately the Assisi frescoes are by Giotto, then it is necessary to determine their position vis-à-vis his other works.

The frescoes have suffered some damage, but they do not appear to have undergone any extensive repainting, and they are relatively clean. In certain areas there are paint losses and abrasions. The paintings, which are executed in true fresco, have preserved much of their original color.

When one becomes accustomed to the cool, subdued atmosphere of

the upper church of San Francesco one immediately looks at the long line of marching scenes on either side of the nave. Coloristically the frescoes appear evenly balanced. That is, no hue is really outstanding, and there is a subtle, even play of light, airy colors. There are almost pastel shades of maroon, mustard yellow, pinks, creams, blues and, of course, everywhere the browns and grays of the Franciscan habit. One receives an almost fanciful impression from the palette; it is light, somewhat joyful. At once it is evident that in the individual scenes color plays a very different role than it did in the paintings by Giotto we have seen thus far where, even in the Peruzzi Chapel, it was an aid to composition. It helped to delineate the figures, to shape the narrative; never did it have an independent life of its own. In Assisi the hues form patterns that often have very little to do with the narrative. They are chorded to produce their own independent, decorative rhythms. Thus two fundamentally different conceptions of the handling of color are seen when secure works of Giotto are contrasted with the Assisi frescoes.

A good formal contrast between paintings by Giotto and the Assisi cycle can be made by comparing several scenes from the Bardi Chapel with those in San Francesco. This will be especially revealing since the narratives in question illustrate the same story. Also the Bardi frescoes can be taken as good representatives of Giotto's idiom midway between the classic style of the Arena Chapel and the late Peruzzi paintings. The differences in condition between the Assisi and Bardi cycles are not sufficient to impede a useful contrast.

The first pair of comparisons is found in the frescoes of *The Trial by Fire* (Plates 57 and 36). The story, as we have seen, centers around the sultan's amazement and wonder at the power of Francis' faith. Narratively and psychologically, the core of the scene, as it is told in the early literary sources of the saint's life, is built around the ruler's reaction to the refusal of his own men to submit to the fire test and to the willingness of Francis to enter the flames as proof of his overwhelming faith.

Giotto had read the text carefully and given it one of its greatest performances. The Bardi Chapel fresco centers around the sultan. He is the formal nexus of the scene. His great body dominates the center of the composition, while his hand points one way and his head looks in another. The tabernacle-like structure in which he sits divides the composition almost exactly in two. On either side are other actors, but they are not nearly as important as the majestic, vexed figure who towers above them. Beautiful compositional rhythms prevail. The

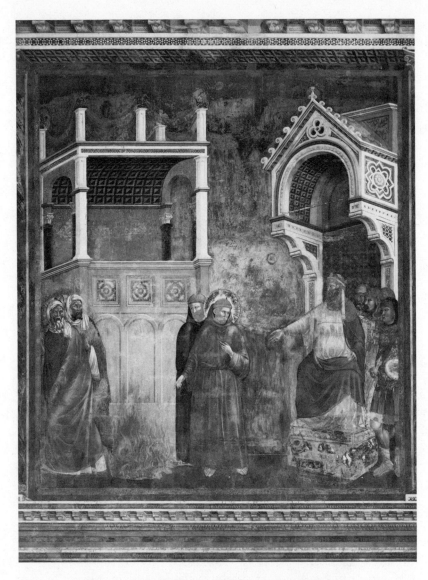

Plate 57. *The Trial by Fire*. Assisi, San Francesco

slinking movement of the sultan's men, the gestures of the bodies of the blacks and the advance of the saint toward the fire—all this action is heightened by being placed before a wall extending almost the entire length of the fresco.

When we turn to the Assisi painting a quite diverse treatment of the same story is seen. The fundamental difference centers around the major protagonist of the narrative, for at Assisi it is no longer the sultan but Francis. It is the saint and not the exotic ruler who is the focal point of the composition. He is placed in the center of the fresco, and his willingness to enter the fire is made the most important action of the painting. It is only to the right that we see the sultan, but here he is not the almost heroic, troubled ruler but rather a vaguely pointing figure whose reactions and actions are not quite clear. At the left a group of his men slink off, avoiding the fearful challenge offered by St. Francis.

Thus, the very heart of the story, its most basic interpretation, is different in the two frescoes. The roles of the sultan and the saint have been reversed; the formal and psychological interpretations vary greatly. One must ask at once if such a fundamental change in interpretation is possible between two works by the same artist.

Of course, it might be argued that since the Assisi fresco of *The Trial by Fire* is in the mother church of the Franciscan order it would naturally depict the story as centering around Francis. This may or may not be correct. However, if we recall certain narratives by Giotto we remember that often the traditional protagonist of a scene is given a position other than the highly important center of the picture. This is the case in the Arena Chapel's *Raising of Lazarus* (Plate 27) and *Mocking of Christ* (Plate 30) and it also occurs in *The Trial by Fire* in the Bardi Chapel (Plate 36). So while we might speculate that the role of St. Francis in the Assisi *Trial by Fire* is partially dictated by the fresco's location in San Francesco, we know—on the basis of works by Giotto—that Giotto often made key figures important by other devices than that of simply placing them in the middle of the fresco. In other words, in Giotto's mind central importance was not always equated with central location.

The two frescoes may also be compared on a more formal level. Their basic shapes are different (this is partially due to the shape of the wall surface), but even taking this into consideration, the proportionate size of the figures to the total picture surface is much smaller at Assisi than it is at Florence. Compare the distance from the top of the heads to the upper border in both paintings. Never in the work of Giotto

have we seen such an extended space between figures and frame, not even in the Peruzzi Chapel, where the spatial environment is the most vast of any work by Giotto.

The way in which the buildings in the Assisi scene are set in space is interesting. The open structure with the blind arcade and rosette decoration gently recedes in one direction, while the throne room of the sultan moves back into space on a different course. This creates a spatial jumble not found in the works of Giotto. The Assisi figures hug a very narrow ground plane, while the recession of the large buildings suggests, but does not delineate, a much greater spatial ambiance. The tension is disturbing, not at all like the carefully controlled space of the Arena or Bardi Chapels or even the much looser but firmly guided composition of the Peruzzi cycle.

When we turn to our next comparison, *The Apparition of St. Francis at Arles*, some of the same differences are again immediately apparent (Plates 58 and 38). In the painting at Santa Croce, Francis is in the center of the composition, which is the most graphic way of portraying the story, since his appearance at the convent of Arles is the central motif of the narrative. To either side sit groups of six Franciscans. The only figural note that disturbs the symmetry of the arrangement is introduced by St. Anthony of Padua, standing to the left of the saint. Of course, the fresco is much more complicated than that, for, as we have seen, the axis of the architecture has been shifted, creating a certain amount of subtle spatial dislocation.

In Assisi Francis has been placed slightly to the right of center. Although standing in the same position as in the Bardi fresco, Francis and the architecture around him do not so immediately hold our attention. Rather, our eyes tend to wander among the jumble of complicated, often lovely forms that so abundantly populate the picture. Once again, each fresco tells the story in a fundamentally different way. In the Bardi painting the composition directs our eyes to the essence of the scene that has been grasped and illustrated, while in San Francesco its true meaning, that of miraculous appearance, has been submerged. Obviously the mind that ideated and designed the Assisi frescoes read narratives in quite a different way from the Giotto we know. One need only compare any scene from the Arena, Bardi or Peruzzi cycles with the *Apparition* in San Francesco to see how widely they vary.

At first glance the architecture in the Assisi *Apparition* seems to be somewhat like that of the Arena Chapel. The opened interior with its receding wall might remind one of the *Mocking of Christ* or one of the

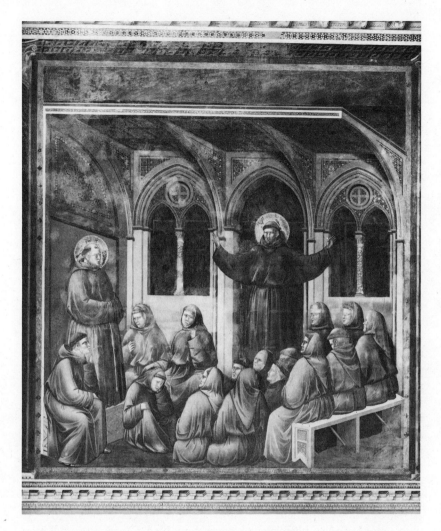

Plate 58. *The Apparition of St. Francis at Arles*. Assisi, San Francesco

other inside scenes at Padua. But on closer inspection the similarity pales. The architecture is too grand; seldom is there such a scale relationship between figure and architecture in the Arena Chapel. The buildings in the Assisi frescoes seem really habitable, not merely symbolic. In this respect they are nearer those of the Bardi and Peruzzi Chapels, but again there are vast differences. At Assisi the architecture also assumes a decorative function unknown in any work by Giotto seen thus far. Look, for example, at the coffered arch or finialed gable of the elaborate architectural canopy over the sultan's throne or the inlaid consoles supporting the roof in the *Apparition*; all are features alien to Giotto's frescoes. There is a love for the busy, intricate play of column, arch and console that is absent from the works by Giotto we have seen. Color adds a distinct note to this decorative play. In the Assisi *The Trial by Fire* the architecture of the pavilionlike structure is a pale blue-green and its decorations are a cool red. The buildings in the *Apparition* are warm brownish-gray. Such colors impart a fantasylike feeling to the elaborate architecture.

In the San Francesco *The Trial by Fire* and the *Apparition of St. Francis at Arles*, the figure types differ from those of any period of Giotto's career yet surveyed. Their heads appear too small for their ample bodies, and, in fact, the entire articulation of the body lacks the confidence seen as early as the Santa Maria Novella cross. One does not immediately sense the presence of bodies under the cloth; gestures and movements are awkward. The heavy fabric that covers most of the figures is broadly molded with wide, white highlights that, at times, make it almost shimmer. The important interval between the figures themselves is seldom as carefully calculated as it is in the Arena, Bardi or Peruzzi Chapels. It is true that in the Assisi *Apparition* the relative positions of Sts. Francis and Anthony have remained the same as in the Bardi, but the adjustment of figures and groups has been altered. As much emphasis has been placed on the jumbled figures sitting before Francis as on the saint himself. Facial features are often sharply outlined. There is a remarkable similarity about many of the faces, whose flinty countenances look, in great part, not toward Francis but to St. Anthony.

In truth, the entire formal articulation of the *Apparition* and *The Trial by Fire* is quite unlike any fresco by Giotto we know. The Assisi scenes lack a fundamental spark. There is an awkwardness about them that not only makes the story less immediate but that also lowers their qualitative level.

The last Assisi fresco we shall survey is *The Verification of the*

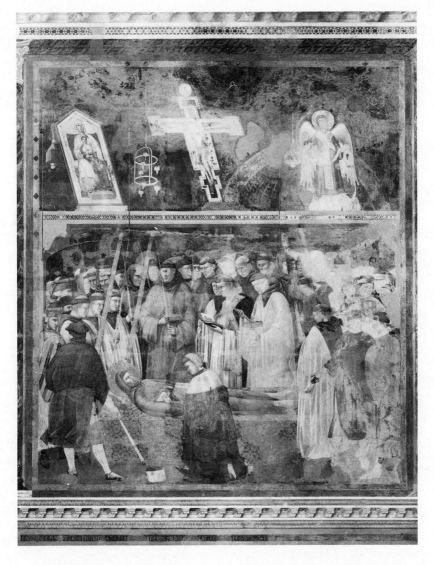

Plate 59. *The Verification of the Stigmata*. Assisi, San Francesco

Stigmata (Plate 59). A certain Jerome of Assisi, not believing the veracity of the stigmata of Francis, was allowed to touch the wound on the dead saint's side. This is one of many obvious parallels between the lives of Christ and Francis, a fact not overlooked by the saint's contemporaries and followers; the *Verification of the Stigmata* can only remind one of the Doubting Thomas story in the life of Christ. In the early literary sources for the life of St. Francis there is a clear division between this scene and that of the death of the saint.[6] They do not even take place in sequence, for there are a number of intervening episodes. However, as we saw, the two are combined in the fresco by Giotto in the Bardi Chapel (Plate 39), where the *Verification* occurs while the saint's soul rises to heaven. The painting—unlike the one at Assisi—thus combines two separate scenes into one and, in fact, seems to be the first example of their combination. Why this should be is unknown, but it may have been that the patron wanted both episodes in the chapel and it was necessary, because of the limited space, to conflate them. Whatever the reason, it is remarkable how Giotto has been able to blend the two in such a compact, seamless fashion.

Both frescoes center around the body of the saint, and in each Jerome kneels, thrusting his finger into the wound. But the similarity does not extend much further, for while the fresco in the Bardi Chapel is a tightly organized, highly rhythmical unity set into a well-defined but limited space, the scene at Assisi is characterized mainly by its multitudinous throng and rather confused spatial ambiance.

In the rear of the Assisi fresco is a large but faint coffered semi-dome. It appears as if this is the apse of the church in which the *Verification* takes place, and its presence at once suggests a deep spatial setting in the fresco. How different is this vague presence of profound space from the rigidly controlled frescoes of Giotto. Even when the painting was new it must have been hard to reconcile the foreground and background; such ambivalence is decidedly not a familiar feature in the work of Giotto.

A beam resting on consoles supports three paintings: a *Madonna and Child*, a *St. Michael* and a *Crucifix* (which is also attached to the roof). Much has been made of the supposed resemblance between the Madonna panel and the San Giorgio alla Costa Madonna and between the crucifix and the cross by Giotto in Santa Maria Novella. Although there are some general resemblances among the paintings, the Assisi Madonna being, however, surely of a more old-fashioned Duecento kind, they are not nearly alike enough to prove that Giotto's hand was

at work on this fresco. In fact, the qualitative level of these little representations is in no way up to Giotto's standard; the figures appear awkward in comparison to their counterparts by him.

The exact spatial position of the beam on which the pictures rest is, like the placement of the apse, not quite clear. One is not sure if it is in the very near foreground or is supposed to be farther back, over the body of St. Francis; this makes the location of the three panels hard to determine. Do they lean out into the observer's space or are they further in the background? Without doubt, some of this ambiguity is caused by the rather poor state of preservation, but even when the fresco was just finished many of these puzzling aspects must have been apparent.

Giotto's power to organize crowds and their movements is graphically demonstrated in the Bardi *Death and Verification*. The two small groups to either side of the saint, the three figures kneeling before the body and the highly rhythmic cluster of people behind it set up movements and counter-movements that guide and direct the eye. The figures, their gestures and glances draw our attention toward the head of Francis, creating an inescapable mood of sadness.

No such feeling is evoked by the group standing around the body of the saint in the Assisi picture. The crowd is not well articulated. Several figures, like the man in the lower left corner who has his back to the spectator or the two people in the lower right corner, direct our glance, but on the whole the crowd is loosely composed.

At Assisi color also helps create an even, overall mood. In the front row behind the saint a number of the monks wear white, while farther back the brown-gray Franciscan habit predominates. Some red appears in the foreground, while the throne of the Madonna panel, the base of the crucifix and the hats of various people are further red notes among the white and brown of the clerical garb.

Thus, the three Assisi frescoes we have contrasted with corresponding subjects in the Bardi Chapel differ from the work of Giotto in the most important visual indicators of an artist's style. In their color, composition and narrative construction they are markedly different from anything yet seen by his hand. So much so, in fact, that if the old tradition giving them to Giotto did not exist it is unlikely that an attribution to the painter would arise from the visual structure of the frescoes themselves.

The Assisi paintings contain scenes of vivacious narrative where many individualized actors often unite to form stories that pulse with a variegated, animated action. Their particularized, sometimes homey

flavor lends an immediacy and accessibility to Francis' legend that is endearing indeed. But these are characteristics not seen in Giotto's known paintings, where a much more aloof and stately world is revealed, one in which people move heroically through monumental, measured space.

But could it be possible that the Assisi paintings represent an unknown phase of Giotto's style even before the Arena Chapel? Might not they be his first major work in fresco? It is a belief among some critics that the Assisi paintings are Giotto's and that they date from sometime during the last two decades of the Duecento.[7] If this were the case, however, one would expect to find some strong, personal stylistic and narrative connections between Assisi and the Paduan cycle. Such ties do not seem to exist, and every reliable indication seems clearly to show that the ideation and actual painting of the *Legend of the Life of St. Francis* belong to a mind and hand other than Giotto's. If, however, we accept the work as being by the young artist, then we have to explain away a shift of absolutely major proportions, in both the visual and psychological sense, between Assisi and Padua. And, in any case, the quality and innovation of Giotto's early panels cannot be made to mesh with the Assisi frescoes.

Could it be possible that the young Giotto worked on the Assisi cycle as a helper? This theory might explain the Giottesque quality of the frescoes seen in gestures, figure and head types and in the drapery. If accepted, it would help to explain these similarities by reasoning that Giotto was influenced by the painter of the St. Francis Legend. It is, of course, chronologically possible for Giotto to have worked as an assistant in Assisi, since the lack of documents does not allow us to set any precise temporal limits for the execution of the frescoes there. Of course, the workshop method and its submergence of the individual style make it almost impossible to point out any area in a fresco clearly by the hand of individual members of a shop, so we can come to no certain conclusion.

Or could it be that the frescoes were influenced by works of the young Giotto? If one looks at the construction of the facial features, the folding of the robes or, more importantly, the basic gestures and attitudes of the figures, there seems indeed to be some connection with Giotto. As we have seen, it is most unlikely that the Francis *Legend* could have been ideated by him, and it is impossible to determine if he worked on the paintings as a young assistant. Thus, the possibility of the influence being explained by the stylistic impact of a work or works by the young Giotto is an attractive one.

The influence of the early paintings by Giotto was great and immediate.[8] If, as there is good reason to believe, his first works date from the early nineties of the Duecento, there is every chance that their impact was felt in Assisi during the same decade or even slightly later. There can be no doubt that the frescoes of the *Legend of St. Francis* are Florentine, although many have questioned their attribution to Giotto. It could then be possible that the Assisi frescoes are by Florentine artists working under the influence of Giotto. And, in fact, many of the similarities and differences we have observed between the Bardi Chapel paintings and the scenes in Assisi are exactly the type that appear between the works of Giotto and some of the artists he influenced most early. We have already seen a panel by Jacopo del Casentino, one of these men (Plate 45). There are others, such as Pacino di Buonaguida and the Santa Cecilia Master, so called after a panel with scenes from the life of that saint (now in the Uffizi Gallery), to name just two.[9] In fact, the very first and the last three frescoes of the St. Francis *Legend*, which appear stylistically to vary from the others, have already been rather convincingly attributed to the Santa Cecilia Master.[10] An attribution to the Florentine circle of Giotto would also explain the qualitative level of the frescoes, which is quite typical of the minor masters who, like Jacopo del Casentino, were deeply impressed by the paintings of the young Giotto.[11] As a working hypothesis to the problem such an answer seems, at present, the most logical.

But if the cycle is attributed to Florentine painters working under the influence of Giotto during the very late Duecento, how can we explain the shared compositional motifs of *The Apparition at Arles* and the *Verification of the Stigmata* in the Assisi and Florence cycles? The answer to this question appears to be rather simple. The style of the youthful Giotto influenced the artists who ideated and painted the St. Francis cycle in Assisi. These frescoes, since they were in the mother church of the Franciscan order, then became the standard pictorial renditions of the saint's legend. Thus, when it was necessary for Giotto to paint a cycle dealing with the life of Francis he referred to the frescoes at Assisi either through a personal visit or drawings. If this theory is accepted, one must not see the frescoes at Assisi as compositional variants on those of Santa Croce but vice versa, although the stylistic influence seems to run just the opposite way—from early works by Giotto to Assisi.[12]

The very nature of the Assisi question is highly complicated. Without documentation it will probably never be resolved.[13] Each

student will bring his own particular methodical and psychological slant to bear on it and will find his own personal answer. The problem is important not only for Giotto but also for the history of art, for as a classical methodological set piece it forces the art historian to examine the cycle from every angle and continually to question the logic of his approach.

We must consider what impact the final answer to the problem, were it ever found, would be. If it were proved through an as yet to be discovered document or by some other means that Giotto was the author of the Assisi cycle, our whole notion of his early development would have to be changed. We would be forced to see him as already a fully formed fresco painter well before the Arena cycle, and then we would have to accept a great change between Assisi and Padua. An almost total transformation in his art would somehow have to be understood.

On the other hand, if a new document were to prove definitely that the scenes of *The Life of St. Francis* were by a hand other than Giotto's, our image of the artist would remain the same. We could, however, see even more clearly the amazing influence of his style during its earliest phase. Also, it would not be necessary to visualize a major qualitative leap between the Assisi paintings and the Arena Chapel frescoes.

Whatever the final answer, the image of the artist's triumphant development remains constant and clear. From the early paintings in the Florentine churches of Santa Maria Novella and San Giorgio alla Costa that established a revolutionary visual and iconographic conception, through the majestic, heroic stories of the Paduan cycle where new and lasting canons of narrative were developed, to the later works in the Bardi and Peruzzi Chapels that formulated spatial and narrative conceptions destined to have enormous impact on all subsequent Florentine art, Giotto followed a continuing route of intellectual and visual success. His is a progression of genius and quality seldom matched in the history of art, for in it we discern not only the workings of a brilliant formal imagination but also the meditations of a mind of supreme understanding, humanity and intelligence. It is little wonder that Giotto's work has so held the attention of Western civilization for over half a millennium.

VIII

Afterword—Giotto's Critics

 The study of an artist's reputation is often interesting and rewarding, for it can reveal a number of things not seen in his art. The formation of a particular reputation may, and many times does, give us a great deal of insight into what the artist's contemporaries thought of his work. Sometimes the estimate turns out to be very different from that which we hold. Constable and Van Gogh, for instance, are good examples of painters not particularly admired during their lifetimes but who are now thought to be of considerable stature. Linked with the development of a contemporary reputation is the critical reception the artist has been given from his time to ours. An analysis of the vagaries of an artist's reputation can tell us much about how the past saw him, if attitudes about him fluctuated, what men liked or disliked about his works and to what place he has been assigned in the history of art. On occasions the historical estimate of an artist is at odds with the opinions his contemporaries held. For example, artists like Sebastiano del Piombo or Edwin Landseer, who were adored during their lifetimes, are hardly lionized today. Often changes in taste alternately admire and disparage a single artist; the history of opinion on Rembrandt is a good case in point.[1]

With this in mind let us turn to some sources from the Trecento onward that mention Giotto. These selected passages from the literature on the artist are meant not to construct a history of Giotto criticism but, rather, to convey some sense of what past writers have felt and said about him.[2] Such an impression may also give the reader a glimpse into how different times and different tastes react to the same artist; such an insight, not surprisingly, is often as revealing about the observer as it is about what is being observed.

Giotto, unlike most artists of his period, was declared famous

during his lifetime. The artistic worth and historical importance of his works were recognized at once, and his contemporaries thought him a man of unusual talent and skill.

Until Giotto's day there was almost no cult of artistic personality. Prior to his time we know the names of very few artists and most of these simply through the signatures they left on their works. His is really the first artistic personality in the Christian West to be sharply drawn by his contemporaries; this alone makes him a very important historical figure.

Exactly how this happened is unclear, but several clues suggest why it took place. One is found in Giotto's innovative and revolutionary painting, while another is furnished by the age in which the artist lived. The early Trecento, as we have seen, witnessed the beginnings of the assertion and recording of the individual ego and its deeds. Dante, Petrarch and Boccaccio all drew vivid literary portraits of numerous Florentines, while merchants and bankers began to write diaries and histories filled with accurate and acute information.[3] Giotto's career thus coincides with a time when the individual was emerging from the personal and historical anonymity that had surrounded him for years.

As we know, the first and most important writer to mention the painter was Dante, who, in the *Divine Comedy* (c. 1310), honored him by citing Giotto alone among all living artists. Dante's words did much to insure Giotto a permanent place in the history of Western art.[4]

During the fourteenth century there were a number of comments on Giotto's personality and painting. Some of these are found in a tale in Boccaccio's *Decameron* (c. 1360), in which the artist is one of the principals. The story is fascinating for its nearly contemporary picture of Giotto and his art; it is worth quoting at length. Pamfilo the narrator tells a tale about two citizens of Florence, each ugly but both intelligent and witty:

One of these men, called Forese da Rabatta, was a dwarfed, mis-shapen man, with a face so flat and doggish that it would have been a fright even had it graced the notoriously ugly family of the Baronci. Yet this ugly little creature was so well versed in law, that many a brilliant man looked upon him as a veritable storehouse of civil learning. The other, whose name was Giotto, was so extraordinary a genius, that there was nothing Nature, the mother of all things, displays to us by the eternal revolution of the heavens, that he could not recreate with pencil, pen or brush so faithfully, that it hardly seemed a copy, but rather the thing itself. Indeed, mortal sight was often puzzled, face to face with his creations, and took the painted thing

for the actual object. Well, as he brought to light again that art, which had lain buried through the mistaken notions of those who painted more to flatter the eye of the ignorant, than to satisfy the intellect of the connoisseur, he might well be called one of the luminaries of Florence's glory. And all the more deservedly, because despite his mastery over others, he bore his honors humbly, and would never consent to be called 'master.' Yes—but that title which he would not adopt, reflected all the more resplendent glory upon him, the more invidiously it was usurped by his disciples, or others who could not compare with him. However, although his genius was phenomenal, he was no better off in personal attractiveness than Messer Forese. But to my story:

You must know that both Messer Forese and Giotto owned property at Mugello, and one day, during the season when lords hold open-court, while Messer Forese, mounted on a disreputable-looking nag, was on his way back to Florence from visiting his estates, he came upon Giotto, returning from a similar errand, and no better mounted or equipped than himself.

Both of them, at the time of my story, were fairly old men, so retarding the pace of their nags, they went their way together, when suddenly an unexpected summer shower overtook them. With all the haste they could muster, they fled to take shelter in the hut of a laborer whom both knew; but after a while, as the rain seemed to show no signs of abating, and as they were anxious to get to Florence before sunset, they borrowed two old fustian cloaks from the peasant for lack of anything better, and two hats, gnawed with age, and once more they proceeded toward the town.

Now when they had gone a while on their way, their clothes hanging limp with the wet, and all spattered and muddy from the continual splashing of their horses' hoofs (which certainly did not add distinction to their appearance) the sky began to clear, and the two, who had gone on in silence, struck up conversation anew.

Giotto was a very entertaining speaker, and as Messer Forese trotted on, listening to him, he could not help considering him from top to toe. The sight of him so disreputable, ill-dressed, and in that predicament, tickled his sense of humor, and without considering his own plight he laughed aloud, saying: "Ha! Ha! Giotto! If a stranger who had never cast eyes on you before, were suddenly to meet you in this condition, do you suppose he would take you to be the finest painter in the world, as indeed you are?"

"Perhaps he would," replied Giotto readily, "if when he saw you, he had the faintest suspicion that you had even learned your A B C."

Messer Forese no sooner heard Giotto's retort than he was aware of his mistake, and saw that he had been paid in his own coin.[5]

It is clear that Boccaccio, like so many other writers of his century, was mightily impressed by what he considered Giotto's realism; people "took the painted thing for the actual object." This is hard for us to understand, for to our eyes Giotto's pictures are far from realistic, but

to men like Boccaccio who knew that the history of painting up to their time was composed of beautiful but abstract works like Coppo's San Gimignano cross (Plate 6) or even the crucifix by Cimabue in Arezzo (Plate 7) they must have appeared stunningly real.

In his seemingly simple story Boccaccio declares that Giotto revived the art of painting, which had been buried for many centuries. The notion of Giotto as an innovator of monumental historical importance evolved by the artist's near contemporaries was to become an integral part of his reputation. No one before Giotto had been called the renewer of art, and such an appellation indicates the awareness among Italians of the Trecento that there had been a long, dark period between themselves and their Roman ancestors.[6] The concept of the Middle Ages—that period between antiquity and the Trecento—was then being formulated, and Giotto became the first example of an artist who was, according to Boccaccio, able to bring "to light again" the art of painting. So within three decades of his death Giotto was well on his way to becoming one of the great cultural heroes of Florence.

Boccaccio's story also says something about Giotto's personality, and although the writer and painter probably never met, Boccaccio certainly had talked with people who had known Giotto. The author's statement that Giotto had a fast and sharp wit tallies with the estimate of many of the other fourteenth-century texts that discuss the painter. In fact, it seems as if for a while Giotto's wit was nearly as famous as his painting.[7] The artist's humility is also stressed by Boccaccio, and from the *Decameron* emerges a picture of Giotto as a great but humble painter who, even though he was acknowledged as an innovator of monumental importance, refused to be called master. The portrait is a sympathetic one indeed.

On the eve of the Renaissance—about forty years after the *Decameron*—the Florentine chronicler Filippo Villani gave Giotto one of the first modern artistic biographies in his *Lives of Famous Men* (c. 1400). This clear and accurate account contains the following passage:

Johannes, surnamed Cimabue was the first who by his art and genius began to call back to verisimilitude the antiquated art of painting that, owing to the painters' ignorance, had become dissolute and wayward, as it were, and had childishly strayed from reality. . . . After him, with the road to new things already paved, Giotto—not only comparable to the classical painters in fame but even superior to them in art and genius—restored painting to its pristine dignity and great renown.[8]

Villani's enthusiastic statement, which is equivalent to declaring Giotto the greatest painter who ever lived, indicates the esteem and even adoration with which the Florentines regarded the artist about sixty years after his death.

But the praise of Giotto and the awareness of his importance was not limited to Florence, for he was lauded by non-Florentines as well.[9] Never before had there been such a success story in the history of European painting. This is significant, for the image of Giotto as constructed by his contemporaries and near contemporaries was to influence strongly all subsequent thought about him and to condition the response of almost everyone who looked at his works. In other words, his vast early renown was to insure his fame for hundreds of years to come.

Much of the codification and transmission of Giotto's fame was the work of Giorgio Vasari, the important sixteenth-century writer on Italian art. Vasari, a pupil of Michelangelo, wrote a series of biographies of artists entitled *Le vite de' più eccellenti pittori, scultori ed architettori*; a first edition was published in 1550, followed by an enlarged second edition eighteen years later.[10] These *Lives* (or *Vite*) are important, for they set down many facts and legends that Vasari had gathered in sixteenth-century Florence. Vasari's influence has been enormous, and many of his evaluations of artists have been unquestioningly accepted.

From the outset Vasari's *Life of Giotto* puts a high value on the artist:

The debt owed by painters to Nature, which serves them continually as an example, that from her they may select the best and finest parts for reproduction and imitation, is due also, in my opinion, to the Florentine painter Giotto; because, when the methods and outlines of good painting had been buried for so many years under the ruins caused by war, he alone, although born in the midst of unskilful artists, through God's gift in him, revived what had fallen into such an evil plight and raised it to a condition which one might call good. Certainly it was nothing short of a miracle, in so gross and unskilful an age, that Giotto should have worked to such purpose that design, of which the men of the time had little or no conception, was revived to a vigorous life by his means.[11]

Vasari continues a tradition begun by Boccaccio when he credits Giotto with the revival of painting, but he gives the legend a meaningful new twist. Giotto, he says, raised painting to new heights by "nothing short of a miracle," and it was "God's gift" that allowed him to do so. The artist's work was thus the work of the divine. Now it is the

inspired Giotto that we see, an artist aided by God miraculously to renew painting in the midst of a gross and unskilled age. Such a concept would have very probably surprised Giotto and his fellow artists who had grown up in the workshop tradition thinking of painting as a trade, although a very special trade indeed.

Vasari, however, lived in a different age, and he saw the history of painting in Florentine terms. He had three heroes—Giotto, Masaccio and, greatest of all, Michelangelo. For Vasari, Michelangelo stood at the end—and summit—of a glorious tradition of Florentine art that found its origin in the painting of Giotto. The *Life* of Giotto thus became important not only for itself but also as a seminal first chapter in Vasari's idea of Florentine art history, a scheme of historical development that still exerts influence on the writing of art history.[12]

Vasari's *Life of Giotto* was the fullest biographical account of the painter published to that time. In it we see Giotto as a very busy artist, rushing from one job to another all over Italy. This may really have been true, but Vasari's detailed accounts of the various commissions were probably also meant to bolster the image of Giotto as an artist always much in demand. Like Michelangelo, he is pictured by Vasari as hurrying to complete one commission after another.

According to Vasari, Giotto, again like Michelangelo, worked for many important patrons: the Pope, a king and numerous wealthy businessmen. One of Vasari's accounts of Giotto's attitude toward a patron is famous. When the Pope was making plans for the decoration of St. Peter's he sent a courtier to see "what sort of man Giotto was."

On the way the courtier learned that there were other excellent masters in painting and mosaic in Florence, and he interviewed a number of artists at Siena. When he had received designs from these, he proceeded to Florence. Entering Giotto's shop one morning, as he was at work, the envoy explained to him the Pope's intention, and the manner in which he wished to make use of his work, and finally asked Giotto for some small drawing to send to His Holiness. Giotto, who was always courteous, took a sheet of paper and a red pencil, pressed his arm to his side to make a compass of it, and then, with a turn of his hand, produced a circle so perfect in every particular that it was a marvel to see. This done, he turned smiling to the courtier and said: "Here is the drawing." The latter, who thought he was being mocked, said: "Am I to have no other design but this?" "It is enough and more than enough," replied Giotto; "send it in with the others and you will see if it obtains recognition." The messenger perceived that he would get nothing else, and left in a state of considerable dissatisfaction, imagining that he had been laughed at. However, when he sent in the other designs with the names of their authors, he included that of Giotto, and

related how the artist had executed it without moving his arm and without compasses. From this the Pope and many of the well-informed courtiers recognized to what an extent Giotto surpassed all the other painters of the time in excellence. When the story became public it gave rise to a saying which is still used for people of dull wits: "You are more simple (*tondo*) than Giotto's O."[13]

In the story Giotto appears as a proud, self-confident artist not deigning to give even the Pope a requested drawing but rather making an amazing demonstration of his powers by drawing the O. The story may not be true, but it shows what Vasari's time could believe about Giotto. The tale sounds more like something Michelangelo would do than Giotto, and it may thus echo the feelings of mid-sixteenth-century artists toward their patrons.

Giotto's *Vita* is full of interesting information and quite long for a Trecento artist. The *Vita* and the historical view of Giotto as the great founder of the Florentine school it contains were to find a vast and sympathetic audience, for the *Lives* were read and reread by many subsequent generations all over Europe. In fact, for centuries the *Vite* served as the major source for anyone interested in the history of Italian painting, and almost everything written about Giotto from Vasari's time forward contains some reference to them. The importance of Giotto's *Vita* for the codification of previous thought about the artist cannot be underrated, nor can its position as the key literary document of the painter's reputation be denied.

There have been few authors who did not agree with Vasari's assessment of Giotto, and it is difficult to find any really adverse criticism of the artist in any period. However, one of the rare exceptions is this spirited comment contained in a letter by the French scholar Charles de Brosses, written in Italy in 1739:

The works of Giotto, successor to Cimabue, are a great deal better, though in themselves they are pretty poor. . . . This great master, whose work is lauded to the skies in every history of art, would today hardly be considered fit to paint a signboard. Yet one must admit that there is a trace of genius and talent in his scribbles.[14]

It is obvious that Giotto's paintings did not appeal to the eighteenth-century taste of de Brosses, although in the Frenchman's harsh criticism there is some grudging praise.

Luigi Lanzi's *History of Italian Art* (1795–1796)—one of the first great modern compendia of Italian art history—gives us an example of Giotto's historical position on the eve of the nineteenth century.

Lanzi's book is still one of the most important studies of the art of Italy, for it displays a questioning, critical attitude toward what had been written in the past, and its author possessed a sharp sense of the evolution of stylistic trends. He writes:

If Cimabue was the Michelangelo of that age, Giotto was the Raffaello. Painting, in his hands, became so elegant, that none of his school, nor any other, till the time of Masaccio, surpassed, or even equalled him, at least in gracefulness of manner.[15]

For Lanzi to mention Giotto with Raphael is revealing, for the late eighteenth century regarded the latter as one of the greatest artists; Raphael was a model still to be imitated, while anyone before him— with very few exceptions—was thought to be primitive, barbarous and without much worth. Of course, one exception was Giotto, who, through Vasari, was considered the founder of Florentine painting.

Before Lanzi's period the style of the 1300s was still so alien to much of the fanciful, highly decorative taste of current eighteenth-century art that what men said about it was dictated not by firsthand observation of the works but, rather, by what had been published about them long before. With the rise of the sterner Neoclassical style during the second half of the eighteenth century the balanced, austere painting of the Trecento must have appeared less distant and more interesting. So one feels that Lanzi must have really been enraptured as he gazed at the nave frescoes of the upper church that were then unanimously attributed to Giotto:

The first histories of the patriarch S. Francesco, at Assisi, near the paintings of his master [Cimabue] show how greatly Giotto excelled him. As his works advanced he became more correct; and towards the conclusion, he already manifested a design more varied in the countenances, and improved in the extremities; the features are more animated, the attitudes more ingenious, and the landscape more natural. To one who examines them with attention, the composition appears the most surprising; a branch of the art in which he seems not only to surpass himself, but even sometimes appears unrivaled.[16]

Lanzi's age saw a turning point in the history of criticism of Giotto. Men actually began looking at his works and saw in them great quality instead of assuming, without observation, that Vasari was right in declaring Giotto a supremely important artist. In other words, much of the study of Giotto became more visual and less literary. Writers on Giotto started to use their eyes as well as their libraries.

One of the most important of these new critics was the Englishman

John Ruskin (1819–1900), whose books on painting and architecture
did much to arouse and popularize a new interest in the art of the
Italian thirteenth century. Ruskin's prose was as beautiful as it was
influential, and his many books soon became an integral part of the bag-
gage of tourists and scholars on their way to Italy. Ruskin wrote a great
deal on Giotto, much of it important even today. His precise observa-
tions on a fresco by Giotto (*The Trial by Fire*, Plate 36) are of
particular interest for their comparison with Turner, who was one of
the most progressive but little understood English painters. At the time
Ruskin wrote Giotto's fresco had been partially overpainted, but this
does not invalidate the method and point of his comparison. The words
that follow were published in *Mornings in Florence*, which first ap-
peared between 1875 and 1877.

For in all his use of opalescent and warm color, Giotto is exactly like
Turner, as, in his swift expressional power, he is like Gainsborough. All the
other Italian religious painters work out their expressions with toil; he only
can give it with a touch. All the other great Italian colorists see only the
beauty of color, but Giotto also its brightness. And none of the others,
except Tintoret, understood to the full its symbolic power; but with those
—Giotto and Tintoret—there is always, not only color harmony, but a color
secret.[17]

Such obviously careful study of Giotto's paintings and the compari-
son of them with then modern works makes exciting reading while
allowing the spectator to observe Ruskin coming to grips with the
formal qualities of the works.

This new approach was not an isolated phenomenon, for it was
closely paralleled by the growing desire on the part of artists working
in the late nineteenth century for increasing abstraction in their paint-
ings. There can be little doubt that the striving of contemporary artists
like Cézanne, Seurat and Gauguin toward new, more abstract pictorial
images helped many critics all over Europe find new formal values
in the art of Giotto.

Among the most famous of these critics was Bernard Berenson
(1865–1959), who was also an early admirer of Cézanne. In one of his
first books, *The Florentine Painters of the Renaissance* (1896), appears
an incisive and sensitive new appreciation of Giotto that ranks among
the finest things ever written on the artist:

Still another exemplification of his sense for the significant is furnished by
his treatment of action and movement. The grouping, the gestures never
fail to be just such as will most rapidly convey the meaning. So with the

significant line, the significant light and shade, the significant look up or
down, and the significant gesture, with means technically of the simplest,
and, be it remembered, with no knowledge of anatomy, Giotto conveys a
complete sense of motion such as we get in his Paduan frescoes. . . . This,
then, is Giotto's claim to everlasting appreciation as an artist: that his
thorough-going sense for the significant in the visible world enabled him so
to represent things that we realize his representations more quickly and
more completely than we should realize the things themselves, thus giving
us that confirmation of our sense of capacity which is so great a source of
pleasure.[18]

Berenson here is really talking about formal values in Giotto's art.
Ideas on the brilliant simplification of such elements in painting would
have been impossible had not the same current been present in late-
nineteenth- and early-twentieth-century art.

In fact, it is during the advent of the Post-Impressionists that a
different understanding of Giotto appeared. His paintings first became
highly valued for their abstract formal qualities and the abstract
symbols they conveyed. This is well illustrated in a passage from
Marcel Proust's *Swann's Way* of 1915:

. . . in later years I understood that the arresting strangeness, the special
beauty of these frescoes [Giotto's in the Arena Chapel] lay in the great part
played in each of them by its symbols, while the fact that these were
depicted, not as symbols (for the thought symbolised was nowhere ex-
pressed), but as real things, actually felt or materially handled, added some-
thing more precise and more literal to their meaning, something more
concrete and more striking to the lesson they imparted.[19]

The concrete, visually significant images recognized by Berenson
and Proust have been the concern of a number of modern art historians.
Their search for the core of Giotto's art has led to a better understand-
ing of how the artist conceives and carries out a painting.

Friedrich Rintelen, for example, in his pioneering monograph of
1912—*Giotto und die Giotto-Apokryphen*—was one of the first critics
to see Giotto's works as a wonderful series of pictures composed by the
most skillful manipulation of light, line, color, space, void and the
other building blocks of visual form. In the following description of
The Feast of Herod (Plate 41) and in its comparison with frescoes
from the Arena Chapel, the reader may get a sense of Rintelen's
method.

A broad hall is open to view. The heavy roof is borne by columns on the
left; in back and on the right side it rests on solid walls. To the hall's right

is joined a narrower vaulted chamber. The layout is once again diagonal, as always in the Peruzzi Chapel. In this way the artist could allow the massive tower in which John was incarcerated to work powerfully in depth as well. This elegantly articulated tower is reminiscent of those of the city gate, in Padua, and the rudiments of the double room, with its wide, full walls and opposed flat and vaulted ceilings, are there too, in Saint Anna's modest little house. Although the architectural principles have remained the same and the joy in beautiful individual forms is likewise constant, the assurance—expressed in the development of great spatial relationships and the spreading out of the most dignified richness—is incomparably greater here. Even now, however, the space is neither a decorative display nor the bravura accomplishment of a painting architect in love with building. It has the greatest significance for the picture itself, and gives the scene a wonderful freedom.[20]

In a famous essay of 1939, Richard Offner, a younger contemporary of Rintelen and one of the most eminent historians of Trecento art, also described the Arena Chapel frescoes in very formal terms.

The composition being conceived as a system of interdependent elements, each figure is accommodated to the whole by being contoured and modelled large in order not to draw too much attention to itself by individualization or description of its physical character. To the same end it needs be immobilized. The composition thus subjugates the individual form to a corporate order and equilibrium, which it brings into predominating evidence.[21]

Order, balance, rhythm, the significant, the symbol—these are all terms of a new way of looking at Giotto's paintings. The historical picture of him as the first revolutionary painter of Italy remains unaltered even today, over six hundred years after his birth. But he is no longer viewed in historical terms alone, for his art is now seen as living, vital and highly forceful in its bold and exciting formal qualities.

The abstract art of the last three decades has helped motivate recent critics and students to discover in Giotto's painting other formal structures and relationships. His use of solid and void, his utilization of color areas and his handling of space and line are now more immediately visible than at any time in the past. This is understandable; for Giotto's art, like that of his predecessors and immediate followers, was built on a formal, geometric and often abstract base. We have only to think back to the great crosses of Coppo and Cimabue to see that this is true. Giotto himself constantly displayed a mastery of the most basic vocabulary of art, always using it to create paintings of almost un-

matched formal brilliance. So, in a very real sense, Giotto criticism has come full circle; we now see, and value, much of what Giotto's contemporaries admired. Present-day eyes observe in the artist's work a highly structured compositional network that is just as appealing as the story it narrates. Thus, when we look at *The Flight into Egypt* (Plate 27) from the Arena Chapel we are as attuned to the sweep of the mountain, the rhythm of the feet and the compressed void behind the figures as we are aware of the story itself.

Ultimately men have observed in Giotto's art what their experience has allowed them to see. Nevertheless, his painting has usually been highly appreciated; it has more than survived the test of time, for it, like all great art, has something for each age. Its spirit has exercised a basic, universal force on all those who have first been attracted to and then irresistibly held by the work of this human and accessible painter.

Notes

1: Giotto di Bondone

1. For years a controversy has been going on over exactly when Giotto was born. For the latest word on the problem, see P. Murray, "On the Date of Giotto's Birth," *Giotto e il suo tempo*, Rome, 1971, pp. 25–34.

2. The fullest survey of documents on Giotto is found in G. Previtali, *Giotto e la sua bottega*, Milan, 1967, pp. 148–52. The archival sources for most of the Giotto documents discussed in this chapter are found in Previtali's digest of documents.

3. See G. Vasari, *Le vite de' più eccellenti pittori, scultori ed architettori* (ed. G. Milanesi), Florence, 1878, Vol. I, pp. 370–72. The *Lives* has been published in several English translations, the most accessible being *The Lives of the Painters, Sculptors, and Architects by Giorgio Vasari* (trans. A. B. Hinds), London, 1927, 4 Vols. Vasari seems to have taken this story from the *Commentari* of the sculptor Lorenzo Ghiberti written around 1450; see *I Commentari* (ed. O. Morisani), Naples, 1947, p. 32.

4. For the latest study on Cimabue, see E. Battisti, *Cimabue*, University Park, 1967. For a different version (dating from the Trecento) of Giotto's meeting with Cimabue—which states that Giotto's father had apprenticed him to a Florentine wool worker—see Vasari (ed. Milanesi), Vol. I, p. 371.

5. For the standard publication of *Il Libro dell' Arte* in the original Italian, see D. Thompson, *Il Libro dell' Arte*, New Haven, 1932. The best English translation, also by Thompson, is *The Craftsman's Handbook (Il Libro dell'Arte)*, New Haven, 1933. There have, unfortunately, been very few studies of the shops of Italian painters.

Three works of interest on the problem of the shops are M. Wackernagel, *Der Lebensraum des Künstlers in der florentinischen Renaissance*, Leipzig, 1938; U. Procacci, "Di Jacopo di Antonio e delle compagnie di

pittori del Corso degli Adimari nel XV secolo," *Rivista d'arte,* XXXV, 1960, pp. 3–70; and J. Larner, *Culture and Society in Italy 1290–1420,* New York, 1971, pp. 285–348.

6. *The Craftsman's Handbook,* p. 3.

7. *Ibid.,* p. 15.

8. *Ibid.*

9. Sometimes contracts or payment documents for large works reveal the number and tasks of the helpers. One particularly interesting set of documents detailing the names of a number of apprentices and helpers for the painting of a chapel in the Duomo at Prato has been published by G. Poggi, "La Cappella del Sacro Cingolo nel Duomo di Prato e gli affreschi di Agnolo Gaddi," *Rivista d'arte,* XIV, 1932, pp. 355–76. See also Larner, pp. 335–48.

10. For a discussion of the relationship between design and execution in fresco painting, see B. Cole, "Some Sinopie by Taddeo Gaddi Reconsidered," *Pantheon* (forthcoming); *The Great Age of Fresco,* New York, 1968, pp. 18–46.

11. For a contract for an important altarpiece from the early Trecento (Duccio's *Maestà*), see G. Milanesi, *Documenti per la storia dell'arte senese,* Siena, 1854, Vol. I, pp. 166–69. For a survey of some Trecento contracts, see Larner, pp. 335–48.

12. See note 9.

13. For a discussion of the types of commissions executed by a shop and the organization of the work, see U. Procacci, and Larner, pp. 285–98.

14. Agnolo Gaddi, the most well-known Florentine painter in the late Trecento, painted a number of timbered ceilings in the Palazzo Datini in Prato. See B. Cole, "The Interior Decoration of the Palazzo Datini in Florence," *Mitteilungen des Kunsthistorischen Institutes in Florenz,* XVIII, 1967, pp. 61–82.

15. For Sacchetti's story, see his *Novella* LXIII (trans. in J. Crowe and G. Cavalcaselle, *A New History of Painting in Italy,* London, 1908, Vol. I, pp. 263–64).

16. *Purgatory,* Canto XI; translation from H. W. Longfellow, *The Divine Comedy of Dante Alighieri,* Boston, 1867, Vol. II, p. 68.

17. For Giotto's *Navicella* for St. Peter's, see W Körte, "Die 'Navicella' des Giotto," *Festschrift Wilhelm Pinder,* Leipzig, 1938, pp. 223–63, and W. Oakeshott, *The Mosaics of Rome,* Greenwich, 1967, pp. 328–32. On Giotto's possible work in Rome, see G. Matthiae, *Pittura romana del medioevo,* Rome, 1966, Vol. I, pp. 247–56.

18. Giotto also invested some money in the *Monte,* the funded communal debt. See M. Becker, "Notes on the *Monte* Holdings of Florentine

Trecento Painters," *The Art Bulletin*, XLVI, 1964, pp. 376–77.

19. For the most recent investigations in the dating of painters' entries in the *Arte dei Medici e Speziali*, see I. Hueck, "Le matricole dei pittori fiorentini prima e dopo il 1320," *Bollettino d'arte*, Aprile–Giugno, 1972, pp. 114–21. The standard study of the *Arte dei Medici e Speziali* is R. Ciasca's *L'Arte dei Medici e Speziali*, Florence, 1927.

20. For the history of Neapolitan painting in the Trecento, see O. Morisani, *Pittura del Trecento in Napoli*, Naples, 1947, and F. Bologna, *I Pittori alla corte angioina di Napoli 1266–1414*, Rome, 1969.

21. In his *Vita* of Giotto, Vasari tells a story of the artist joking rather freely with the King. *Le Vite* (ed. Milanesi), Vol. I, p. 390. See *The Lives* (trans. A. B. Hinds), Vol. I, p. 76.

22. The document is published C. Guasti, *Santa Maria del Fiore*, Florence, 1887, pp. 43–44; the translation is by John Wright.

23. For the question of Giotto as architect, see D. Gioseffi, *Giotto architteto*, Milan, 1963. On the campanile, see M. Trachtenberg, *The Campanile of Florence Cathedral*, New York, 1971. For a very informative survey on Giotto as architect and a discussion of what the term "architect" meant in the Trecento, see Larner, pp. 285–309.

24. G. Villani, *Cronica* XI.12. See *Cronica di Giovanni Villani*, Florence, 1815, Vol. III, p. 232. On some recently discovered tombs in the Cathedral of Florence and for the search for Giotto's tomb, see P. Bargellini, G. Morozzi and G. Batini, *Looking Back to Santa Reparata*, Florence, 1971, pp. 58–70.

25. The most compendious modern history of Florence is R. Davidsohn's *Geschichte von Florenz*, Berlin, 1896–1927, 4 vols. A good general view of the city's history is furnished by F. Schevill, *Medieval and Renaissance Florence*, New York, 1963, 2 vols. Two excellent recent studies have shed much light on Trecento Florence. These are G. Brucker, *Florentine Politics and Society, 1343–1378*, Princeton, 1962, and M. Becker, *Florence in Transition*, Baltimore, 1967 and 1968, 2 vols.

26. For bibliography on the history of Tuscan cities other than Florence, see F. Schevill, *Siena*, New York, 1964; J. K. Hyde, *Padua in the Age of Dante*, New York, 1966; D. Herlihy, *Pisa in the Early Renaissance*, New Haven, 1958, and *Medieval and Renaissance Pistoia*, New Haven, 1967; D. Waley, *The Italian City-Republics*, New York, 1969.

27. On the city's ancient buildings, see W. Limburger, *Die Gebäude von Florenz*, Leipzig, 1910. For the churches of Florence, see W. and E. Paatz, *Die Kirchen von Florenz*, Frankfurt am Main, 1940–1954, 6 vols. On public buildings in Tuscany, see W. Braunfels, *Mittelalterliche Stadtbaukunst in der Toskana*, Berlin, 1966.

28. For an interesting, if not wholly convincing, article that suggests that usury and atonement for it were partly responsible for the erection of the Arena Chapel, see U. Schlegel, "On the Picture Program of the Arena Chapel," in J. Stubblebine, *Giotto: The Arena Chapel Frescoes*, New York, 1969, pp. 182–202. A fascinating selection of economic and family documents is published by G. Brucker in *The Society of Renaissance Florence*, New York, 1971. A Marxist approach to the relationship between Florentine society and painting is found in F. Antal, *Florentine Painting and its Social Background*, London, 1948 and New York, 1975.

29. A great deal of research still remains to be done on the relationship between the various religious orders and the art they commissioned. A valuable source for this problem is H. Thode, *Franz von Assisi und die Anfänge der Kunst der Renaissance in Italien*, Vienna, 1934 (2nd ed.). For a translation of St. Francis' writings and those of a number of his followers, see *St. Francis of Assisi—Writings and Early Biographies* (ed. M. Habig), Chicago, 1972; the Habig edition also contains a very full bibliography on Francis and the religious life of his time. For St. Francis and painting, see B. Bughetti, "Vita e miracoli di San Francesco nelle tavole istoriate dei secoli XIII e XIV," *Archivum Franciscanum Historicum XIX*, 1926, pp. 636–732; G. Kaftal, *Saint Francis in Italian Painting*, London, 1950. G. Kaftal's *The Iconography of the Saints in Tuscan Painting*, Florence, 1952, is the standard reference work for the legends of the saints in Florentine painting. For a masterful essay on Dante's view of St. Francis, see E. Auerbach, *Scenes from the Drama of European Literature*, New York, 1959, pp. 79–98.

30. For Francis' vision, see *St. Bonaventure's Life of St. Francis*, Chapter II. St. Bonaventure's *Life of St. Francis* and *The Little Flowers of St. Francis* (a collection of stories about the saint) are conveniently found in *The Little Flowers of St. Francis, The Mirror of Perfection, St. Bonaventure's Life of St. Francis*, London, 1973. See also *St. Francis of Assisi— Writings and Early Biographies*, pp. 640–41.

31. A good example of the type of direct spiritual experience common to Franciscan thought is the *Meditations on the Life of Christ* sometimes attributed to St. Bonaventure; see *Meditations on the Life of Christ* (trans. I. Ragusa, ed. R. Green), Princeton, 1961.

32. The best history of early Italian sculpture is J. Pope-Hennessy, *Italian Gothic Sculpture*, London, 1972.

33. For the types of early Italian altarpieces, see E. Garrison, *Italian Romanesque Panel Painting; An Illustrated Index*, Florence, 1949. On the development of the Italian altarpiece, see H. Hager, *Die Anfänge des italienischen Altarbildes*, Munich, 1962.

34. The standard work on the painted crucifix is E. Sandberg-Vavalà's

La croce dipinta italiana e l'iconografia della Passione, Verona, 1929. For the various liturgical uses of the cross, see Garrison, pp. 174–75.

35. See note 30. For other visions inspired by paintings, see M. Meiss, *Painting in Florence and Siena after the Black Death*, New York, 1964, pp. 105–131.

II: Giotto's Heritage

1. The literature devoted to the development of the early Tuscan schools is not great and much work remains to be done on the problem. The best general introduction is J. Crowe's and G. Cavalcaselle's *A New History of Painting in Italy*, first published in London in 1864. This monumental work of scholarship remains the standard reference work on Italian painting. Crowe and Cavalcaselle's knowledge of paintings, documents which relate to them, and their artists have never been equaled. For the early history of the Tuscan schools, see also O. Sirén, *Toskanische Maler im XIII Jahrhundert*, Berlin, 1922; F. Edgell, *A History of Sienese Painting*, New York, 1932; E. Garrison, *Italian Romanesque Panel Painting; An Illustrated Index*, Florence, 1949; E. Garrison, "Toward a New History of Early Luchese Painting," *Art Bulletin*, XXXIII, 1951, pp. 11–31; E. Sandberg-Vavalà, *Sienese Studies*, Florence, 1953; E. Carli, *La pittura senese*, Milan, 1955; E. Carli, *Pittura medievale pisana*, Milan, 1958; J. White, *Art and Architecture in Italy 1250–1400*, Harmondsworth, 1966, and R. Oertel, *Early Italian Painting to 1400*, New York, 1968; R. Longhi, "Giudizio del Duecento," *Proporzioni*, II, 1948, pp. 5–54. See also the excellent bibliography on the first Italian schools in F. Bologna, *Early Italian Painting*, Leipzig, 1964, pp. 217–24.

2. A photographic corpus of the Baptistry mosaics is published by A. de Witt, *I mosaici del Battistero di Firenze*, Florence, 1954–1959, 5 vols.

3. On the general problem of the influence of Byzantine art in the West, see O. Demus, *Byzantine Art and the West*, New York, 1970.

4. For the St. Francis altarpiece, which is in the Bardi Chapel, see G. Sinibaldi and G. Brunetti, *Pittura italiana del Duecento e Trecento* (*Catalogo della Mostra Giottesca di Firenze del 1937*), Florence, 1943, pp. 177–80. Sinibaldi and Brunetti's book, which is the catalogue of the great show of early Italian painting held at the Uffizi in 1937, is an excellent source for the paintings of Tuscany from c. 1250–c. 1350.

5. For the tempera painting in the Trecento the best source is Cennino Cennini's *Il Libro dell'Arte*; English translation, *The Craftsman's Handbook "Il Libro dell'Arte,"* New Haven, 1933. See also D. Thompson, *The Materials and Techniques of Medieval Painting*, New York, 1956.

6. On Coppo, see Garrison, pp. 15–16, and White, pp. 108–11.

7. The Christ from the Florentine Baptistry has been attributed to Coppo; see C. Ragghianti, *Pittura del Dugento a Firenze*, Florence, n.d., pp. 47–78. Ragghianti's book contains an excellent selection of photographs of Tuscan Duecento painting.

8. On the development of the cross, see E. Sandberg-Vavalà, *La croce dipinta italiana e l'iconografia della Passione*, Verona, 1929, and Garrison, pp. 174–221.

9. For Cimabue, see E. Battisti, *Cimabue*, University Park, 1967. Battisti's book contains a number of very good photographs of the frescoes and panels by Cimabue. On Cimabue and Rome, see J. Strzygowski, *Cimabue und Rom*, Vienna, 1888.

10. For a listing of other panels of the same shape as the Santa Trinita *Maestà*, see Garrison, pp. 78–85.

11. On Duccio, see C. Weigelt, *Duccio di Buoninsegna*, Leipzig, 1911, 2 vols.; C. Brandi, *Duccio di Buoninsegna*, Florence, 1951; G. Cattaneo and E. Baccheschi, *L'opera completa di Duccio*, Milan, 1972.

12. For a complete summary of the research on Ugolino da Siena's Santa Croce altarpiece, see M. Davis, *The Earlier Italian Schools* (National Gallery Catalogues), London, 1961.

13. See G. Vasari, *Le vite de' più eccellenti pittori, scultori ed architettori* (ed. G. Milanesi), Florence, 1878, Vol. I, p. 454, where Vasari claims that an altarpiece by Ugolino then in the Spanish chapel, Santa Maria Novella, at one time stood on the high altar of the same church. For the English translation of the passage in question, see *The Lives of the Painters, Sculptors, and Architects by Giorgio Vasari* (trans. A. B. Hinds), London, 1927, Vol. I, pp. 97–98.

14. See I. Hueck, "Le matricole dei pittori fiorentini prima e dopo il 1320," *Bollettino d'arte*, Aprile–Giugno, 1972, pp. 114–21.

15. See note 10.

16. On early Italian sculpture, see G. Crichton, *Romanesque Sculpture in Italy*, Cambridge, 1938; P. Toesca, *Il Medioevo*, Turin, 1927; J. White, *Art and Architecture in Italy 1250–1400*, Harmondsworth, 1966; and J. Pope-Hennessy, *Italian Gothic Sculpture*, London, 1972.

17. On Nicola Pisano, see G. and E. Crichton, *Nicola Pisano*, Cambridge, 1938; G. Fasola, *Nicola Pisano*, Rome, 1941; Pope-Hennessy, pp. 169–75.

18. On Nicola and the antique, see Crichton, *Pisano*, pp. 11–20.

19. For Giovanni Pisano, see H. Keller, *Giovanni Pisano*, Vienna, 1942, and Pope-Hennessy, pp. 175–76.

20. For Arnolfo di Cambio, see V. Mariani, *Arnolfo e il gotico italiano*,

Naples, 1967; A. Romanini, *Arnolfo di Cambio e lo 'stil nuovo' del gotico italiano*, Milan, 1969; Pope-Hennessy, pp. 180–83.

III: First Works

1. Substantial discussion of the Santa Maria Novella cross began only when it was cleaned and exhibited in good light at the great exhibition of the works of Giotto and his time held in the Uffizi Gallery in 1937. The catalogue of this exhibition has become one of the standard reference works of early Italian painting. For its entry on the Santa Maria Novella cross, see G. Sinibaldi and G. Brunetti, *Pittura italiana del Duecento e Trecento* (*Catalogo della Mostra Giottesca di Firenze del 1937*), Florence, 1943, pp. 301–307.

The Santa Maria Novella cross is attributed to Giotto by most scholars (see A. Martindale and E. Baccheschi, *The Complete Paintings of Giotto*, New York, 1966, pp. 95–96, and G. Previtali, *Giotto e la sua bottega*, Milan, 1967, pp. 331–333), with the notable exception of Richard Offner, who gave it to a painter he called the Master of the Santa Maria Novella Cross. See R. Offner, *Corpus of Florentine Painting*, Glückstadt, 1956, III, VI, pp. 9–18.

2. Documentation connected with a crucifix by Giotto in Santa Maria Novella dates back to 1312. In that year a Florentine named Riccuccio di Pucci left money for a lamp to be lit in front of a cross by Giotto. According to the terms of the legacy of the same Riccuccio, three years later a lay confraternity paid for an ounce of oil for the lamp in front of a cross by Giotto. In the eighteenth century Domenico Manni copied from the archives of the church part of a document stating that Giotto finished a cross in 1312.

It seems at first glance that these documents must refer to the cross under discussion. After all, they clearly state that there was a cross by Giotto in Santa Maria Novella by at least 1312. It is tempting, indeed, to put records and cross together and declare the work a documented painting dating from the year 1312. This, however, does not seem to be the case, for here we have one of those examples in which perfectly authentic documents can lead to wrong conclusions when matched to a work with which they do not belong.

The major obstacle blocking the connection of the documents with the painting is style. Given the rest of Giotto's work, it is clearly impossible to date this cross as late as 1312. The Arena Chapel frescoes (the subject of the next chapter) cannot be much later than 1306, and their style is much more developed than the Santa Maria Novella cross, which is, as we shall see, closely related to other work that can be attributed to Giotto's youth. It is,

therefore, highly unlikely that it is the painting mentioned in the documents.

What, then, is one to do with these perfectly authentic records? The only other solution is to postulate that they do not refer to the extant cross but to yet another work by Giotto that has since been lost or destroyed. It would have been not at all unusual for an artist of Giotto's stature to do more than one work in a single church. In Santa Croce he painted, for example, at least two chapels and perhaps their altarpieces as well. Much the same is true of a number of important Florentine artists.

But would there be a need for more than one cross in a church? The answer is yes. In the first place we do not know the size of the documented cross; it could have been quite small and placed over a minor altar. On the other hand, even if it were as large as the extant cross there would be no reason why both of them could not have been in the church. (There are two large crosses in Santa Croce.) One of Giotto's crosses may have been placed over the high altar, while the other could have hung on the entrance wall of the church.

A cross by Giotto in Santa Maria Novella had a considerable fame from the Trecento onward. It is mentioned in the 1500s by Antonio Billi and by the Anonimo Maliabechiano, an anonymous manuscript in the Biblioteca Nazionale in Florence. Vasari also mentions a crucifix by Giotto in Santa Maria Novella (*Le vite de' più eccellenti pittori, scultori ed architettori* [ed. G. Milanesi], Florence, 1878, Vol. I, p. 394), so it appears certain that the cross by Giotto in the same church was still a famous work three centuries after its completion.

For attributions to Giotto made in Tuscan sources before Vasari, see P. Murray, *An Index of Attributions Made in Tuscan Sources Before Vasari*, Florence, 1959, pp. 79–89. J. Schlosser's *La Letteratura artistica*, Florence, 1964, contains the most complete survey and fullest bibliography of Italian literary sources devoted to art and artists.

3. The story of the meeting of Giotto and Cimabue and the legend of Giotto's apprenticeship in Cimabue's shop appears first in the *Commentari* of the Florentine sculptor Lorenzo Ghiberti (written c. 1450). For Ghiberti and almost all the early (and later) writers on Giotto, see R. Salvini's monumental bibliography of Giotto sources, which contains entries published up to 1938—R. Salvini, *Giotto bibliografia*, Rome, 1938. Now see also C. De Benedictis, *Giotto bibliografia*, Vol II (1937–1970), Rome, 1973. Both Salvini's and De Benedictis' volumes contain the fullest survey of the literature on Giotto ever published and as such are indispensable sources for anyone interested in the artist.

4. For studies of panel shapes and their development, see H. Hager, *Die Anfänge des italienischen Altarbildes*, Munich, 1962, and M. Cämmerer-George, *Die Rahmung der toskanischen Altarbilder im Trecento*, Strasbourg, 1966.

5. For Deodato Orlandi, see E. Garrison, *Italian Romanesque Panel Painting; An Illustrated Index*, Florence, 1949, pp. 16–17.

6. For the question of the influence of Giotto's style in early Trecento Tuscany, see B. Cole, "Old in New in the Early Trecento," *Klara Steinweg. In Memoriam*, Florence, 1973, pp. 57–76. A general survey of some of Giotto's pupils is found in R. Oertel, *Early Italian Painting to 1400*, New York, 1968, pp. 77–194.

7. For the complete bibliography of the San Giorgio Madonna to 1937, see Sinibaldi and Brunetti, p. 357. More recent bibliography and a survey of the panel's condition is found in R. Offner, pp. 3–7. Offner attributed the San Giorgio panel to the Master of the Santa Maria Novella Cross, but most recent scholarship gives the painting to Giotto. See R. Oertel, pp. 78–81, and Martindale and Baccheschi, p. 96. For a discussion of the influence of the San Giorgio Madonna type on the very early Trecento, see B. Cole, "On an Early Florentine Fresco," *Gazette des Beaux-Arts*, LXXX, 1972, pp. 91–96. This article also suggests the possibility that Giotto may have been at work in Florence by 1292.

8. The reconstruction drawing is from Offner, Plate Ia.

9. For the *Madonna and Child with Two Angels*, see for example Garrison, Nos. 1, 7, 12 and 19. Very simple thrones occupied by pre-Giottesque Madonnas can be seen in *ibid.*, Nos. 14, 19 and 33.

10. See, for instance, the vision of Brother Pietro found in the *Fioretti*, Chapter 44. This vision, in which the Virgin, St. John the Evangelist and St. Francis appear, seems to spring from the contemplation of a painted crucifix and resembles the painted images seen on triptychs. See *St. Francis of Assisi—Writings and Early Biographies* (ed. M. Habig), Chicago, 1972, p. 1400. For visions inspired by paintings, see M. Meiss, *Painting in Florence and Siena after the Black Death*, New York, 1964, pp. 105–131.

11. A Madonna panel attributed to Giotto in San Giorgio alla Costa is mentioned by Ghiberti and several other early writers. See P. Murray, pp. 83–84.

12. The tremendous influence made by the innovative features of the *San Giorgio alla Costa Madonna* are reflected in a most interesting way in the work of a painter known as the Vicchio-Paris Master. Two of his panels demonstrate the impact of the young Giotto. In the fiirst (at Vicchio di Rimaggio near Florence) he paints a Cimabue-like Madonna; but in a later panel

(Paris, Musée des Arts Décoratifs) his much more modern Virgin and throne clearly show the strong influence of the young Giotto. See Offner, *Corpus*, Glückstadt, 1956, III, VI, pp. 115–20, and B. Cole, "Early Florentine Fresco," pp. 91–96.

13. On Cavallini, see G. Matthiae, *Pietro Cavallini*, Rome, 1972.

14. For Roman Duecento painting, see *ibid.*, *Pittura romana del medioevo*, Rome, 1966, Vol. II, pp. 120–262.

15. For an up-to-date survey of some of the most important critical opinions and a discussion of the Isaac Master–Cavallini–Giotto question, see A. Smart, *The Assisi Problem and the Art of Giotto*, Oxford, 1971, pp. 107–30.

16. For a detailed bibliography on the *Ognissanti Madonna*, see Sinibaldi and Brunetti, pp. 317–22; Martindale and Baccheschi, p. 96; G. Previtali, *Giotto e la sua bottega*, Milan, 1967, pp. 334–35.

17. For a discussion of the present state of the *Ognissanti Madonna*, see D. Wilkins, "On the Original Appearance of Giotto's Ognissanti Madonna," *Art Quarterly*, XXXIII, 1970, pp. 1–15.

IV: The Arena Chapel

1. There has been some speculation that Giotto was the architect of the Arena Chapel. For this theory and for an architectural survey of the building, see D. Gioseffi, *Giotto architetto*, Milan, 1963. For an introduction to the iconography, documentation and painting in the Arena Chapel, see J. Stubblebine, *Giotto: The Arena Chapel Frescoes*, New York, 1969, and for further bibliography and illustrations C. Gnudi, *Giotto*, Milan, 1958, pp. 105–69; G. Previtali, *Giotto e la sua bottega*, Milan, 1967, 347–64.

2. For a survey and the translations of the sparse documentation connected to the Arena Chapel, see Stubblebine, pp. 103–08 and 110–11.

3. For a recent discussion of the Paduan *Annunciation* and other miniatures from the same set of manuscripts that reproduce motifs from the Arena Chapel and that can also be dated 1306, see C. Bellinati, "La Capella di Giotto all'Arena e le miniature dell' antifonario 'Giottesco' della Cattedrale (1306)," in *Da Giotto al Mantegna*, Milan, 1974, pp. 23–30. Bellinati's article also contains an interesting survey of the documentation on the Arena Chapel. See also Stubblebine, pp. 103–07.

4. *Ibid*, pp. 106–07.

5. See especially U. Schlegel, "On the Picture Program of the Arena Chapel," in *Ibid.*, pp. 182–202.

6. For an interesting example of a will in which money is left for the erection of a chapel, see G. Brucker, *The Society of Renaissance Florence*, New York, 1971, pp. 52–56.

7. The more complex iconographic programs of the fourteenth century, such as those found in the Spanish Chapel, Santa Maria Novella, Florence, or in the Castellani Chapel, Santa Croce, Florence, surely must have been planned by men with considerable theological knowledge. On the other hand, it is fascinating to note that a priest is paid to translate a text for the Sienese painter Pietro Lorenzetti so that the artist could read the holy story he was to paint. Could this mean that Pietro was to have some share in the planning of the picture? Much archival work remains to be done on the whole question of who actually commissioned artists and how pictorial programs were planned. For the document mentioning Pietro Lorenzetti, see E. DeWald, *Pietro Lorenzetti*, Cambridge, 1930, p. 5.

8. The Virtues and Vices may play a more important part in the iconography of the chapel than has been suggested to date. There seems to be a tradition of the Virtues as didactic figures that occupy an intermediate position between narrative scenes and the viewer. The full-round virtues of Nicola Pisano's Pisa and Siena pulpits may emphasize the didactic function of the preaching that was done from these structures. They, in other words, are exemplars of the correct path to salvation. A similar function may have been intended for the Virtues and Vices in the Arena Chapel, and their sculptural-like free-standing forms rendered in a monochromatic palette may have reference to the iconographic arrangement of the pulpits.

9. Schlegel, p. 190, believes these were intended to represent burial chapels for the Scrovegni family.

10. For Giovanni Pisano, see H. Keller, *Giovanni Pisano*, Vienna, 1942; G. Mellini, *Giovanni Pisano*, Milan, n.d.; and J. Pope-Hennessey, *Italian Gothic Sculpture*, London, 1972, pp. 175–76. Aside from the three carved figures by Giovanni there is also the tomb of Enrico Scrovegni (died 1336) in the east end of the chapel. For the attribution of this tomb to a Venetian sculptor, see W. Wolters, "Appunti per una storia della scultura padovana del Trecento," in *Da Giotto al Mantegna*, pp. 36–42.

11. See note 1.

12. A detailed account of the technique of fresco painting is found in the following: Cennino Cennini, *The Craftsman's Handbook* (*Il libro dell'arte*), New Haven, 1933; U. Procacci, *Sinopie e affreschi*, Milan, 1961; M. Meiss and L. Tintori, *The Painting of the Life of St. Francis of Assisi*, New York, 1967; *The Great Age of Fresco: Giotto to Pontormo*, New York, 1968; R. Oertel, *Early Italian Painting to 1400*, New York, 1968. For some specific comments on the fresco technique of the Arena Chapel (and Giotto's later chapels in Santa Croce, Florence), see Meiss and Tintori, pp. 159–85.

13. For a monumental corpus of early Italian drawings, see B. Degenhart

and A. Schmitt, *Corpus der italienischen Zeichnungen 1300–1450*, Berlin, 1968, 4 vols.

14. A detailed survey of the restorations carried out in the Arena Chapel in the nineteenth century is found in A. Prosdocimi's fascinating "Il Comune di Padova e la capella degli Scrovegni nell Ottocento," *Bullettino del Museo Civico di Padova*, XLIX, 1961.

15. See R. Oertel, pp. 70–77.

16. For textual sources for the life of the Virgin, her parents and Christ, see M. von Nagy, *Die Wandbilder der Scrovegni-Kapelle zu Padua: Giottos Verhältnis zu seinen Quellen*, Bern, 1962. Giotto may also have been acquainted with Jacobus de Voragine's *Golden Legend* (c. 1260); see *The Golden Legend of Jacobus de Voragine* (eds. G. Ryan and H. Ripperger), London, 1941. It is also possible that the artist knew the *Meditations on the Life of Christ* sometimes attributed to St. Bonaventure; see *Meditations on the Life of Christ* (trans. I. Ragusa, ed. R. Green), Princeton, 1961.

17. For speculation on who this woman might be, see A. Smart, *The Assisi Problem and the Art of Giotto*, Oxford, 1971, pp. 104–05.

18. On the textual sources for the *Betrayal*, see von Nagy, p. 26.

19. For the pioneering study of the iconographic parallelism in the Arena Chapel, see M. Alpatoff, "The Parallelism of Giotto's Paduan Frescoes," *The Art Bulletin*, XXIX, 1947, pp. 149–59. Much work still needs to be done before the incredibly complex iconographic and stylistic interrelationships and parallelisms of the Arena Chapel are fully understood.

20. For further discussion of this fresco, see B. Cole, "Another Look at Giotto's *Stigmatization of St. Francis*," *The Connoisseur*, 181, 1972, pp. 48–53.

21. For examples of the use of architecture during the late Duecento, see Plates 50, 71, 145, 150, 151, 173 in C. Ragghianti, *Pittura del Duecento a Firenze*, Florence, n.d.

22. For an illustration of this fresco, see Stubblebine, Plate 25.

23. There are ten of these little quatrefoils in the borders next to the Arena Chapel narratives. They have an iconographic reference—a typological one—to the frescoes they flank. For a study of these often very beautiful figures, see A. Bertini, "Per la conoscenza del medaglioni che accompagnano le storie della vita di Gesù nella Capella degli Scrovegni," *Giotto e il suo tempo*, Rome, 1971, pp. 143–47.

24. For the latest survey of literature on the Paduan cross—which several critics assign to Giotto's shop—see *Da Giotto al Mantegna*, No. 1.

25. Recently U. Schlegel has attempted to identify the hand of the Master of Figline in the Arena Chapel. For this study, which I find un-

convincing, see U. Schlegel, "Un collaboratore di Giotto a Padova. Osservazioni sul Maestro di Figline," *Giotto e il suo tempo*, pp. 161–67.

26. Cennino Cennini, pp. 14–15.

V: Santa Croce—The Bardi and Peruzzi Chapels

1. For the history of the Bardi Chapel, see W. and E. Paatz, *Die Kirchen von Florenz*, Frankfurt, 1955, Vol. I, pp. 570–86.

2. On the Bardi family around the time of the painting of the chapel, see A. Sapori, *La Crisi delle compagnie mercantili dei Bardi e dei Peruzzi*, Florence, 1926.

3. For a quattrocento inventory of the chapels in the church of Santa Croce, including the possessions of the family hanging inside these chapels, see P. Mencherini, *Santa Croce di Firenze*, Florence, 1929, pp. 22–26.

4. See P. Murray, *An Index of Attributions Made in Tuscan Sources before Vasari*, Florence, 1959, pp. 82–83.

5. G. Vasari, *Le vite de' più eccellenti pittori, scultori ed architettori* (ed. G. Milanesi), Florence, 1878, Vol. I, p. 373. Translation from *The Lives of the Painters, Sculptors, and Architects by Giorgio Vasari* (trans. by B. Hinds), London, 1927, Vol. I, p. 67.

6. Vasari (ed. Milanesi), pp. 373–74.

7. *Ibid.*, p. 374.

8. For the attribution and the Master of Figline, see A. Graziani, "Affreschi del Maestro di Figline," *Proporzioni*, I, 1943, pp. 65–79.

9. The single dissenting voice known to me is R. Oertel, who, in his *Early Italian Painting to 1400*, New York, 1968, pp. 110–86, attributes it to an artist whom he calls the Master of the Bardi Chapel.

10. On the nineteenth-century restorations of the Bardi and Peruzzi Chapels, see A. Conti, *Storia del restauro*, n.d., Milan, pp. 252–54.

11. For the Franciscan texts for these stories, see *St. Francis of Assisi—Writings and Early Biographies* (ed. M. Habig), Chicago, 1972.

12. For a discussion of the *Stigmatization* fresco, see B. Cole, "Another Look at Giotto's *Stigmatization of St. Francis*," *The Connoisseur*, 181, 1972, pp. 48–53.

13. On the question of painted architecture and its symbolism in the Arena Chapel and in other works by Giotto, see D. Gioseffi, *Giotto architetto*, Milan, 1963; L. Bongiorno, "The Theme of The Old and The New Law in the Arena Chapel," *Art Bulletin*, XLX, 1968, pp. 11–20; W. Euler, *Die Architekturdarstellung in der Arena-Kapelle*, Bern, 1967.

14. For an analysis of gravity in Giotto's painting, see H. Davis, "Gravity in the Painting of Giotto," *Giotto e il suo tempo*, Rome, 1971, pp. 367–82.

15. For this scene Giotto combined two separate stories from the legend of St. Francis. See St. Bonaventure's *Life of St. Francis*, XIV, 6, and XV, 4; *St. Francis of Assisi—Writings and Early Biographies*, pp. 740–41, 743.

16. For Taddeo's Accademia panel, see G. Sinibaldi and G. Brunetti, *Pittura italiana del Duecento e Trecento* (*Catalogo della Mostra Giottesca di Firenze del 1937*), Florence, 1943, Plate 137y. This little painting seems to come from quite early in Taddeo's career and was probably painted shortly after the Bardi Chapel was finished.

17. For a history of the Peruzzi Chapel and its decoration, see Paatz, pp. 567–68.

18. On the restorations of the Peruzzi Chapel in the 1950s, see L. Tintori and E. Borsook, *Giotto—the Peruzzi Chapel*, New York, 1965. This book also contains much valuable information on the history and patronage of the chapel.

19. For the history of the Peruzzi family around the time of the painting of the chapel, see Sapori, and Tintori and Borsook, pp. 7–14.

20. *Ibid.*, p. 10, cite later documentation that states that the donor of the frescoes was Giovanni di Rinieri Peruzzi. There seems, however, to be no certain Trecento evidence to substantiate this.

21. On the pictorial framing and disposition of the frescoes of Giotto and his school, see C. A. Isermeyer, *Rahmengliederung und Bildfolge in der Wandmalerei bei Giotto und den Florentiner Malern des 14. Jahrhunderts*, Würzburg, 1937.

22. The decapitated body of St. John is hard to see in its present condition. For a discussion of how the area appears under infrared light, see Tintori and Borsook, p. 78.

23. *Ibid.* claim that the two robes did not originally meet. For this thesis, which I find hard to understand, see *Ibid.*, p. 28.

24. For Duccio's *Maestà*, see G. Cattaneo and E. Baccheschi, *L'opera completa di Duccio*, Milan, 1972, pp. 88–94. For bibliography on Duccio, see Chapter II, note 11.

25. For Ugolino's altarpiece, see Chapter II, note 12.

26. On Ambrogio Lorenzetti, see G. Rowley, *Ambrogio Lorenzetti*, Princeton, 1958, 2 vols.

27. For the works of Bernardo Daddi, one of the Florentines most under the sway of Ambrogio Lorenzetti, see R. Offner, *Corpus of Florentine Painting*, III, III, Berlin, 1930.

28. For Ambrogio's altarpiece, see L. Marcucci, *Gallerie nazionali di Firenze, I dipinti toscani del secolo* XIV, Rome, 1965, pp. 161–63.

29. For Pietro Lorenzetti, see E. DeWald, *Pietro Lorenzetti*, Cambridge,

1930; G. Sinibaldi, *I Lorenzetti*, Siena, 1933; E. Borsook, *Ambrogio Lorenzetti*, Florence, 1966.

30. On Simone Martini, see G. Paccagnini, *Simone Martini*, Milan, 1955, and G. Contini and M. Gozzoli, *L'opera completa di Simone Martini*, Milan, 1970.

31. For a survey of the history of the dating of the Bardi and Peruzzi Chapels, see A. Martindale and E. Baccheschi, *The Complete Paintings of Giotto*, New York, 1966, p. 113 (Peruzzi) and pp. 116–17 (Bardi). It should be pointed out that many critics believe that the Peruzzi Chapel antedates the Bardi, a view which, in my opinion, is not confirmed by stylistic evidence of the paintings.

32. For a survey of many of the works either documented to Giotto and now lost, or attributed to him at one time, see the following: P. Murray, *An Index of Attributions made in Tuscan Sources before Vasari*, Florence, 1959; Martindale and Baccheschi, pp. 124–25; and G. Previtali, *Giotto e la sua bottega*, Milan, 1967, pp. 290–377.

VI: Giotto's Heirs

1. For a study on the problem of the stylistic disruptions caused by Giotto's idiom, see B. Cole, "Old in New in the Early Trecento," *Klara Steinweg. In Memoriam*, Florence, 1973, pp. 57–76.

2. On Jacopo del Casentino, see R. Offner, *Corpus of Florentine Painting*, Berlin, 1930, III, II, pp. 87–186.

3. For a discussion of each panel and a survey of the most important bibliography on it, see the following: Bologna, Pinacoteca Nazionale, Polyptych with the Madonna and Child enthroned, flanked by St. Peter, the Archangels Gabriel and Michael and St. Paul—A. Martindale and E. Baccheschi, *The Complete Paintings of Giotto*, New York, 1966, pp. 118–120; G. Previtali, *Giotto e la sua bottega*, Milan, 1967, pp. 316–17; Paris, Louvre, *Stigmatization of St. Francis* with a predella containing the *Dream of Innocent III*, *The Approval of the Franciscan Rule*, *St. Francis Preaching to the Birds*—Martindale and Baccheschi, p. 95; Previtali, pp. 366–67; Florence, Santa Croce, *The Baroncelli Altarpiece*, *Coronation of the Virgin with Saints and Angels*—Martindale and Baccheschi, p. 118; Previtali, pp. 329–30.

Other paintings sometimes attributed to Giotto but, in my opinion, of a quality inferior to the artist's work are the following: Florence, Badia, Polyptych—Martindale and Baccheschi, p. 97; Previtali, p. 342. Rimini, Tempio Malatestiano, Crucifix—Martindale and Baccheschi, p. 111; Previtali,

pp. 368–69. Berlin, Staatliche Museen, *Dormition of the Virgin*—Martindale and Baccheschi, p. 112; Previtali, pp. 315–16; Raleigh, North Carolina Museum of Art, Polyptych—Martindale and Baccheschi, pp. 114–15; Previtali, pp. 367–68. A reconstructed polyptych made up of panels in the Horne Museum of Florence, the National Gallery of Art, Washington (a Madonna and Child quite close to Giotto's late style), and the Jacquemart-André Museum, Châalis—Martindale and Baccheschi, p. 115; Previtali, p. 355. Vatican, Pinacoteca Vaticana, Polyptych, "The Stefaneschi Polyptych." The necrology of Cardinal Jacopo Stefaneschi records a commission to Giotto for the high altar of old St. Peter's. It is quite possible that the altarpiece in the Pinacoteca Vaticana is the work referred to, but it is not by Giotto's hand. We may have here another example of a work commissioned to the master but entirely executed by his shop. For the Stefaneschi polyptych, see M. Gosebruch, "Giottos Stefaneschi-Altarwerk aus Alt St. Peter in Rome," *Miscellanea Bibliothecae Hertzianae*, Munich, 1961, pp. 104–30; Martindale and Baccheschi, pp. 120–21, 372–74.

Several fragments of a destroyed fresco cycle of the *Life of the Virgin* (attributed to Giotto by Ghiberti and Vasari) from the Florentine Badia have recently been discovered. These few fragments allow us to say only that they seem close to the style of Giotto; see *ibid.*, p. 96, and Previtali, p. 344.

For the numerous other works occasionally ascribed to Giotto, see Previtali's catalogue *passim*.

4. For a rather typical survey of the *Giotteschi*, which sees most of them as weak imitators of Giotto, see O. Sirén, *Giotto and Some of His Followers*, Cambridge, 1917, 2 vols.

5. On Daddi, see R. Offner, *Corpus of Florentine Painting*, III, III, Berlin, 1930.

6. On Maso di Banco, see R. Offner, "Four Panels, a Fresco and a Problem," *The Burlington Magazine*, LIV, 1929, pp. 224–45.

7. For the Bardi–Bardi di Vernio Chapel, see W. and E. Paatz, *Die Kirchen von Florenz*, Frankfurt am Main, 1955, Vol. I, pp. 575–76.

8. For Taddeo Gaddi, see P. Donati, *Taddeo Gaddi*, Florence, 1966, and R. Oertel, *Early Italian Painting to 1400*, New York, 1968, pp. 188–92.

9. Cennino Cennini, *The Craftsman's Handbook* (*Il libro dell'arte*), New Haven, 1933, p. 2.

10. For Taddeo's copy of the *Ognissanti Madonna*, see G. Sinibaldi and G. Brunetti, *Pittura italiana del Duecento e Trecento* (*Catalogo della Mostra Giottesca di Firenze del 1937*), Florence, 1943, p. 459.

11. For photographs and discussion of these interesting panels, see G.

Sinibaldi and G. Brunetti, Plates 137b–137y, and L. Marcucci, *Gallerie nazionali di Firenze. I dipinti toscani del secolo XIV*, Rome, 1965, pp. 56–62.

12. For the Baroncelli Chapel, see Paatz, pp. 556–59.

13. On Taddeo's Uffizi Madonna, see Marcucci, pp. 65–66.

14. M. Meiss, *Painting in Florence and Siena after the Black Death*, New York, 1964.

15. For the San Giovanni Fuorcivitas Polyptych see Sinibaldi and Brunetti, p. 45.

16. For the Uffizi altarpiece of 1355, see Marcucci, pp. 65–66. On the Santa Felicita polyptych, see Sinibaldi and Brunetti, p. 142. The 1355 Uffizi altarpiece could represent a stylistic anomaly in Taddeo's work, since it was painted for the provincial town of Poggibonsi, a center that may have had rather old-fashioned tastes.

17. For Orcagna see R. Offner, *Corpus of Florentine Painting*, Glückstadt, 1962, IV, I.

18. For the Spanish Chapel, see Paatz, *Die Kirchen von Florenz*, Frankfurt am Main, 1952, Vol. III, pp. 720–22.

19. See Taddeo's strange, ritualistic *Presentation in the Temple* (c. 1330, Florence, Accademia, Marcucci, Plate 31d) or the same subject in Bernardo Daddi's San Pancrazio Polyptych (c. 1340, *ibid.*, Plate 13n).

20. For Giovanni del Biondo, see R. Offner, *Corpus of Florentine Painting*, Glückstadt, 1967–1969, IV, IV, and IV, V. On Niccolò di Pietro Gerini, see R. Offner, *Studies in Florentine Painting*, New York, 1927 and 1972, pp. 83–95. Giovanni da Milano (active 1346–1369) was another near contemporary of Orcagna who retained what was basically a Giottesque feeling for form and space. While some of his brilliant frescoes in the Rinuccini Chapel (Santa Croce, Florence, c. 1365) do show contacts with Orcagna's idiom, they seem even more indebted to the late Giotto and early Taddeo Gaddi. For Giovanni, see A. Marabottini, *Giovanni da Milano*, Florence, 1950, and M. Gregori, *Giovanni da Milano alla Cappella Rinuccini*, Milan, 1965.

21. There are fragments of a large *Triumph of Death* fresco by Orcagna in Santa Croce, Florence (Offner, *Corpus*, IV, I, pp. 43–58). It is curious that several of the painters active in Santa Maria Novella in the 1350s and 1360s appear never to have worked for the Franciscans in Santa Croce.

22. For Spinello Aretino, see G. Gombosi, *Spinello Aretino*, Budapest, 1926. For Antonio Veneziano, see Offner, *Studies*, pp. 67–81. For Agnolo Gaddi, see R. Salvini, *L'arte di Agnolo Gaddi*, Florence, 1936; and B. Cole, *Agnolo Gaddi*, Oxford (forthcoming). The Giotto revival is discussed by

M. Boskovits, " 'Giotto born Again,' Beiträge zu den Quellen Masaccios," *Zeitschrift für Kunstgeschichte*, XXIX, 1966, pp. 51–66; and D. Wilkins, "Maso di Banco and Cenni di Francesco: A Case of Late Trecento Revival," *The Burlington Magazine*, CXI, 1969, pp. 83–84.

23. Antonio Veneziano's frescoes in the Pisa Camposanto and Spinello's cycles at Santa Caterina, Antella, San Miniato al Monte, Florence and in the Palazzo Pubblico, Siena, are all representative of the increasing compositional clarity and narrative integration of the late Trecento and very early Quattrocento. This is especially true of Spinello's late work and of Agnolo Gaddi's last fresco cycle in the Cappella della Sacra Cintola in Prato.

24. See Wilkins and Boskovits.

25. On Masaccio, see L. Berti, *Masaccio*, University Park, 1967.

26. B. Berenson, *The Florentine Painters of the Renaissance*, New York, 1896, p. 27.

27. On Ghirlandaio, see G. Davies, *Ghirlandaio*, London, 1908, and J. Lauts, *Domenico Ghirlandaio*, Vienna, 1943.

VII: Assisi

1. For a complete survey of the church and its decorations, see B. Kleinschmidt, *Die Basilika San Francesco in Assisi*, Berlin, 1915–1928, 3 vols. On the church's architecture, see also E. Hertlein, *Die Basilika San Francesco in Assisi*, Florence, 1964.

2. For the legend of St. Francis, see H. Thode, *Franz von Assisi und die Anfänge der Kunst der Renaissance in Italien*, Vienna, 1934 (2nd ed.); G. Kaftal, *Iconography of the Saints in Tuscan Painting*, Florence, 1952; H. Schrade, *Franz von Assisi und Giotto*, Cologne, 1964.

3. For Ghiberti's attribution and other written sources before Vasari, see P. Murray, *An Index of Attributions Made in Tuscan Sources before Vasari*, Florence, 1959, pp. 79–80.

4. G. Vasari, *Le vite de' più eccellenti pittori, scultori ed architettori* (ed. G. Milanesi), Florence, 1878, Vol. I, p. 377, and *The Lives of the Painters, Sculptors, and Architects by Giorgio Vasari* (trans. A. B. Hinds), London, 1927, Vol. I, pp. 68–69.

5. Scholars working on the Assisi problem have basically occupied one of two camps—those who claim that the *Legend of St. Francis* frescoes are by Giotto and his shop and those who deny that he had any share in their planning and execution. For a representative view of those who see Giotto's hand in the Francis cycle, see P. Toesca, *Giotto*, Turin, 1941, pp. 58–66; C. Gnudi, *Giotto*, Milan, 1958. A. Smart's *The Assisi Problem and the Art of*

Giotto, Oxford, 1971, contains one of the most recent comprehensive refutations of Giotto's authorship of the Assisi paintings. See also R. Offner's magistral study "Giotto, Non-Giotto," *The Burlington Magazine*, LXXIV, 1939, pp. 259–68; LXXV, pp. 96–113. Recently a new solution has been proposed by R. Oertel, *Early Italian Painting to 1400*, New York, 1968, pp. 64–82, who suggests that the frescoes were designed by Giotto but executed by his shop. For a bibliography on the entire question, see G. Previtali, *Giotto e la sua bottega*, Milan, 1967, pp. 303–13.

6. See Bonaventure's *Life of St. Francis*, chaps. XIV and XV in *St. Francis of Assisi—Writings and Early Biographies* (ed. M. Habig), Chicago, 1972, pp. 737–46.

7. See note 5.

8. For the influence of the early Giotto, see B. Cole, "On an Early Florentine Fresco," *Gazette des Beaux-Arts*, LXXX, 1972, pp. 91–96.

9. For the Master of Santa Cecilia, see R. Offner, *Corpus of Florentine Painting*, Berlin, 1931, III, I, pp. 15–37. On Pacino di Buonaguida, see *Ibid.*, Berlin, 1930, III, II, Plate 1, pp. 1–20.

10. *Ibid.*, 1931, III, I, pp. 18–23.

11. Giotto's early influence was not just confined to Florence. His style was especially important in Naples, Rimini and Padua. For a general survey of Trecento painting outside of Tuscany, see Oertel, pp. 317–34. For more detailed literature on some of the local schools, see O. Morisani, *Pittura del Trecento in Napoli*, Naples, 1947; F. Bologna, *I Pittori alla corte angioina di Napoli 1266–1414*, Rome, 1969; C. Volpe, *La pittura riminese del Trecento*, Milan, 1965; and L. Coletti, *I primitivi. I padani*, Novara, 1947. Giotto's style was even felt as far away as England. For the influence on England—and on some other European countries—see O. Pächt, "A Giottesque Episode in English Mediaeval Art," *Journal of the Warburg and Courtauld Institutes*, VI, 1943, pp. 51–70.

12. The signed *Stigmatization of St. Francis* panel in the Louvre, Paris, also contains, in the predella, scenes taken from Assisi. This must be the result of the patron's desire to have the canonical scenes in San Francesco reproduced. For the Louvre panel, see A. Martindale and E. Baccheschi, *The Complete Paintings of Giotto*, New York, 1966, p. 95, and G. Previtali, pp. 366–67.

13. J. White ("The Date of 'The Legend of St. Francis' at Assisi," *The Burlington Magazine*, XCVIII, 1956, pp. 344–51) and M. Meiss (*Giotto and Assisi*, New York, 1967, p. 3) have suggested that the *Stigmatization of St. Francis* from Giuliano da Rimini's altarpiece of 1307 (Gardner Museum, Boston) is copied from the St. Francis cycle at Assisi. Although there can be little doubt that Giuliano's figure reflects the Assisi type, it may well have

been taken from another source (a copybook, a panel painting or a fresco in another location?), and so the date of 1307 on the altarpiece may not be the *terminus ante quem* for the cycle. Meiss' suggestion that the St. Clare from Giuliano's altarpiece is a copy of the same figure in the Giottesque St. Nicholas Chapel in Assisi is open to a similar interpretation.

VIII: Afterword—Giotto's Critics

1. For a study of Rembrandt criticism, see S. Slive, *Rembrandt and His Critics, 1630–1730*, The Hague, 1953.

2. For the most comprehensive survey of the writings on Giotto from his day to the present, see R. Salvini, *Giotto bibliografia*, Rome, 1938, and C. De Benedictis, *Giotto bibliografia*, Vol. II (1937–1970), Rome, 1973. An interesting study of the reputations of early Italian artists is found in G. Previtali's *La fortuna dei primitivi*, Turin, 1964.

3. See J. Burckhardt, *The Civilization of the Renaissance in Italy*, New York, 1958, 2 vols.; H. Baron, *From Petrarch to Leonardo Bruni, Studies in Humanistic and Political Literature*, Chicago, 1968; L. Green, *Chronicle into History*, Cambridge, 1972.

4. On Dante on Giotto and for the other early Italian writers who commented on the artist, see E. Falaschi, "Giotto: The Literary Legend," *Italian Studies*, XXVII, 1972, pp. 1–27.

5. G. Boccaccio, *Decameron*, VI, V (trans. F. Winwar), New York, 1955, pp. 365–67.

6. On the history of revival and renascence, see E. Panofsky, *Renaissance and Renascences in Western Art*, New York, 1969.

7. On Giotto's wit, see, for example, F. Sacchetti, *Novella*, LXXV; *Il Trecento novelle* (ed. E. Faccioli), Turin, 1970, pp. 193–94.

8. Filippo Villani, *De origine civitatis Florentiae et eiusdem famosis civibus*. Translation from Panofsky, pp. 14–15; see *ibid.*, for the Latin text.

9. For some non-Florentines who praised Giotto, see R. Ferrarese, *Compilatio Chronologica* (ed. L. Muratori), *Rerum italicarum Scriptores*, IX, Milan, 1726, p. 235; and F. Petrarch, *Familiarum Rerum Libri* (ed. V. Rossi), Florence, 1933, Vol. II, p. 39.

10. The standard modern edition of Vasari's *Vite* is G. Vasari, *Le vite de' più eccellenti pittori, scultori ed architettori* (ed. G. Milanesi), Florence, 1878, 9 vols.

11. *Ibid.*, p. 369. English translation from *The Lives of the Painters, Sculptors, and Architects by Giorgio Vasari* (trans. A. B. Hinds), London, 1927, Vol. I, pp. 65–66.

12. On Vasari, see J. Schlosser, *La Letteratura artistica*, Florence, 1964, pp. 289–346.

13. G. Vasari (ed. Milanesi), p. 383. English translation from *The Lives* (ed. Hinds), p. 72.

14. C. de Brosses, *Lettres familières écrites d'Italie en 1739 et 1740*, Paris, 1869, Vol. I, p. 143. Translation from A. Martindale and E. Baccheschi, *The Complete Paintings of Giotto*, New York, 1966, p. 10.

15. L. Lanzi, *Storia pittorica della Italia*, Bassano, 1795–96, Vol. I, p. 17. English translation from L. Lanzi, *The History of Painting in Italy* (trans. T. Roscoe), London, 1847, Vol. I, p. 43.

16. Lanzi, *Storia*, p. 18. Translation from Lanzi, *History*, p. 46.

17. J. Ruskin, *Mornings in Florence*, Orpington, 1875–1877, reprinted in *The Works of John Ruskin* (ed. E. Cook and A. Wedderburn), London, 1906, Vol. XXIII, p. 350.

18. B. Berenson, *The Florentine Painters of the Renaissance*, New York, 1896, p. 19.

19. M. Proust, *Swann's Way* (trans. C. K. Moncrieff), New York, 1928, p. 103.

20. F. Rintelen, *Giotto und die Giotto-Apokryphen*, Basel, 1923, pp. 123–24. Translation by A. van Buren.

21. R. Offner, "Giotto, Non-Giotto," *The Burlington Magazine*, LXXIV, 1939, pp. 259–68; LXXV, pp. 96–113. For other twentieth-century criticism of Giotto, see G. Luzzatto, "Giotto: Da primitivo a classico nel giudizio critico degli ultimi anni," *Giotto e il suo tempo*, Rome, 1971, pp. 319–30.

Selected Bibliography

The selected bibliography is divided into three sections, each mainly concerned with the period covered by this book: "Culture, Society and Religion," "Early Italian Art" and "Giotto." Whenever possible I have listed books that contain further bibliography on their respective subjects. If an English translation of a book written in another language exists, I have included it. Indispensable for Giotto are the two splendid bibliographies devoted to the artist: R. Salvini, *Giotto bibliografia*, Rome, 1938; C. De Benedictis, *Giotto bibliografia*, Vol. II, Rome, 1973.

Culture, Society and Religion

F. Antal, *Florentine Painting and Its Social Background*, London, 1948; M. Becker, *Florence in Transition*, Baltimore, 1967 and 1968, 2 vols.; G. Brucker, *Florentine Politics and Society 1343–1378*, Princeton, 1962; G. Brucker, *The Society of Renaissance Florence*, New York, 1971; J. Burckhardt, *The Civilization of the Renaissance in Italy*, New York, 1958, 2 vols.; R. Davidsohn, *Geschichte von Florenz*, Berlin, 1896–1927, 4 vols.; *St. Francis of Assisi—Writings and Early Biographies* (ed. M. Habig), Chicago, 1972; D. Herlihy, *Pisa in the Early Renaissance*, New Haven, 1958; D. Herlihy, *Medieval and Renaissance Pistoia*, New Haven, 1967; J. Hyde, *Society and Politics in Medieval Italy* New York, 1973; G. Kaftal, *Iconography of the Saints in Tuscan Painting*, Florence, 1952; G. Kaftal, *Iconography of the Saints in Central and South Italian Schools of Painting*, Florence, 1965; J. Larner, *Culture and Society in Italy 1290–1420*, New York, 1971; *Meditations on the Life of Christ* (trans. I. Ragusa, ed. R. Green), Princeton, 1961; M. Meiss, *Painting in Florence and Siena after the Black Death*, New York, 1964; N. Ottokar, *Il Comune di Firenze alla fine del dugento*, Florence, 1926; W. and E. Paatz, *Die Kirchen von Florenz*, Frankfurt am Main, 1940–1954, 6 vols.; E. Panofsky, *Renaissance and Renascences in Western Art*, New York,

1969; F. Schevill, *Medieval and Renaissance Florence*, New York, 1963, 2 vols.; R. Schevill, *Siena*, New York, 1964; H. Thode, *Franz von Assisi und die Anfänge der Kunst der Renaissance in Italien*, Vienna, 1934; G. Volpe, *Movimenti religiosi e sette ereticali nella società medievale italiana*, Florence, 1961; Jacobus de Voragine, *The Golden Legend*, London, 1941; D. Waley, *The Italian City-Republics*, New York, 1969.

Early Italian Art

B. Berenson, *Italian Painters of the Renaissance—Venetian School*, London, 1957, 2 vols.; B. Berenson, *Italian Painters of the Renaissance—Florentine School*, London, 1963, 2 vols.; B. Berenson, *Italian Painters of the Renaissance —Central Italian and North Italian Schools*, London, 1968, 3 vols.; W. Biehl, *Toskanische Plastik des frühen und hohen Mittelalters*, Leipzig, 1926; F. Bologna, *Early Italian Painting*, Leipzig, 1964; F. Bologna, *I pittori alla corte Angioina di Napoli 1266–1414*, Rome, 1969; E. Borsook, *The Mural Painters of Tuscany*, London, 1960; M. Cämmerer-George, *Die Rahmung der toskanischen Altarbilder im Trecento*, Strasbourg, 1966; E. Carli, *Pittura medievale pisana*, Milan, 1958; E. Carli, *Pittura pisana del Trecento*, Milan, 1961, 2 vols.; L. Coletti, *I primitivi, I padani*, Novara, 1947; J. Crowe and G. Cavalcaselle, *A New History of Painting in Italy*, London, 1864, 3 vols. (later English, Italian and German eds.); E. Garrison, *Italian Romanesque Panel Painting; An Illustrated Index*, Florence, 1949; H. Hager, *Die Anfänge des italienischen Altarbildes*, Munich, 1962; L. Lanzi, *The History of Painting in Italy*, London, 1847, 3 vols.; G. Marchini, *Italian Stained Glass Windows*, London, 1957; R. van Marle, *The Development of the Italian Schools of Painting*, The Hague, 1923–1938, 19 vols.; G. Matthiae, *Pittura romana del medioevo*, Rome, 1966, 2 vols.; O. Morisani, *Pittura del Trecento in Napoli*, Naples, 1947; R. Oertel, *Early Italian Painting to 1400*, New York, 1968; R. Offner, *Studies in Florentine Painting*, New York, 1927 and 1972; R. Offner, *A Critical and Historical Corpus of Florentine Painting*, Berlin, New York, Glückstadt, 1930– ; G. Previtali, *La fortuna dei primitivi*, Turin, 1964; M. Salmi, *Romanesque Sculpture in Tuscany*, Florence, 1928; M. Salmi, *Italian Miniatures*, London, 1957; G. Sinibaldi and G. Brunetti, *Pittura italiana del Duecento e Trecento (Catalogo della Mostra Giottesca di Firenze del 1937)*, Florence, 1943; O. Sirén, *Toskanische Maler im XIII Jahrhundert*, Berlin, 1922; P. Toesca, *La Pittura e la miniatura nella Lombardia*, Milan, 1912; P. Toesca, *Storia dell'arte italiana—Il Medioevo*, Turin, 1927; P. Toesca, *Il Trecento*, Turin, 1951; E. Sandberg-Vavalà, *Sienese Studies*, Florence, 1952; A. Venturi, *Storia dell'arte italiana*, Milan,

1901–40, 18 vols.; C. Volpe, *La Pittura riminese del Trecento*, Milan, 1965; J. White, *Art and Architecture in Italy 1250–1400*, Harmondsworth, 1966; J. White, *The Birth and Rebirth of Pictorial Space*, New York, 1972.

Giotto

E. Battisti, *Giotto*, Geneva, 1960; C. Carrà, *Giotto*, Rome, 1924; W. Euler, *Die Architekturdarstellung in der Arena-Kapelle*, Bern, 1967; R. Fry, *Vision and Design*, New York, 1957, pp. 131–77; D. Gioseffi, *Giotto architetto*, Milan, 1963; *Giotto e il suo tempo*, Rome, 1971; C. Gnudi, *Giotto*, Milan, 1958; W. Hausenstein, *Giotto*, Berlin, 1923; R. Longhi, "Giotto spazioso," *Paragone*, III, 1952, pp. 18–24; A. Martindale and E. Baccheschi, *The Complete Paintings of Giotto*, New York, 1966; M. Meiss, *Giotto and Assisi*, New York, 1967; A. Moschetti, *La Cappella degli Scrovegni*, Florence, 1904; M. von Nagy, *Die Wandbilder der Scrovegni-Kapelle zu Padua: Giottos Verhältnis zu seinen Quellen*, Bern, 1962; R. Offner, "Giotto, Non-Giotto," *The Burlington Magazine*, LXXIV, 1939, pp. 259–68; LXXV, pp. 96–113; F. Perkins, *Giotto*, London, 1902; G. Previtali, *Giotto e la sua bottega*, Milan, 1967; F. Rintelen, *Giotto und die Giotto-Apokryphen*, Basel, 1923; J. Ruskin, *Giotto and His Works in Padua*, London, 1854; R. Salvini, *All the Paintings of Giotto*, New York, 1963, 2 vols.; H. Schrade, *Franz von Assisi und Giotto*, Cologne, 1964; P. Selvatico, *Sulla Cappellina degli Scrovegni nell'arena di Padova e sui freschi di Giotto in essa dipinti*, Padua, 1836; O. Sirén, *Giotto and Some of His Followers*, Cambridge, 1917, 2 vols.; A. Smart, *The Assisi Problem and the Art of Giotto*, Oxford, 1971; J. Stubblebine, *Giotto: The Arena Chapel Frescoes*, New York, 1969; I. Supino, *Giotto*, Florence, 1920, 2 vols.; L. Tintori and E. Borsook, *The Peruzzi Chapel*, New York, 1965; L. Tintori and M. Meiss, *The Painting of the Life of St. Francis*, New York, 1967; P. Toesca, *Giotto*, Turin, 1941; K. Weigelt, *Giotto*, Berlin, 1925.

Outline of Important Dates

The dates given in this outline are some of the most important in the art of the period covered by this book. Presumed dates appear in italics.

1260 Nicola Pisano's Pisa Pulpit

1265 Birth of Dante

1267 Probable date of Giotto's birth

1272 Cimabue recorded in Rome

1296 Arnolfo di Cambio made *Capomaestro* of the Florentine Duomo

1301 First record of Giotto in Florence

1304 Birth of Petrarch

1310 Dante completes the *Divine Comedy*

1311 Duccio finishes the *Maestà* for the Duomo of Siena

1311 Giotto acts as a guarantor for a loan

1313 Birth of Boccaccio

1315 Simone Martini's earliest dated painting (*Maestà*, Palazzo Pubblico, Siena)

1318 Giotto legally emancipates his son Francesco

1319 Ambrogio Lorenzetti's earliest dated painting (*Madonna and Child*, formerly Sant'Angiolo, Vico l'Abate)

1320 Giotto's entry into the Florentine painters guild (*Arte dei Medici e Speziali*)

1321 Dante dies

1325 Giotto acts as a guarantor for a loan

1328 Bernardo Daddi's earliest dated painting (*Triptych*, Uffizi, Florence)

1330 King Robert of Naples proclaims Giotto "our faithful and familiar friend"

1334 Giotto made *Capomaestro* of the Duomo and works of the commune of Florence

1335 Giotto involved in a legal action in Florence
1337 Giotto dies
1341 Petrarch crowned Poet in Rome
1343 Orcagna's entry into the Florentine painters guild
1348 The Black Death
1351 Final version of Boccaccio's *Decameron*
1357 Orcagna's *Strozzi Altarpiece*, Santa Maria Novella, Florence
1365 Andrea da Firenze begins work on the Spanish Chapel, Santa Maria Novella, Florence
1366 Taddeo Gaddi dies
1374 Petrarch dies
1375 Boccaccio dies
1378 Lorenzo Ghiberti born
1383 Agnolo Gaddi's first major commission (Castellani Chapel, Santa Croce, Florence)
1385 Spinello Aretino's earliest dated painting (Monteoliveto Maggiore altarpiece)
1389 Birth of Cosimo de' Medici
1401 Masaccio born

List of Illustrations

Index

SCHEDULE OF PHOTOGRAPHS

Photographs not listed below are reproduced by courtesy of the museums specified in the List of Illustrations.

Alinari-Anderson, Florence: 3, 11, 12, 13, 14, 15, 16, 19, 20, 21, 23, 24, 36, 38, 39, 40, 43, 46, 47, 50, 51, 53, 56, 57, 58, 59.

G. F. N., Florence: 1, 2, 4, 5, 6, 7, 8, 9, 10, 17, 35, 37, 41, 42, 44, 45, 48, 49, 55.

Museo Civico, Padua: 22, 25, 26, 27, 28, 29, 30, 31, 32, 33, 34.

From R. Offner, *Corpus of Florentine Painting*, Glückstadt, 1956, III, VI, pl. Ia.